The De-definition of Art

Harold Rosenberg

The University of Chicago Press
Chicago and London

Other books by Harold Rosenberg from Chicago

The Tradition of the New
The Anxious Object
Artworks and Packages
Act and the Actor
Art on the Edge

The De-definition of Art

This book originally appeared under the title
The De-definition of Art: Action Art to Pop to Earthworks.

The University of Chicago Press, Chicago 60637
The University of Chicago Press, Ltd., London

90 89 88 87 86 85 84 83 1 2 3 4 5

Library of Congress Cataloging in Publication Data

Rosenberg, Harold.
 The de-definition of art.

 Originally published: New York: Horizon Press, 1972.
 Includes index.
 1. Art, American. 2. Art, Modern—20th century—
United States. 3. Art—Philosophy. I. Title.
[N6512.R675 1983] 709′.73 83-1101
ISBN 0-226-72673-8 (pbk.)

For Saul Steinberg

"*Painting today is a profession one of whose aspects is the pretense of overthrowing it.*"

—from *The De-definition of Art*

Contents

Illustrations

On the De-definition of Art

An excited view, recently become prevalent in advanced artistic and academic circles, holds that all kinds of problems are waiting to be solved by the magical touch of art. So intense is this enthusiasm for what the artist might accomplish that mere painting and sculpture are presented as undeserving of the attention of the serious artist.

"There are already enough objects," writes an artist, "and there is no need to add to those that already exist."

"I choose not to make objects," writes another. "Instead, I have set out to create a quality of experience that locates itself in the world."

And here is a clincher by the sculptor Robert Morris, who concludes in a recent article that "The static, portable indoor art object [a rather nice materialistic way to describe a painting or sculpture] can do no more than carry a decorative load that becomes increasingly uninteresting."

In contrast to the meagerness of art, the artist is blown up to gigantic proportions. He is described as a person of trained sensibility, a developed imagination, a capacity for expression and deep insight into the realities of contemporary life.

The artist has become, as it were, too big for art. His proper medium is working on the world: Ecology—Transforming the Landscape—Changing the Conditions of Life. Among the followers of Buckminster Fuller this super- or beyond-art activity is called, significantly, the World Game.

This aggrandizement, and self-aggrandizement, of the artist seems on the surface to represent an expanded confidence in the creative powers of artists today. Everything can be done through art, and whatever an artist does is a work of art. "Why is *The Chelsea Girls* art?" Andy Warhol reflected in an interview, and answered, "Well, first of all, it was made by an artist, and, second, that would come out as art." You have the choice of answering, Amen!—or, Oh, yeah?

Actually, the artist who has left art behind or—what amounts to the same thing—who regards anything he makes or does as art, is an expression of the profound crisis that has overtaken the arts in our epoch. Painting, sculpture, drama, music, have been undergoing a process of de-definition. The nature of art has become uncertain. At least, it is ambiguous. No one can say with assurance what a work of art is—or, more important, what is not a work of art. Where an art object is still present, as in painting, it is what I have called an anxious object: it does not know whether it is a masterpiece or junk. It may, as in the case of a collage by Schwitters, be literally both.

The uncertain nature of art is not without its advantages. It leads to experiment and to constant questioning. Much of the best art of this century belongs to a visual debate about what art is. Given the changing nature of twentieth century reality and the unbroken series of upheavals into which the world has been plunged since World War I, it was inevitable that the processes of creation should have become detached from fixed forms and be compelled to improvise new ones from whatever lies ready at hand. In countries where high art is maintained according to the old definitions—as in the Soviet Union—art is either dead or engaged in underground revolt. So art must undergo—and has been undergoing—a persistent self-searching.

However, it is one thing to think about art in new ways—and another not to think about it at all, but to pass beyond art and become an artist in a pure state. The post-art artist carries the de-definition of art to the point where nothing is left of art but the fiction of the artist. He disdains to deal in anything but essences. Instead of painting, he deals in space; instead of dance, poetry, film, he deals in movement; instead of music, he deals in

sound. He has no need for art since by definition the artist is a man of genius and what he does "would," in Warhol's phrase, naturally "come out as art." He need no longer confine himself to a single genre or form language, such as painting or poetry— or even to a mixture of genres, such as theater or opera—he can go from one medium to the other, and innovate in each through refusing to find out what it is about. Or he can be an inter-media creator who blends the visual, the aural, the physical, into a super-art presumably able to encompass all experience into something he calls a "quality that locates itself in the world."

The post-art artist can go further—he can fashion an "en-vironment" (most potent word in present-day art jargon) in which all kinds of mechanically induced stimuli and forces play upon the spectator and make him no longer a spectator but, willy-nilly, a participant and thus a "creator" himself.

The vision of transcending the arts in a festival of forms and sensations rests upon one crucial question: "What makes one an artist?" This issue is never raised in the post-art world, where it is assumed that the artist is a primal force, a kind of first cause —and that he therefore exists by self-declaration.

In reality, however, an artist is a product of art—I mean a particular art. *The* artist does not exist except as a personifica-tion, a figure of speech that represents the sum total of art itself. It is painting that is the genius of the painter, poetry of the poet —and a person is a creative artist to the extent that he participates in that genuis. The artist without art, the beyond-art artist, is not an artist at all, no matter how talented he may be as an im-presario of popular spectaculars. The de-definition of art neces-sarily results in the dissolution of the figure of the artist, except as a fiction of popular nostalgia. In the end everyone becomes an artist. Set out for Clayton! (See Chapter 22.)

Despite the Great Expectations held for the new open-form fabrications, the individual arts, in whatever condition they have assumed under pressure of cultural change and the actions of individual artists, have never been more indispensable to both the individual and to society than they are today. With its accumulated insights, its disciplines, its inner conflicts, painting (or poetry, or music) provides a means for the active self-

development of individuals—perhaps the only means. Given the patterns in which mass behavior, including mass education, is presently organized, art is the one vocation that keeps a space open for the individual to realize himself in knowing himself. A society that lacks the presence of self-developing individuals—but in which passive people are acted upon by their environment—hardly deserves to be called a *human* society. It is the greatness of art that it does not permit us to forget this.

Part One / Art and Words

Part One: Art and Words

1 / Redmen to Earthworks

Now that taste has ceased to exist (since a value that no one will defend is dead), the influence it once exerted upon art seems to belong to distant times. If the paintings and sculptures in the "Nineteenth-Century America" exhibition at the Metropolitan were alien to the representative art of America today, the reason lay less in formal and conceptual differences than in the extreme politeness of the earlier works in presenting their matter to the spectator. That a picture which might be emotionally upsetting, such as Vanderlyn's of the tomahawking of Jane McCrea, is a rarity in nineteenth-century American art underlines the rule of aesthetic good manners—violence, the Catalogue of the Metropolitan exhibition pointed out, is an aspect of American life which "most artists, governed by nineteenth-century ideas of suitability and decorum, chose not to emphasize." The same was true of nakedness. Raphaelle Peale's amusing "After the Bath"— a female completely concealed behind a *trompe l'oeil* kerchief— is a cultural companion piece to Hiram Power's "The Greek Slave," the sculpture of a sexless nude of which her creator said that "not her person but her spirit stands exposed." (The spirit was that of a cool, abstracted neoclassicism that would excite no one.) On the other hand, Thomas Eakins's naked women got him into trouble and, being inimical to the artistic etiquette of the period, were perhaps justifiably excluded from the Metropolitan's nineteenth-century America.

The art of new nations is inherently conservative; its primary function is to satisfy the nostalgia or the striving for high culture of artists and their patrons, and this is best accomplished by imitating the styles favored by the most respectable circles of the home countries. The very notion of art thus becomes identified with "suitability and decorum." The aesthetic is a dressing-up of nature to meet standards of propriety. In the period on display at the Metropolitan, the avant-garde principle of irritating the spectator was not yet active in American art. Works endeavored to make themselves agreeable to the public, not to challenge its sensibility. No one in American painting thought of matching Poe's program of working on the nerves of his audience.

As seen at the Metropolitan, nineteenth-century American painting and sculpture reflected the American scene as it was found acceptable in the drawing room. Alongside the mountain peaks and lakes in sundry moods; the Indians, birds, and broncos; the yokels and rivermen; the darkies in the cottonfields; the newsboys and comic idlers; plus a few industrial workers (John Weir's "The Gun Foundry" and Thomas Anshutz's well-known "Steelworkers—Noontime," were almost the only traces of modern industry in the Metropolitan exhibition), were the portraits, conversation pieces, and idealized busts of those who inhabit the drawing room. To clinch the correlation of art and class tastes, the paintings and sculptures in the Metropolitan galleries were surrounded by the elegant furniture and decorative relics of the drawing rooms themselves. The wild vistas, waterfowl, and uncultivated folk of crude America had been allowed into these distinguished precincts only long enough to get their pictures taken. Throughout the show there was the feeling of self-conscious posing, not only by the people depicted but by landscapes and things as well.

The figures, including the cat, in George Caleb Bingham's "Fur Traders Descending the Missouri"—probably the most frequently reproduced painting of mid-nineteenth-century America—face the spectator, the old trader with a grimace, his son with a meditative smile, as if reacting to the interest in them of the art-loving gentry. The large landscapes pardonably

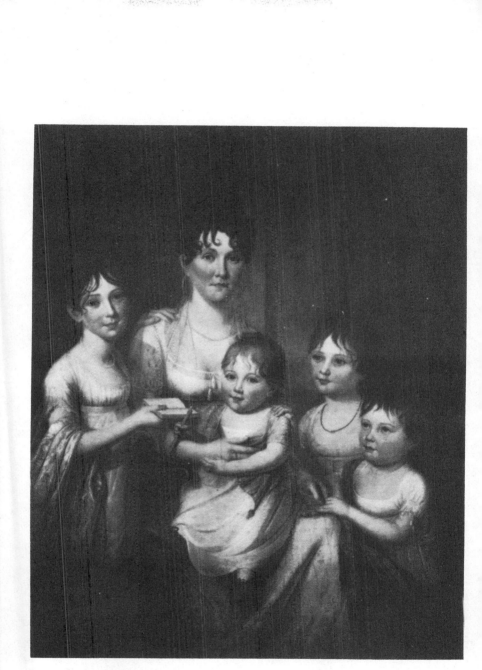

James Peale, *Madame Dubocq and Her Children*, 1807, oil on canvas. J. B. Speed Art Museum, Louisville.

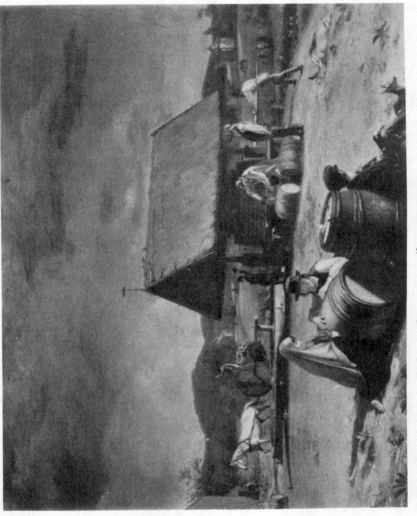

William Sidney Mount, *Cider Making*, 1841, oil on canvas.
The Metropolitan Museum of Art, Purchase, Charles Allen Munn Bequest, 66.126.

swagger, as their overpowering distances are accentuated by microscopic human beings spotlighted near the bottom of the composition. In Durand's "Kindred Spirits," a painting like a colored engraving that is a favorite in histories of American art, the romantic and allegorical landscapist, Thomas Cole, standing on a rock platform with a pointer in his hand, lectures not only his companion, William Cullen Bryant, but the spectator, too, on the transcendent grandeur of the scene.

In contrast to the landscapists the genre painters bring faces close, in order to identify them as social types. In the left foreground of William Sidney Mount's "Cider Making," a young girl gazes tenderly at a youth, who, however, is concerned more with the impression he is making on the person standing in front of the painting than with his admirer, while a girl and a boy sitting on a rail in the background also keep their eyes fixed on the onlooker. The gem of the exhibition, in terms of awareness of being watched, was Charles Ingham's "The Flower Girl," a portrait in which the paint is used as if it were cosmetics, and of which the Catalogue states, "that the young lady, playacting as a soulful flower vendor, is given the bland, sweet and refined features fashionable in mid-century novel-reading circles." The theatricality of American painting is magnified by the fondness of the painters for the style called luminism, with its sharp highlights and deep shadows calculated to bring out the contour and texture of every leaf, pebble, and water ripple. It is a mode of painting that in its smooth, glossy, and thinly pigmented surface comes closest to printed illustrations and reproductions, and anticipates the color photograph; a magnificent exception is Frederic Church's "Niagara," where uneven paint thicknesses are rhythmically modulated to match the swirlings and stillness of the waters.

Along with art as nature processed for the drawing room, nineteenth-century America developed an opposite conception —that of art as fashion and falsification. The notion of the superiority of "nature" as the true teacher of beauty keeps cropping up among American "realists," from George Catlin through Eakins, as well as among academic idealizers and sentimentalists. "Black and blue cloth and civilization are destined not only to

veil, but to obliterate the grace and beauty of Nature," wrote Catlin, painter of Indians, and he went on to argue that the "wilderness of North America," in which man appeared "unfettered by the disguises of art," was "unquestionably the best study or school of art in the world." This is a way of testifying that everything in the American landscape, just as one finds it, is art—or something higher than art: beauty. Art is conceived of as a barrier between the artist and what Henry James called "the real thing" (though James's sophisticated imagination recognized that the real thing might be less convincing than an artistic counterfeit). Painting, opposing art, reaches its peak by coming as close as possible to appropriating nature—by, in effect, lifting the Plains Indians out of the West and depositing them in a salon or the Smithsonian. Even Bingham, preeminent among the painters who converted the American scene into taste-satisfying art—and whose anxious straining after high style led him, when he was already a successful and mature painter, to study for several years at Düsseldorf—was dedicated to the conviction that art is inferior to nature, though on the simpleminded basis (often reiterated in recent years) that in a painting things don't move or make noise. Nineteenth-century American art—from that of naives and self-taught craftsmen to that of the most highly European-educated professionals, such as Eakins and Anshutz—complements its fashionable academicism with the beginnings of anti-art. Americans dream of taking home hunks of raw nature, of attaining, as Robert Henri said of Eakins, "the reality of beauty in nature as is"—in anticipation of twentieth-century bicycle wheels and bottle racks in museums and of such preoccupations with the real thing as today's rocks and piles of dirt dumped in art galleries, or a section of seacoast turned into a sculpture by wrapping it in plastic.

The ideal of art as the real thing made portable manifests itself in the patient copying of scenes and objects—an approach that James Jarves, a mid-century critic, condemned as "heedless of idealisms of any sort," adding, "if it labored for any special end, it was that of ocular deception." Art with an eye-fooling objective was played down at the Metropolitan exhibition, which seemed to share Jarves's lofty-mindedness; *trompe l'oeil* was

represented solely by a handful of paintings by Raphaelle Peale, Charles Bird King, William Harnett, John Peto, and John Haberle. This type of painting is handled comprehensively in Alfred Frankenstein's careful exploration of the subject, *After the Hunt* (University of California Press, 1969). The magical illusion of three-dimensionality makes it possible for the artist to reach beyond taste to the wonder shared by people of all classes at seeing nature duplicated on a flat surface. Thus, he can dispense with traditions of excellence in composition, color harmony, and drawing in favor of a kind of sideshow skill—Harnett's dead rabbit with red bullet holes in his still life "After the Hunt" has the effect of a rabbit pulled out of a hat. King's "The Poor Artist's Cupboard"—one of the earliest examples of American illusionism—is an arrangement of domestic junk of the same order as Daniel Spoerri's assemblages of the actual debris of his breakfast table in the nineteen-sixties. In it—as in S. E. Harlow's painting of woolen socks hanging on a clothes line, John Haberle's faked velvet drapes, and Harnett's horseshoes, letter racks, worn five-dollar bills—randomness, or the simple placement of a single object against a flat background (a door, a wall), is in dramatic contrast with formal American still lifes, such as John Francis's "Still Life with Wine Bottles and Basket of Fruit," built upon what I have called the self-conscious posing of things. Frankenstein points out that once Harnett had been to Munich he began "to display a compositional formula." In the *trompe l'oeil* still life, as in the luminist landscape, lighting and the firm definition of edges are means for theatrical effect; a favorite device of the illusionists is illuminating the texture of newspapers, the torn sides or folded corners of old letters, the heads of nails (in Peto's "Lincoln and the Pfleger Stretcher," one cannot be sure that the nail is painted without touching it). In these paintings, however, in contrast with the luminist landscapes, presenting the object in the round is in the service not of light contrasts in the manner of eighteenth-century European masterpieces, but of versimilitude in the rendering of everyday things, as in waxworks, the stereoscope, or the photograph. It is a device of popular art; its ideal is nothing more than diversion. Situated outside the aesthetic fashions of nineteenth-century

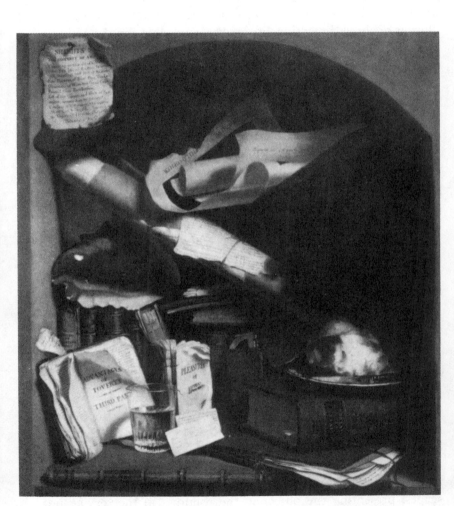

Charles Bird King, *The Poor Artist's Cupboard*, c. 1815, oil/panel.
In the Collection of the Corcoran Gallery of Art, Washington.

America, the *trompe l'oeil* painters suffered the fate of other borderline artists who create for the popular taste—paintings by Thomas Nast, for example, were featured at the Whitney only recently and were not included in the Metropolitan's "Nineteenth-Century America." By the time Harnett, Peto, and other appropriators of the American thing were rediscovered as art during the class-conscious nineteen-thirties, most of their works had disappeared, along with the mass of furniture and decorations (picture postcards, commemorative tableware, wooden Indians, and merry-go-round carvings) that had not earned a place in what Mr. Thomas Hoving's preface to the Metropolitan catalogue calls "America the Beautiful."

Artists paint not what they see but the art in what they see. The female whom artists in nineteenth-century fiction kept seeking as the ideal model is one who is already all art—a kind of "ready-made"—and can be copied without alteration. Art and the "grace and beauty of nature" have become one. To find art in nature makes art superfluous, while to do away with art makes nature perfect. The world is a museum, and the museum exhibits Robert Morris's live trees and Duchamp's bottle rack. A fixation of American painters is that they can create art without the benefit of art, or even by going against art—an attitude that Willem de Kooning likes to describe as "feeding off John Brown's body."

The issue of style as a means of seeing or as a barrier to seeing spans the history of American art, from the earliest explorer-draftsmen to present-day conceptualists. This issue overarches America's stylistic borrowings, from Baroque to Bauhaus. The reality-versus-art controversy reflects the aesthetic self-consciousness of United States art vis-à-vis European cultural superiority. "Reality" is the radical side of the argument and is identified with defiance, in the name of the new American experience, of traditional culture, and of the monied and educated élite that has laid claim to that culture. "Provincialism or coarseness or unculture is greater for creating art than fineness or polish," wrote the late David Smith in 1953, in a variation of Catlin's theme. "Creative art has a better chance of developing from coarseness and courage than from culture. One of the good

things about American art is that it doesn't have the spit and polish [tell it to the luminists!] that some foreign art has. It is coarse."

The rejoinder to the American fixation on creating art without benefit of art and even by going against art to nature—exemplified by Catlin's "grace and beauty" and Smith's "coarseness"—is typified by the exclamation of William Merritt Chase when he was offered the opportunity to study abroad. "My God!" he exclaimed, "I'd rather go to Europe than to heaven." Basically, it was Chase's view that prevailed. Regardless of their attitudes, American artists of the nineteenth-century did "go to Europe"—if not in actuality, then through copying engravings of European masters or following manuals on their methods. Catlin himself, for all his preference for the American "heaven," could not break through his European-derived models for the real thing of the West. His portraits of Indians are psychologically superficial—white people with painted faces and hung with Indian ornaments. Dorothy Dunn, in her *American Indian Painting of the Southwest and Plain Areas* (University of New Mexico Press, 1968), complains that in Catlin's studies "accurate representation of ethnological aspects of the Indian subjects had been largely sacrificed to . . . academic style."

In practice, "reality" as an alternative to art has been less an anti-art program than a social slogan. It may call for the abandonment of art; actually, it anticipates a renewal of art through raising substance above form. This amounts to challenging prevailing tastes, since it is through accord as to form that tastes are established. Eakins's scientific naturalism did not exclude refined compositional structure, or cause him to forget his Beaux-Arts teacher, Gérôme, but the rigorousness of his investigations did violate Philadelphia's concepts of "suitability and decorum" and made him an undesirable there. Something comparable on the subjective plane put a distance between the art public and that other great American independent, Ryder. In America, the social-political dimensions of art, and of attitudes toward art, are perhaps more palpable than elsewhere. Reality in art—that is to say, artless art—is unattainable, but in their stress on reality artists assert themselves against antagonistic values, as

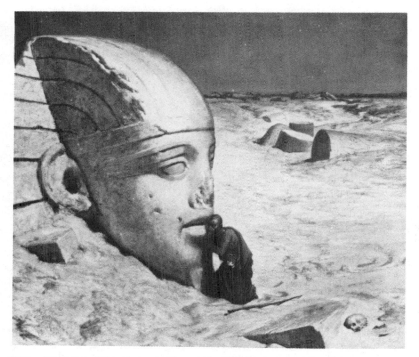

Elihu Vedder, *The Questioner of the Sphinx*, 1863, oil on canvas.
Museum of Fine Arts, Boston, Bequest of Mrs. Martin Brimmer.

in the contemporary earthworks and anti-form artists' stated
intention of rejecting the current museum-dealer-collector sys-
tem. In the nineteenth-century, liberation from official taste was
achieved only in rare instances. In the opinion of Henry James,
Winslow Homer succeeded in throwing off aesthetic self-
consciousness through meshing art and reality ("Things," de-
clared James, "come already modelled to his eye"), but James
found the result "horribly ugly." The Metropolitan exhibition
suggested that the fact that the taste of any one social group no
longer has power over art, and that all tastes are compelled to
coexist with rival tastes and with tastelessness, need not be a
cause for regret by American painting and sculpture.

2 / De-aestheticization

The sculptor Robert Morris once executed before a notary public
the following document:

Statement of Esthetic Withdrawal

The undersigned, Robert Morris, being the maker of the
metal construction entitled Litanies, described in the annexed
Exhibit A, hereby withdraws from said construction all esthetic
quality and content and declares that from the date hereof said
construction has no such quality and content.
Dated: November 15, 1963

Robert Morris

Not having seen "Litanies" or read the description of it in
Exhibit A, I cannot say how it was affected by Morris's with-
drawal or what its aesthetic condition was after the artist signed
his statement. Perhaps the construction turned into what one
permissive critic has called a "super-object of literalist art" or an
"anti-object of conceptual art." Or perhaps it became an "anxious
object," the kind of modern creation that is destined to endure
uncertainty as to whether it is a work of art or not. In any case,
the obvious intent of Morris's deposition was to convert
"Litanies" into an object of the same order as the reductionist-
inspired boxes, modules, and shaped canvases that flooded the
art world in the sixties. Morris's de-aestheticized construction
anticipated, for example, the demand of Minimalist Donald Judd

for an art with "the specificity and power of actual materials, actual colors, actual space."

Both Morris's aesthetic withdrawal and Judd's call for materials that are more real, or actual, than others—for example, brown dirt rather than brown paint—imply a decision to purge art of the seeds of artifice. Toward that end, Morris's verbal exorcism would probably be less effective than Judd's preselected substances. For works to be empty of aesthetic content, it seems logical that they be produced out of raw rocks and lumber, out of stuff intended for purposes other than art, such as strips of rubber or electric bulbs, or even out of living people or animals. Better still, non-aesthetic art can be worked into nature itself, in which case it becomes, as one writer recently put it, "a fragment of the real within the real." Digging holes or trenches in the ground, cutting tracks through a cornfield, laying a square sheet of lead in the snow (the so-called earthworks art) do not in their de-aestheticizing essence differ in any way from exhibiting a pile of mail sacks, tacking a row of newspapers on a wall, or keeping the shutter of a camera open while speeding through the night (the so-called anti-form art). Aesthetic withdrawal also paves the way for "process" art—in which chemical, biological, physical, or seasonal forces affect the original materials and either change their form or destroy them, as in works incorporating growing grass and bacteria or inviting rust—and random art, whose form and content are decided by chance. Ultimately, the repudiation of the aesthetic suggests the total elimination of the art object and its replacement by an idea for a work or by the rumor that one has been consummated—as in conceptual art. Despite the stress on the actuality of the materials used, the principle common to all classes of de-aestheticized art is that the finished product, if any, is of less significance than the procedures that brought the work into being and of which it is the trace.

The movement toward de-aestheticization is both a reaction against and a continuation of the trend toward formalistic over-refinement in the art of the sixties, and particularly in the rhetoric that accompanied it. Asserting the nostalgia of artists for invention, craftsmanship, and expressive behavior, earthworks protest against the constricting museum-gallery system organized

Donald Judd, *Untitled*, 1968, galvanized iron.
Courtesy Leo Castelli Gallery, New York.

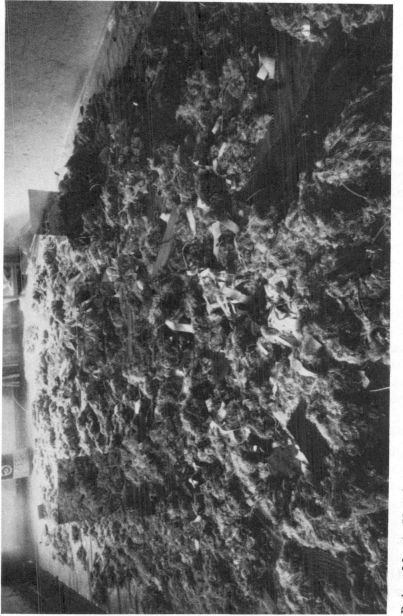

Robert Morris, *Untitled*, 1968, thread, mirrors, asphalt, aluminum, lead, felt, copper, steel.
Courtesy Leo Castelli Gallery, New York.

around a handful of aesthetic platitudes. Works that are constructed in the desert or on a distant seashore, that are not for sale and cannot be collected, that are formless piles of rubbish, or that are not even works but information about plans for works or events that have taken place are, one earthworks artist is quoted as saying, a "practical alternative to the absolute city system of art." Here the sociology of art overtly enters into the theory and practice of creation. The current defiance of the aesthetic is the latest incident in the perennial reversion to primitivism in the art of the past hundred years and the exaltation of ruggedness, simplicity, and doing what one chooses without regard to the public and its representatives.

On the other hand, de-aestheticized art is the latest of the avant-garde movements, and is presently engaged in permeating and taking over leadership in the situation it symbolically denounces. Such earthworkers, anti-formers, processors, and conceptualists as Morris, Carl André, Walter de Maria, Robert Smithson, Bruce Nauman, Richard Serra, Eva Hesse, Barry Flanagan, Keith Sonnier, Dennis Oppenheim, and Lawrence Weiner have been enjoying increasing prestige. At the Museum of Modern Art "Spaces" exhibition, Morris planted a hundred and forty-four Norway-spruce seedlings in bins of peat moss a foot deep in a room whose temperature and humidity were controlled to promote growth. An exhibition of works by Michael Heïzer, earth gouger, mound builder, and displacer of giant boulders, has been featured in *Artforum*, hitherto largely the house organ of Minimalists and "cool" Abstractionists; in addition to the Heizer article and a color photograph of a looped trench dug by that artist at Dry Lake, Nevada, *Artforum* contained interviews with the Düsseldorf "action-plastic" and chemical-process artist Joseph Beuys, who uses everything from sheets of copper and felt to live Christmas trees and dead hares (Interviewer: "There must be a lot of action in these works for you"), and with the meta-materialist Richard Van Buren, a former box builder, who contributes the following sample of the new vocabulary of active materials: "The wood was at one speed, at one sense of time, and the resin was at another sense of time. The wood was overpowering what was going down

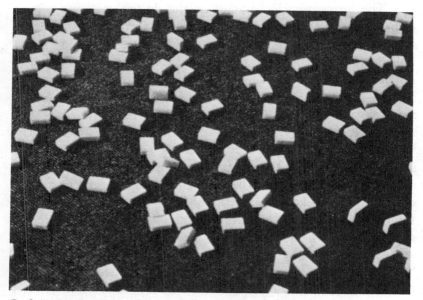

Carl Andre, *Spill (Scatter Piece)*, 1966, plastic and canvas bag.
Collection of Kimiko and John Powers, Aspen, Colorado.

with the resin. That was one of the problems. Now it's simple:
the material is all one material (even though I add different
ingredients to the resin)." *Art News*, too, though as always a
little slower than its rivals in leaping on bandwagons, accommo-
dated itself to self-realizing matter with an article on Gary
Kuehn, a sculptor who "explores form governed by pressure and
constraint motifs—with clamped, springy mats, sagging fiber-
glass, and rickety fences." Given this concentration of public
interest, the earthworks sites have become less remote (Robert
Scull, early Pop patron, has acquired an art-marred parcel of real
estate in Nevada—"it cost me a thousand dollars a day for earth-
moving equipment"); the unsalable art is being sold in the form
of drawings, diagrams, specimens, miniatures, photographs, and
documents; the non-object objectifies itself in records and me-
mentos; and the art that rejects aesthetics in favor of "a solitary
dialogue between man and the universe," to quote the critic in
Arts, keeps gaining recruits both in the United States and abroad.

The international character of the de-aestheticizing movement is conveyed in a pictorial survey of earthworks, materials art, and conceptual art assembled by Germano Celant, a young Italian art historian-critic; it was published here under the title of *Art Povera* (Praeger, 1969), and had appeared earlier in Milan. The book, which contains Morris's Withdrawal Statement as well as illustrations of works by Heizer, Beuys, and most of the artists I have mentioned, is about evenly divided between Americans and Europeans. De-aestheticized art is as self-conscious about aesthetic content as if it were ritually taboo, and *Art Povera* extends this fear of contamination into self-consciousness about the aesthetics of being a book. (In this spirit, I wondered whether Morris's Withdrawal Statement, since it appears in an art book and could thus be a work of conceptual art, might not need another Statement guaranteeing the original Statement's lack of aesthetic content.) Celant shudders at the disparity between the rigorous addiction to privacy of the works he has reproduced and the dissemination of those works as "consumer goods and cultural goods." His brief prefatory text amounts to a caution printed on the package; it contains such warnings as "The book narrows and deforms, given its literary and visual oneness, the work of the artist" and "The book is a precarious and contingent document and lives hazardously in an uncertain artistic-social situation." (What doesn't?)

Despite Celant's apprehensions, however, *Art Povera* is a useful book, more adequate to its subject than art books are generally. No art lends itself more readily to—in fact, at times depends so completely upon—publication than this art of *actual* materials and events. It might, as we are told, have taken two cranes, one loader, four transports, four cement trucks, and a sixty-eight-ton mass of granite to carry out one of Heizer's boulder-moving enterprises in Nevada, yet the result is essentially art for the book—that is, for photographs with captions—since once the rock has come to rest, visual interest in it depends on the cameraman's angle shots, his choice of distance, and the artist's explanation of his project. In a photograph on the jacket of *Art Povera*, two white lines converge on a gray ground; at right angles to the end of the left line, the body of a man is stretched

face down in the direction of the other line. The effect is strictly photographic and conceptual, and the intention of the artist would be less visible to a witness at the site than in the photograph. Douglas Huebler, one of the more extreme conceptualists, writes about works which are so "beyond direct perceptual experience" that "awareness of the work depends on a system of documentation. This documentation takes the form of photographs, maps, drawings, and descriptive language." Of course, there are exceptions—objects and events that lose in the documentary version—but the balance is on the side of the "documents."

In regard to the objects themselves, rather than the "information" through which they are customarily known, the term "*arte povera*," which means impoverished art, seems a convenient designation. Works that customarily present themselves at second hand and provide no pleasure to the senses certainly deserve to be called poor. (The term reminds me of Arshile Gorky's quip about the W.P.A. Federal Art Program in the nineteen-thirties: "Poor art for poor people.") Art *povera* does not associate itself with the needy, but, like earthworks in America, it asserts its alienation from the art market and its opposition to "the present order in art." In addition, poverty represents for it a kind of voluntary creative detachment from society, a refusal either to adopt the traditional role of the artist or to approve art values of any sort. In reducing the seductiveness of art to the vanishing point, it suggests the presence of a puritanism that conceives of the artist as a member of a mendicant order, independent of the community and disciplined against succumbing to its "cultural goods." To appraise the products of this self-denying movement as visually boring or trivial is to invite the retort that the quality of the object does not matter and that the function of art in our time is not to please the senses but to provide a fundamental investigation of art and reality. Jan Dibbets's remark "I'm not really interested any longer to make an object" is the typical *povera* position.

Yet aesthetic qualities inhere in things whether or not they are works of art. The aesthetic is not an element that exists separately, to be banished at the will of the artist. Morris could

no more withdraw aesthetic content from his construction than he could inject it where it was missing. Apart from metaphysics, however, the program of de-aestheticization has been of practical importance in the art of the past few years in that it has promoted among *povera* artists a salutary disregard for prevailing aesthetic dogmas. Denying all aesthetic aims in a work permits the artist to draw freely on the entire aesthetic vocabulary of modern art. The pictures in Celant's book recall the styles of half a dozen twentieth-century modes: they are strung on a line that meanders from Duchamp and Futurism through Dada, Surrealism, Action painting, Pop, Minimalism, and Mathematical Abstraction. De Maria's menacing "Bed of Spikes"—an instance of the inability of the photograph to do justice to the quality of the object—is a piece of Dadaist sadism which is made compatible with Marinus Boezem's Constructionist composition of discs, "Aerodynamic Object," by the rule of aesthetic indifference. The central concept of art *povera*—that the artist's idea or process is more important than his finished product—is an inheritance from Surrealism, which abandoned the art object for "research," and from Action painting, which subordinated the object to the act of the artist. Jannis Kounellis's "Cotoniera," a structure of rectangular steel plates out of which escapes a cloud of cotton, and Giovanni Anselmo's "Torsione," in which a sinister black cloth twisted to resemble an arm clutches a bar of iron, draw their effects from Surrealist dream displacement, as do Beuys's dead beasts. Oppenheim's lacerations of grass and snow are directed toward Action paintings, Happenings, and big-scale geometric art (nothing could be more "painterly" than a furrowed field). Of Morris's contributions, the three pieces made of felt are compositions of bands that make formal references to Morris Louis, Barnett Newman, and Oldenburg's soft sculpture. Aesthetic withdrawal has consisted mainly in cutting across existing styles in painting and sculpture by using previously unexploited mediums in making art.

This is another way of saying that de-aestheticized art, like most art of this epoch, is deeply involved in parody. Art *povera* mimics earlier paintings and sculptures by adapting their formal elements, in the manner of Rauschenberg or Johns, and by re-

discovering their forms in physical processes. An Abstract Expressionist gash in the earth, such as Heizer's "Foot-Kicked Gesture," or a Pop-style bale of wastepaper derives art from a phase of mining or of cleaning up the ticker tape on the floor of the New York Stock Exchange. But while the object is thus de-aestheticized through being found in the actual world, mining and the Stock Exchange are converted by association into aesthetic activities, as if their purpose were to produce shapely low reliefs in the ground or waves of paper for people to play in. As in traditional aesthetics, art *povera* is identified by its gratuitousness and absence of practical effect, so that Christo's wrapping in plastic of a million square feet of Australian coastline, which as an undertaking is similar to drilling for oil off the coast of Santa Barbara or defoliating a province of South Vietnam, becomes art only because Christo seeks neither oil nor victory and his "real" creation contaminates no beaches and destroys no lives. In thus shrinking the difference between art and facts to the question of motive, de-aestheticized art goes hand in hand with aestheticized events, with the increasing injection into actual situations of the ambiguity, illusoriness, and emotional detachment of art. In the distant background of art *povera* is the "real" art of Marinetti's bursting shrapnel of the First World War visualized as a stupendous earthwork, and the patterns and rhythms of the Nuremberg rallies seen as communications systems.

Ideally, art *povera* strives to reach beyond art to the wonder-working object, place ("environment"), or event. It extends the Dada-Surrealist quest for the revelatory found object into unlimited categories of strange responses. Redefining art as the process of the artist or his materials, it dissolves all limitations on the kind of substances out of which art can be constituted. Anything —breakfast food, a frozen lake, film footage—is art, either as is or tampered with, through being chosen as a fetish. Serra with sheets of lead, André with bricks, Heizer with a field in Nevada are like Old Testament conjurers with flowering staffs and potent jawbones, or Brigham Young indicating the appointed spot in the mountains of Utah. Art in our era oscillates between the conviction that meeting the resistance of a craft tradition is indispensable to acts of creation and the counter-conviction that secrets

can be fished alive out of the sea of phenomena. Art *povera* leaves no doubt about where it stands. A statement by a group known as "The Zoo," of Turin, announces, "It is useless to predict the end of art. Art was done with fifty years ago." A circular neon sign reproduced on the back jacket of *Art Povera* states the final conclusion that "the true artist helps the world by revealing mystic truths."

Whatever the case may be with regard to the end of art, the art world is more populous and pervasive than ever. In it a kind of malice toward art encourages assent to all forms of light-headedness at the same time that the apparent exhaustion of painting and sculpture arouses uneasiness. For all its nostalgia for reality, de-aestheticized art has never been anything but an art movement. The uncollectible art object serves as an advertisement for the showman-artist, whose processes are indeed more interesting than his product and who markets his signature appended to commonplace relics. To be truly destructive of the aesthetic, art *povera* would have to forsake art action for political action. As art, its products bear the burden of being seen by non-believers, who must be persuaded to respond to them. But to make a fetish potent outside its cult is precisely the function of the aesthetic.

3 / Educating Artists

Though outsiders might not suspect it, the training of students in universities to be painters and sculptors is an extremely touchy subject not only in educational circles but in the art world as well. Almost any suggestion or critical comment threatens existing interests, often invisible to the critic. Even mention of the fact that the typical artist today has been educated in a university is sufficient to provoke outcries. At a conference not long ago on cultural changes in the Americas since the war, I emphasized the shift of art training from professional schools and artists' studios. My mere citing of some figures—for example, only one of ten leading artists of the generation of Pollock and de Kooning had a degree (and not in art), while of "thirty artists under thirty-five" shown in "Young America 1965" at the Whitney Museum the majority had B.A.s or B.F.A.s—was taken by a prominent younger painter as implying that he and his age group were academic. "Academic" is still a bad word, even though no one knows any longer exactly what it means. Perhaps the term that used to designate ennobled nudes ought not be applied to carefully calculated dispositions of parallel lines or patterns of color. For my own part, I am willing to drop "academic" and substitute "calculated"—a term to which younger artists have no objection. My point was only that a new source of instruction for artists will affect their attitudes toward art, their handling of materials, and, ultimately, the styles in which they choose

to work. Can there be any doubt that training in the university has contributed to the cool, impersonal wave in the art of the sixties? In the classroom—in contrast to the studio, which has tended to be dominated by metaphor—it is normal to formulate consciously what one is doing and to be able to explain it to others. Creation is taken to be synonymous with productive processes, and is broken down into sets of problems and solutions. In a statement, published in a pamphlet sponsored by several foundations, on *The Arts and the Contemporary University*, Dr. Martin Meyerson, president of the State University of New York at Buffalo, noted the "tremendous production emphasis [that] pervades much of the university's work in the arts."

Paintings and sculptures typical of the past decade make the spectator aware of the presence of model works that have been not so much imitated or drawn upon for imaginative hints as systematically analyzed and extended by rational inference. For instance, Alber's impacted-color squares have become the basis of impacted-color rectangles, chevrons, circles, stripes—works bred out of studying works, often without the intervention of a new vision. In the shift from bohemia to academe, American art has become more conceptual, methodological, and self-assured. So pointing to the university training of today's artists very likely does carry a criticism.

If merely noting the new university connections of art can be regarded as an insult, far more menacing is any inquiry into who is teaching what and how. Or what relation there is between an academic degree and the capacity to function as an artist in the last third of the twentieth century. Dr. William Schuman, former president of Lincoln Center, calls for art training that will "produce practitioners," and then at once complains that "there are innumerable campuses where there are second-rate artists who give nothing but their own point of view to students." First-rate artists also tend to give their own point of view, and while this may at least be a valuable or, at any rate, interesting experience, it will not always suffice to meet the needs of art study. Dr. Schuman may have had in mind that a good teacher will present all relevant points of view, but in painting and sculpture the first-rate artist is the least likely to do this. My own observations

of the quality of artists on campuses support those of Dr. Schuman, and I shall present additional testimony on the second-rate later. Yet to say that most artists now teaching in universities haven't much to contribute either to art or to their students threatens not only their jobs but the entire position of art in the university—a position still highly infirm, despite the advances of the last fifteen years. Dr. Samuel B. Gould, chancellor of the State University of New York, who believes in the future of art in the universities, recognizes that there are still educators who "earnestly and sincerely doubt that art production has any place in higher education," and Dr. Meyerson says that "in common rooms and faculty clubs, it [art] is often referred to as 'hobby lobby' or other terms [sic] of opprobrium." Given this opposition, deans are hardly likely to be eager to allocate funds to enlist faculty members publicly characterized as second-rate; comparable questions are not raised about mediocre art historians.

If good artists are needed to teach art, the situation seems irremediable. Where are art departments to obtain first-rate artists willing to spend their time teaching, especially in colleges remote from art centers? And, thus isolated, how long would these artists remain first-rate? Is there even any agreement—except among a handful of names, perhaps—about who is first-rate? Beyond the quality of the teacher, there is the problem that art changes almost from season to season in outlook, concept, and even the materials out of which it is made. If the subject being taught could be defined, the matter of whether those who teach it are first-rate or second-rate might be less important. As it is, even if the quality of an artist's work is beyond dispute, an attempt by him to encompass each new move in the art world makes him, as a teacher, in effect second-rate, since only the inventor of the new move is first-rate in relation to it. (I would not have expected to learn much about the art of Andy Warhol in a class conducted by Giacometti.) Ambitious students are apt to be aware of this situation; no matter how distinguished the creations of their artist-teacher, they regard him as inadequate to impart the latest mode popular in New York. Speaking to a university audience, Jack Tworkov, then chairman of the Art Department at Yale, observed that the students in his department

(the oldest and, in my opinion, the best in the United States) scarcely listened to their teachers but derived their ideas from the art journals.

Failing to make up their minds that art teaching is their business, the universities have been content to let matters drift. Still engaged in agitating for administrative support, advocates of art in the universities tremble at the thought of confronting the problems of teaching it. A speaker who raises questions of direction at conferences of the College Art Association is met with nods and silence. Debates likely to disrupt one's own side are taken to be less useful than clichés designed to hold off the enemy. According to Dr. Gould, "the major reason" educators remain uncertain about admitting artist training into the universities "is that so much of what one wishes to deal with in the arts touches upon technique as opposed to philosophy." To overcome the doubt of his colleagues, Dr. Gould presents an idealized version of the artist-on-campus as "the whole man" whom humanity is in danger of losing in the face of the growing mass of "insensitive specialists" turned out by the sciences. Generous to art as Dr. Gould's outlook is, I am unable to agree that only scientists produce works "unintelligible to the uninitiated." Art today is as specialized and esoteric as the sciences, and the way it is being taught much of it does "touch upon technique" rather than philosophy. Studio courses are a kind of vocational training that swings from extremes of avant-guardism (experiments with light, film, electronics, synthetics, computers) to extremes of standing pat on whatever technique the instructor has been practicing as an artist. Having called attention to the second-raters, Dr. Schuman goes on to refer to a famous college "where students are either given the music of the sixteenth century or John Cage but almost nothing in between," and he speaks of another school, "equally distinguished, where the music of John Cage is not even permitted to be mentioned." The situation in painting is identical: either Minimalism, earthworks, lights—or copying Renaissance masters, drawing from casts, painting Impressionist interiors. Between these two orientations, everything taught depends on the chance of finding the best-known artist who happens to be available. The conservative/avant-garde polarization reflects the deep

division in modern culture; restricted to the level of techniques, the conflict serves as a substitute for a coherent concept of art in our time. Dr. Gould's doubters are correct, and if art teaching remains what it is, perhaps the art workshops do not belong on campus—though one could reply that most subjects taught in universities today touch upon "technique as opposed to philosophy."

While advocates of art in the universities invoke the image of the artist as creator, the actual education of the student as artist is indistinguishable from that of the commercial designer. The formation of the New York Studio School of Drawing, Painting, and Sculpture came about through the revolt of students in a degree-granting institution against courses unrelated to the vocation of artist. In a speech describing the founding of the School, Mercedes Matter, chairman of the faculty, exposed the absurdity of training painters by depriving them of the opportunity to paint. Remembering the academic enslavement of its students, the Studio School has made a fetish of not awarding degrees. Its solution of the problem of educating artists was to return to the old verities of the art academy: continuous drawing, painting, and modeling, contact with older artists, reliance on "the gift, the temperament, the purpose." Opposing the "practical" emphasis of university art courses, Mrs. Matter insists that art is "a perfectly useless activity." (She might have added that it is also a nostalgic one, since, deprived of the heroic concept of masterpieces, it tends to blend into the communications and entertainment media.)

Taking advantage of the availability of New York artists, museums, and galleries, the Studio School avoids the mental and psychic fragmentation of the typical college art department, and its teaching is a match for all but the best. Since it relies entirely on the individual teachings of artists, it fails, however, to advance the problem of proper training for an artist today, to say nothing of his education in general. Mrs. Matter's argument that Léger, Giacometti, de Kooning, Guston were able to dispense with universities, "thanks to their high degree of intelligence and

curiosity," is beside the point; the function of an educator is to educate, not to hope that lack of education will be compensated for by the student's natural gifts. In the Studio School, applying paint to canvas and talking about painting are accepted as sufficient preparation for a creative response to the contemporary world. The weakness of this position is revealed in the fact that the School has found itself forced into a blanket rejection of current developments in art. "I frankly don't understand anti-art or the causes of the present scene," confesses Mrs. Matter, apparently unaware that art education means precisely to impart to art students the ability to encompass the "present scene" with critical comprehension. In her statement there are indications that she mistakes art for holiness, as when she finds offering an art student a course in commercial design as absurd as teaching a young nun the art of streetwalking. That the art student is entering upon a sacred calling is also intimated by her belief that "an artist can do nothing to influence his own work" —a contention that would eliminate the need for any kind of education. To make up for its innate conservatism, the Studio School, in typical art-department vanguard-mongering, conducted a seminar by Buckminster Fuller on the "World Game."

Another critic of university art courses is Dan Flavin, a sculptor whose medium is fluorescent light tubes; his diatribe in *Artforum* "On an American Artist's Education" was a brilliant and cruel attack—it could not have been brilliant without being cruel—on the concepts and categories of teachers responsible for university "indoctrination of students in art historical media." Flavin's article was a detailed polemic against the art workshops manned by second-rate artists condemned by Dr. Schuman, and he seemed to agree with Mrs. Matter that "a college degree in art is a certificate of the fact that its recipient has not been studying art at such-and-such a place for four years." In his opinion, university studio teaching is largely dominated by "aging refugees from the commercial art game" who deliver "trade courses such as design, lithography, or art history" (censored, he notes) to students working for degrees that will license them to transmit to others their own lack of understanding of art. By Flavin's testimony, all modes of art, from

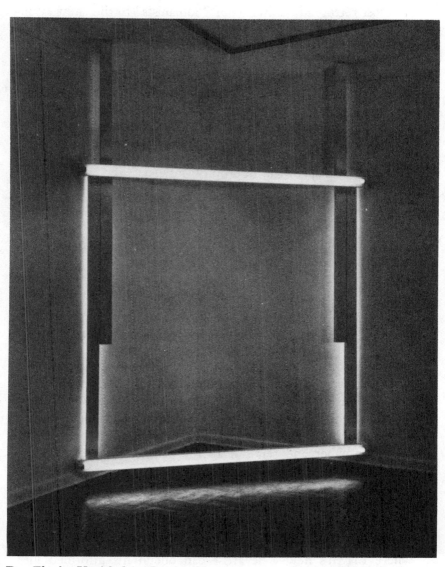

Dan Flavin, *Untitled (to Barnett Newman to commemorate his simple problem, red, yellow and blue).* 1970, flourescent light.
Courtesy Leo Castelli Gallery, New York.

the most retrograde drawings of "humanists" to the latest avant-garde "fun things," are being taught as techniques, the sum of which will constitute an art education. Lacking unity of purpose, the mediums are taught in isolation from one another, and decisions in the art departments are determined by careerism and the struggles of factions.

Flavin's criticism is biting and realistic, but it fails to offer a new approach to university art teaching. Despite his acrimony, he prefers—in contrast to the Studio School—the human product of the university to the disorderly, intellectually groping artist of an earlier time. "The romance of days of belabored feeling," he writes, "of precious, pious, compulsively grimy studio-bound labor by haphazardly informed neurotic 'loners,' often verging on mental illness, relying desperately on intuitive good sense, is passing from art. The contemporary artist is becoming a public man, trusting his own intelligence, confirming his own informed ideas." This sounds hardheaded and forward-looking, though not exactly new; fifty years ago, the Constructivists and the Bauhaus also conceived of the new artist as a sophisticated, healthy, self-confident professional—a "public man" who, like the lawyer or engineer, confirms "his own informed ideas."

It is pleasant, of course, to meet well-educated painters and sculptors instead of the farmer or artisan types to which many artists, especially sculptors, used to belong. The contemporary sculptor who inscribes instructions and a loose sketch on a sheet of blueprint paper and sends it to the foundry for execution is a man of words and mathematical symbols, a cross between a poet and an engineer, and you don't get people like that without intellectual training—I mean, as opposed to training with paint-brushes, hammers, and chisels, and other messy materials. But if "intuitive good sense" is not to be relied on, it is difficult to see where Flavin's new-style artist can obtain his informed ideas except in the university. Flavin's essay is a model of that system-atic packaging of artists, teachers, and art modes that prevails in college teaching. He repudiates this categorizing when it is applied to him ("no significant attempt was ever made to probe my thinking as an artist," he exclaims indignantly when a college instructor rejects his fluorescent sculpture on the ground that it

is technologically surpassed by programmed lights), but he seems not to realize that "probing" another artist's thinking belongs among the habits of self-education of that old, now passé loner, and that his own outlook is that of the avant-garde wing of art-department technical training.

If art teaching in the university is to be improved, the first requisite is to deal with its problems candidly and without excessive delicacy; before these problems are solved, even the most ineffective faculty member will have had ample time to live out his tenure in peace. What can and cannot be taught to artists in a university needs to be rigorously analyzed not only by educators but by artists and others who understand the intellectual nature of art. The function of the university is to impart knowledge, but art is not solely knowledge and the problems proposed by knowledge; art is also ignorance and the eager consciousness of the unknown that impels creation. No matter how cultivated he is, every creator is in some degree a naïf, a primitive, and relies on his particular gift of ignorance. It is the undeveloped, perhaps unacknowledged, areas of the mind that art counts on, even in its most rational aspects. That combination of ignorance, enthusiasm, intuition, and inventiveness cannot be put together for each member of a university course, nor is it the business of the university teacher to attempt to do so. Ignorance in particular is not a quality a university is equipped to supply, or even to honor.

Since it cannot teach all the elements of creation, art education must concentrate on what can be taught. This teachable matter is far more extensive than is generally supposed. An enormous volume of significant information about works of art and their mode of generation has been accumulated in this century, and the failure to open this to the student deprives him of the only currently available equivalent of the atelier. The most backward ideas in art teaching today are the idea of inspiration and the accompanying notion that the teacher need only provide the technical training needed to express that inspiration. Art as craft plus inspiration belongs to the preindustrial era. The history of modern art is a history of varieties of means developed by artists artificially to induce inspiration, including the vigorous

denial of any need for it. Art is a specialization, even when it is a specialization of spirit. Its data can be taught, as the data of any specialization can be taught.

In overstressing technique, both the fundamentalists and the avant-gardists in teaching mistake the nature of art in our time. Despite modern technological self-consciousness, art in the twentieth century is technical to a lesser degree than it was in the age of the potter's wheel or the maulstick. As Adolph Gottlieb has remarked, any artist with an idea will find out how to execute it; on the other hand, artists develop ideas through unfocused playing with their medium. The basic substance of art has become the protracted discourse in words and materials echoed back and forth from artist to artist, work to work, art movement to art movement, on all aspects of contemporary civilization and of the place of creation and of the individual in it. The student-artist needs, while learning to see and execute, above all to be brought into this discourse, without which the history of modern painting and sculpture appears a gratuitous parade of fashions. What used to be called talent has become subsidiary to insight into significant developments and possibilities. In a word, art has become the study and practice of culture in its active day-to-day life. Begin by explaining a single contemporary painting (and the more apparently empty of content it is the better), and if you continue describing it you will find yourself touching on more subjects to investigate—philosophical, social, political, historical, scientific, psychological—than are needed for an academic degree.

4 / Surrealism in the Streets

Reverberations of the students-workers uprising in Paris in May, 1968, reached the New York art world in the form of exhibitions of posters executed largely by students of the École de Beaux-Arts and the École des Arts Décoratifs in a workshop improvised during the demonstration under the title of Atelier Populaire. Posters were made, too, by well-known Paris artists—Matta, Hélion, Le Parc, to name only a few—but these were not included in the collections brought to New York. The student work was uneven, and at its best not distinguished. There was no strong sense of style, the draftsmanship was commonplace, the typography was haphazard, the colors were crude and devoid of emotional or eye-catching power, the symbols were obvious; "RETURN TO NORMAL" was illustrated by a flock of sheep, the riot police by modifying their helmets to represent death-heads. Obviously, there was no thought of advancing the art of poster-making, and Paris professionals did not need to feel challenged. The desire of the students seemed to have tended in the opposite direction, toward work conspicuously "poor" and makeshift, like the *affiches* of the Resistance done on the run and with whatever means lay at hand. Some posters stood out because of their visual aptness: a tiny cartoon figure seen from behind writing "NO" on a wall in red; the facade of a building labeled "FRANCE" sustained by columns, shaped like ninepins that represented the official political parties, including the Communists

and the Gaullists, about to be knocked down by a speeding ball inscribed "POUVOIR POPULAIRE"; an arrow, composed of crowds of people, pointing up like a rocket on a launching pad, above the statement that "THRUST IS GIVEN FOR A PROLONGED STRUGGLE."

Granted the indifferent formal qualities of the posters, their interest lay almost exclusively in their content—which is, no doubt, where it should lie. Political posters may be destined for the museum, but at least in their inception they belong to the event of which they are a part. Taken as a collective act, the Paris posters were, in their off-handedness, a fuller expression of the rebellious students than if they had been more attractive. There was, too, the fact of haste. In any case, here the message overrode any impulse to make the posters more aesthetically gratifying. But in regard to what they said in words, the posters were, by all the evidence, outdone by the Paris wall inscriptions, a medium even more transient. At the Atelier Populaire, ideas were exchanged and drawings were criticized; the authors who published their thoughts upon the walls were spared even this degree of restraint. Anyone with a piece of chalk or a spray can of paint could inscribe his mood or his favorite quotation with a sweep of his arm over the bricks. "I decree the state of permanent happiness," wrote one inspired hand. Persons disposed to challenge this claim of omnipotence were attacked in advance by another inscription, labeled a Chinese proverb: "When a finger points at the moon, an imbecile looks at the finger." The discussion was closed by the slogan: "The imagination seizes power."

A process akin to that of the collective poetry of early Surrealism gave the wall writings a kind of imaginative coherence within the chaos of randomness. The policy line of the uprising as it was expressed by both posters and walls was largely derived from Marxist, anarchist, and Surrealist propositions mixed together in an intellectual substratum of defiance. In the posters, politics were uppermost; in the wall grafitti, Surrealism. Three posters identified de Gaulle with Hitler (one reticently, by suspending a question mark over a de Gaulle Hitlerized by a mustache); several attacked voting and parlia-

mentarism; the fist appeared often to symbolize struggle; workers were advised that "Your boss needs you, you don't need him;" radio, TV, and the press were reviled as tools of government oppression—police on the TV screen were "the police in your home." All these bore the stamp of left-wing politics, from Stalinism to anarchism. Only occasionally did Surrealism intrude, as in the call to "Be realistic, demand the impossible." Nor was there any sign of the influence of Surrealist painting. One suspects that the students of the Beaux-Arts, like students in most American art schools, hadn't been taught much about Surrealism and about the part of politics in modern art.

Yet Surrealist thinking was omnipresent in the thinking of the uprising—and it was the walls that spoke for Surrealism. The Surrealist idea detached from Surrealist art linked the uprising to art history, as Marxist thinking detached from Marxist organization linked the uprising to the history of socialism. Apparently, the idea of a movement can outlive the movement itself. Dada and Surrealism have been dead for thirty years; in terms of art history nothing remains but the more famous of their artifacts and their "heritage." In the Paris uprising, however, Surrealism, laced with Dada, suddenly reappeared as an intellectual force independent of its past creations. In the mid-twentieth century, ideologies that have lost their potency as systems, or have been repudiated, reemerge as bits of folklore. "Culture," said a Paris wall inscription, "is the inversion of life." But this statement itself is culture, since it is inherited from the radical art movements of fifty years ago.

What was involved in the Paris action, it turned out, was not a revolution against culture but a split between living ideas and their institutional forms. Marxist thought was directed against the Marxist parties; "Grafitti in the medical faculty," reported Herbert Lottman in *Cultural Affairs* "suggested that 'PCF' [the initials of the French Communist Party] really meant Parti Complice des Flics, accomplices of the cops." Similarly, the Dada-Surrealist slogans—"No, to the coat-and-tie revolution," "Poetry is in the streets"—were directed against institutional art, to which, of course, Dada and Surrealist masterworks now belong. Separating the idea from the distorted forms in which it

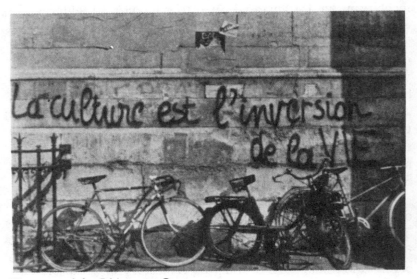

Photograph by L'Agence Gamma.

had realized itself, each ideological wing of the uprising found its antagonist in the social agency officially representing its field of interest. "Sabotage the culture industry," urged a tract distributed at the Odéon the night the students moved in. "Occupy and destroy the institutions. Reinvent life." The mass media were the general target, for political reasons (that is, for favoring the government), but each segment of the cultural apparatus—universities, art schools, film schools, national theatres, orchestras—was equally the enemy. At the very moment when the Museum of Modern Art in New York was presenting "Dada, Surrealism and Its Heritage" as consisting of what is aesthetically valid today in the paintings and constructions of Picabia, Duchamp, Magritte, Ernst, Arp, Miró, and Man Ray, Surrealism as a radical movement had come to life in the streets of Paris. In its attack on the "culture industry," the uprising of the students touched an essential nerve of contemporary culture—the alienation of the creation from its creator and his ideas, and the consequent emptiness of the relation between the artist and his audience. No sooner does the painting, the musical score,

the script leave its author's hands than it becomes a commodity of the culture industry—on a Marxist poster this was translated into "Culture, favorite weapon of the bourgeoisie."

Therefore the repeated call in this "cultural revolution" was to bring art into the streets: "The police are posted in the Beaux-Arts, the Beaux-Arts are posted in the streets," "Poetry is in the street," "The cinema, from now on, is in the streets," and so on. The demonstration is an art form without turnstiles. Everyone in it is at once a performer and a spectator. "Let us take part in the cleaning up, there are no maids here." In the demonstration, life and culture no longer seem at odds. Rhythms of marching awaken the improvisations of individuals and groups. The demonstration assumes the stability of the antagonist and the absence of material means for overthrowing him. Thus its strategy is undefined and its hope is essentially magical—that the walls be toppled by a trumpet blast. For the imagination the highest power is an outcry, the roar of simultaneously aroused desire. The demonstration is a species of collective inspiration, the closest approximation by modern man to ancient rituals of rebirth. Witnesses of the Paris uprising have testified to the new openness, candor, surges of comradeship among strangers—confirmed by the celebrated rejoinders of the rebels to slanders intended to divide them from a leader and some of their members: "We are all German Jews," "We are all undesirables." In such occasions, people, feeling renewed, live in the conviction that "things will never be the same again." Too many discoveries have been made, among them that one pays too dearly for a stability one is better off without. To students today, in whom texts concerning "the revolution in permanence," art as a "development of personality," the university as "a community of scholars," socialism as the "withering away of the state" are still fresh, the street is the arena of the ideal, and throughout the world the demonstration has become their instrument of collective expression.

"The imagination seizes power" describes, of course, a transitory condition, but all conditions precious to man are transitory. The propaganda of the Paris uprising, observes a wall label, "nourished itself in immediacy." But immediacy is the

Photograph by L'Agence Gamma.

essential quality sought by modern art, and the idea of the ephemeral art object, the vanguard concept that unites Duchamp's ready-mades of fifty years ago with today's Happenings and mixed-media performances, attains its culmination in inventions produced and discarded in the course of a liberating act.

In formal terms, a demonstration is a species of mass spectacle that differs from parades and sports events in that its major audience consists of the demonstrators themselves. Participation energizes them and enlarges their confidence in their strength. "To be free in 1968," said a Paris scrawl, "is to participate." In its spontaneous form, the demonstration is a medium of popular self-expression that realizes the slogan of Lautréamont adopted by the Surrealists: "Poetry made by everybody."

An opposite kind of poetry made by everybody may, however, also be produced by the popular demonstration, that of the mass human machine, in which, as in the Nazi Nuremburg rallies, the self-expressive individual of the rebellious street crowd is replaced by the human unit reacting to mechanically timed cues. Such an overwhelming of the individual in the mass produces its own type of afflatus. Thus the mass demonstrations of the twentieth century provide a paradigm of the two poles of modern creation: "expressionism" and depersonalization.

5 / Art and Words

A contemporary painting or sculpture is a species of centaur—half art materials, half words. The words are the vital, energetic element, capable, among other things, of transforming any materials (epoxy, light beams, string, rocks, earth) into art materials. It is its verbal substance that establishes the visual tradition in which a particular work is to be seen—that places a Newman in the perspective of Abstract Expressionism rather than Bauhaus design or mathematical abstraction. Every modern work participates in the ideas out of which its style arose. The secretion of language in the work interposes a mist of interpretation between it and the eye; out of the quasi-mirage arises the prestige of the work, its power of survival, and its ability to extend its life through aesthetic descendants. The art-historical significance conferred by Duchamp and by Duchamp commentators on a bicycle wheel has induced the repeated resurrection of this object as if it were an "Annunciation," an image indispensable to contemporary spiritual life. Its latest rebirth is "The Perpetual Moving Bicycle Wheel of Marcel Duchamp," drawn by the Kinetic artist Takis.

In the last century, it was believed that the exclusion of subject matter (landscapes, people, family scenes, historical episodes, symbols) from painting would disentangle the image on the canvas from literary associations and clear the way for a direct response of the eye to optical data. In becoming more and

more abstract, art is supposed to have attained, or been reduced to, speechlessness. The "Art of the Real" exhibition at the Museum of Modern Art described its selections as chunks of raw reality totally liberated from language; the black paintings of the late Ad Reinhardt aspired to be material equivalents of the silences of his Trappist friend, the late Thomas Merton. The common view was recently summed up as follows: "Modern art has eliminated the verbal correlative from the canvas." Perhaps. But if a work of today no longer has a verbal correlative, it is because its particular character has been dissolved in a sea of words. Literary language has been banished; a painting is no longer conceived as the metaphor of an experience available to both words and paint. But the place of literature has been taken by the rhetoric of abstract concepts.

An advanced painting of this century inevitably gives rise in the spectator to a conflict between his eye and his mind; as Thomas Hess has pointed out, the fable of the emperor's new clothes is echoed at the birth of every modernist art movement. If work in a new mode is to be accepted, the eye/mind conflict must be resolved in favor of the mind; that is, of the language absorbed into the work. Of itself, the eye is incapable of breaking into the intellectual system that today distinguishes between objects that are art and those that are not. Given its primitive function of discriminating among things in shopping centers and on highways, the eye will recognize a Noland as a fabric design, a Judd as a stack of metal bins—until the eye's outrageous philistinism has been subdued by the drone of formulas concerning breakthroughs in color, space, and even optical perception (this, too, unseen by the eye, of course). It is scarcely an exaggeration to say that paintings are today apprehended with the ears. Miss Barbara Rose, once a promoter of striped canvases and aluminum boxes, confessed that words were essential to the art she favored when she wrote, "Although the logic of minimal art gained critical respect, if not admiration, its reductiveness allowed for a relatively limited art experience." Recent art criticism has reversed earlier procedures: instead of deriving principles from what it sees, it teaches the eye to "see" principles; the writings of one of America's influential critics

often pivot on the drama of how he failed to respond to a painting or sculpture the first few times he saw it but, returning to the work, penetrated the concept that made it significant and was then able to appreciate it. To qualify as a member of the art public, an individual must be tuned to the appropriate verbal reverberations of objects in art galleries, and his receptive mechanism must be constantly adjusted to oscillate to new vocabularies.

Since the eye and the analogies it discovers in common-sense experience cannot be trusted, the first rule in discussing modern art is that a painting or sculpture must never be described as resembling (or being) an object that is not a work of art; a sculpture consisting of a red plank must under no circumstance be identified as a red plank, a set of Plexiglas cubes as a type of store fixture. When Theodore Roosevelt observed at the 1913 Armory Show that Duchamp's "Nude Descending a Staircase" reminded him of a "Navajo rug," he committed the archetypal critical *faux pas*. Art is the product of an etiquette, and to neglect its framework of intellectual manner, and reduce it to its physical data is an act of barbarism, like using a prayer shawl for a cleaning rag; the point of the emperor story is that it was a child ignorant of the rules who announced that the emperor was naked. As a sculpture, a painted plank is not only its material substance but the crystallization of a moment in the continuous debate on the nature of art—an intellectual element missing from planks in lumberyards. Injected into this discourse, the plank, or one of Christo's packages, becomes an item of our aesthetic culture, though not necessarily a profound or desirable item. The ban against saying what a painting or sculpture "really is" arises out of the verbal aspect of modern art, and to keep art intact the power of words in it needs to be constantly augmented. By segregating the object it accredits as a painting or sculpture from all other objects in nature, language sustains the sacred or mythical status of art without the need for religion or myth. The taboo against assimilating the description of a painting into the general rhetoric of visual experience, against describing a striped canvas and a striped tablecloth in the same terms, is a twentieth-century version of the outlawing of blas-

phemy. For more than a century, radical art movements have been demanding the "desacralization" of art and the dissolution of all barriers between art and life. Such efforts are bound to fail as long as the word "art" continues to refer to a special category of objects. Regardless of the anti-art character of modern paintings, their verbal ingredient separates them from images and things merely seen and removes them to a realm founded on the intellectual interrelation among works of art. No matter how completely paintings and sculptures succeed in purging themselves of subject matter, they continue to present the essential subject matter of art's own self-conscious history. Without this invisible content, art would no longer exist, though individuals, among them two-year-olds, grandmothers, and automobile designers, might continue to satisfy the impulse to make things attractive through form and color.

To the consternation of art critics, the materials-words composition of art has become an explicit theme in the newest modes of painting and sculpture. With comic literalism, "earthworks" sculpture attempts to overcome the separation of art from nature by acting on a segment of the landscape—in short, by treating nature itself as art material. An artist makes circular tracks on a snowfield or shapes a contour in the desert; another cuts a trench across a driveway. Art that reshapes the terrain was once known as landscape architecture or landscape gardening. The terms are, however, strenuously resisted by contemporary earthworkers, whose aim is not an eye-delighting prospect but the realization of a concept. Art that is part of nature represents a hyper-materialization that overcomes the limits of specialized art materials and even of man-made materials generally (since everything, from foam rubber to magnets, has now been incorporated into art's stockpile). Earthworks also avoid placing creations in art galleries, and so surmount the segregation of art on the social plane, though earthworks art does get into art galleries by informational means—photographs, models, diagrams, maps, statements by the artist. Ironically, earthworks materialism produces in practice an effect opposite to the in-

tended fusion of art and the physical world, for, like "Art of the Real," the existence of an earthwork as art depends entirely on words. Since the earthwork is usually not transportable—it may not even be perceptible as a unit or during a particular time— all that is available to the spectator is its documentation, and this, according to one site-modifier, "creates a condition of absolute coexistence between 'image' and 'language.'"

Art communicated through documents is a development to the extreme of the Action-painting idea that a painting ought to be considered as a record of the artist's creative processes rather than as a physical object. It is the event of the doing, not the thing done, that is the "work." Logically, the work may therefore be invisible—told about but not seen. The sculpture Oldenburg made to be buried underground has become an in- fluential work through hearsay. In the same spirit, a sculpture by Bruce Nauman consists of a flat slab said to have a mirrored surface on the underside, and an item of Richard Artschwager at a Whitney Annual was made up of a hundred pads of varied substances inconspicuously scattered around the gallery (be- cause it conceived the environment of the Annual as part of itself, the Artschwager could never "take place" again). One step further and the work of art need not even be made; the creative act can consist of a proposal for a work. Not long ago, Kienholz exhibited a score of framed sheets describing projects he was prepared to execute. This is, intellectually, a more rare- fied gesture than sending diagrams to a factory and delivering finished products to an art gallery. Two young artists in Latin America contrived a Happening that was reported in detail in the press but never took place, so their "work of art" consisted of their own news releases and the resulting interviews, accounts, and comments. Given the mythical status of art, uncreated art is the myth of a myth. An artist whose current medium is space bought in newspapers put it another way: "Art may exist in the future as a kind of philosophy by analogy."

Robert Smithson, a sculptor who is also the author of arcane meditations and satires, attempted to combine the con- ceptualization of the invisibilists with the rugged materiality of the earthshapers. His "non-sites" consisted of containers of

rocks, gravel, and lumps of asphalt selected and arranged according to a recondite system of formal correspondences, geological information, stone-collecting trips to the country, and interpretations of the recent history of sculpture. For spectators incapable of mastering Smithson's rationale or unwilling to take the trouble, the visual actuality of his exhibition consisted of stones in differently shaped and painted bins (some cut out on top to match the profile of the terrain, others shaped in the chic mode of mathematically patterned floor sculpure), plus diagrams, photo-maps, documents, and framed statements on the wall. Here, aesthetic metaphor was replaced by the "real thing"— what can be more real than raw rocks, piles of gravel, maps, and documents?—but the real thing proved once again to be art as an excrescence of theory. An interviewer wrote that Smithson "reads Worringer, Hulme, Ehrenzweig, Borges, Robbe-Grillet on the subject of art," and, mentioning also Empson and Wittgenstein "on the subject of linguistics," he concluded that Smithson's pieces are "not primarily sensual or even visual [but] are reconstructions of thought processes"; Smithson, like the artist of newspaper inserts, mentioned above, believes that art today must become "speculative philosophy."

In an apparent move away from verbalized or conceptualized art, experiments are being made to produce paintings and sculptures through letting materials "speak for themselves" with a minimum of formal ordering by the artist. Allowing paint, scattered scraps of paper, or flung bits of metal to arrange themselves as they will belongs to the traditional ruse of the art of this century employed to bring forth unknown energies out of its mediums in order to silence in the artist's mind the directives of aesthetics and art history. The reduction of the arts to their material components corresponds to an awareness of the decomposition of inherited art forms—an awareness that keeps growing more acute. The composer Morton Feldman states the proposition that "sound *in itself* can be a totally plastic phenomenon, suggesting its own shape, design, and poetic metaphor." Equivalent ideas are presented in literature by practitioners of "concrete poetry." They stem from the conviction that existing forms in painting, poetry, and music inevitably distort experi-

ence, and that it is necessary to start afresh with the raw matter out of which a poem or painting is made. The medium itself becomes the "mind" that, to Feldman, "suggests its own shape, design, and poetic metaphor." In sum, the medium delivers its own substance as its "message."

The idea of art as the action of the artist's materials complements the idea of art as the act of the artist. The retrospective of the paintings and drawings of Willem de Kooning was the record of thirty years of experiment in fusing these forms of action into a synthesis of will and chance. In de Kooning's laboratory, the animated paint takes its form from the artist's personality, while the artist discovers the changing form of his personality in the physical potentialities of his medium. The Action paintings of Jackson Pollock also represent a union of the artist's action with that of his pigment. Pollock's handling of paint has, however, been misinterpreted as a version of automatic writing, and this has led to distortions concerning the self-activation of materials and the part of materials in the creation of art.

The reputation of Helen Frankenthaler rests on her adaptation of Pollock's "liberated" fluid pigment on unprimed canvas. Frankenthaler's paintings have the immediate attractiveness of tastefully matched colors and, in some of her later canvases, bold design. Unfortunately, the favorable first impression does not hold up, for reasons I shall go into later. At the point of diminishing response, however, words intervene to remove this artist's paintings to a plane other than the visual. In the opening sentences of the catalogue for her retrospective at the Whitney Museum in 1969, Professor E. C. Goossen, who directed the exhibition, credited Miss Frankenthaler with having "invented an original method for applying paint to canvas. Known as the soak-stain technique, it was instrumental in making a new kind of color painting possible." Here materials find a corollary in art-historical verbiage (the alleged significance of Frankenthaler's influence on Noland and Louis)—a magical combination sufficient to give the artist a retrospective at forty and a public advantage over such superior contemporaries as Joan Mitchell and Lester Johnson, both of whom stem, like Frankenthaler, from

Helen Frankenthaler, *Flood*, 1967, synthetic polymer on canvas.
Collection of the Whitney Museum of American Art, New York, Gift
of the Friends of the Whitney Museum of American Art.

Joan Mitchell, *Ladybug*, 1957, oil on canvas.
Collection The Museum of Modern Art, New York.

Action painting. Regardless of the accuracy of attributing the "invention" of soak-stain to Frankenthaler (one thinks of it as customary procedure in watercolor, and of Georgia O'Keefe painting with absorbent cotton), the notion that a new way of using materials can be inherently significant and even progressive is another instance of the overpowering of the eye by words. Writing of an exhibition of "anti-form" art, which calls upon the expressive powers inherent in sheets of rubber, felt, chicken wire, and lead pellets, Gregoire Müller declared that the works are often of "greater intellectual than visual interest." Since the intellectual interest lies not necessarily in the artist's own ideas but in the debate and polemics into which his paintings fall, Mr. Müller's judgment may be applied also to Miss Frankenthaler's self-expressive paint. It is weak visual matter in an envelope of aggressive critical language. The early paintings, with their borrowings from Pollock, Gorky, Kandinsky, and other occasional stainers, are sensitive, but more timid than sensitive. In her middle period, she attempts to detach herself from more patent influences and her work falls into a confusion of blots, stabilized at times by hints of the rectangle. Later, the transparency of acrylics cooperates with her uncertainty by permitting forms to blot visibly over one another without compelling the artist to select among them. In the work of the last three years covered by the exhibition, large, simplified torn shapes communicated an appearance of assurance, but "Flood," 1967, was a relapse into vague spongings.

In the Action paintings of Lester Johnson, the action emanates from the artist in a decisive locking of forms, lyrical rhythms, tension between image and scale, compression of surface by color. With Frankenthaler, the artist's action is at a minimum; it is the paint that is active. The artist is the medium of her medium; her part is limited to selecting aesthetically acceptable effects from the partly accidental behavior of her color. Apparently, Miss Frankenthaler has never grasped the moral and metaphysical basis of Action painting, and since she is content to let the pigment do most of the acting, her compositions fail to develop resistances against which a creative act can take place. The result is a distressing flabbiness, an effect

Lester Johnson, *Early Arrival* (*cold blue*), 1970, oil on canvas.
Martha Jackson Gallery, New York.

(emphasized by the huge dimensions of some of her canvases) of too little out of too much. The soaked-in pigments, which keep the surface flat regardless of the number of veils of color, speed the eye across an expanse as characterless as the sheen of a photograph. In a photograph, the gaze may be arrested by the subject; in the Frankenthalers, apart from patches of lively color, there is nothing to see. In their lack of purpose, her runs and blots often touch the edge of the absurd, and paintings such as "Interior Landscape," "Buddha's Court," and "Small's Paradise" are over the edge. Presented one or two at a time, the Frankenthalers are often pleasing for their color. Massed in a retrospective and featuring the biggest, they were decorative bombast sustained by dubious art history.

Paul Jenkins also sets in motion transparent veils of pigment, but his paintings are haunted by a vocabulary that differs from the art-historical dogmas of the Frankenthaler circle. Jenkins is an occultist with fantasies of action at a distance. His process art collaborates with his psychic detachment to produce an image that is like the chemical flowering of ice or rock. In several of the new mammoth canvases, mountainous flaunts of gray on gray sweep into distances of pure white that solicit silence as intensely as the black squares of Reinhardt.

The animation of materials, in no matter how random a way, cannot be dissociated from the artist's aesthetic aims, which are in turn related to his state of being (Müller speaks of the "occasional lapses into sentimentality" of one of the anti-form arrangers of rubber and plastic) and his general outlook. An artist's choice of material is inevitably expressive; the stained burlap sacks the Italian artist Burri used as his medium in the forties while he was an American prisoner of war represented an emotional universe different from that of the elegant substances to which he turned after he had become internationally known. But in addition to representing feelings, materials, even the rawest, have become conceptualized; as Valéry stated it, "The modern world is being remade in the image of man's mind." There is no turning back to the intuitive astuteness of the traditional craftsman, nor will surrendering to his medium liberate the artist from the obsessions of thought. The words of art will

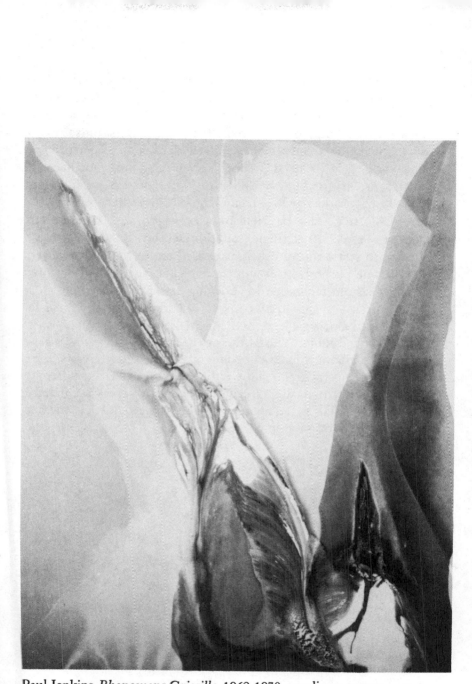

Paul Jenkins, *Phenomena Grisaille*, 1969-1970, acrylic on canvas.
Collection Hillary Jenkins.

continue to speak to the artist either from behind, directing him without his being aware of them, or in the form of conscious problems to be confronted and modified. If, as the sculptor Clement Meadmore has declared, "the current question seems to be 'Is the material, left to its own devices, capable of performing as a work of art,'" the answer is a categorical "no," not because chance or "the natural behavior of different materials" is incapable of producing significant combinations but because no material can in fact be "left to its own devices." Given the present degree of aesthetic self-consciousness, even the most haphazard scattering of debris, if carried out in the milieu of art, has become purposive through the fact that accident is by now a fifty-year-old technique for creating art. Today, chance itself cannot prevail against the potency of aesthetic recollections. In art, ideas are materialized, and materials are manipulated as if they were meanings. This is the intellectual advantage of art as against disembodied modes of thought, such as metaphysics. The current attempt in art to allow either the words or the materials to have their own way sacrifices the advantage of concrete thinking in behalf of an apparently irresistible tendency further to rationalize the practice of art.

Part Two / Artists

6 / Pro-Art Dada

Jean Arp

Though Jean (Hans) Arp was one of the original Cabaret Voltaire founders of Dada, his work has few of the qualities commonly associated with Dadaism. His images—mildly fantastic, and humorous in a genial way—are lacking in rancor; his color is bright, simple, and appealing; his outstanding effect is poetic. Though his choice and handling of materials are radical, there is nothing in his reliefs, collages and sculptures that reflects the catastrophe of Europe in 1914–18 or the rage of Dada against the prevailing powers and values—no mechanical brides, desecrated Mona Lisas, photomontages of sex and violence, ready-mades, scandals, highlighted clichés. Arp's motifs feed on nature (the moon, the leaf, the navel), on dreaming (an "egg board," a "cloud pump"), and the everyday (a mustache, a shirtfront, a fork)—subjects that, while not eternal, carry no date. In the Dada that has defined itself historically by its antisocial and anti-art gestures, periodically revived, Arp appears an outsider. He was present in Zurich in 1916, and, according to Hans Richter's *Dada: Art and Anti-Art* (Abrams, 1970), he "played a part in every Dada event," but Richard Huelsenbeck, one of the bravos of Dada's staged provocations, has gone on record that Arp "seldom if ever participated in these antibourgeois activities." Either Arp was not a true Dadaist or the notion of the movement that has been formed by decades of quoting the most militant utterances of Tzara, Picabia, and Duchamp is an oversimplifi-

cation. Undeniably, Dada originated in "disgust" (Tzara), it encouraged the practice of "anti-painting" (Picabia), and it was permeated by the feeling, which has continued to arise in active minds, that in the midst of the upheavals of this century, art is "not a goal to fill an entire lifetime" (Duchamp). Arp, too, dutifully repeated the ritual attacks on the unimaginative bourgeoisie, which, he wrote, "in place of a heart has an over-life-size corn, which twitches in times of approaching storm—on the stock exchange," and he sought new modes in art because he believed that artists were "disgusted" with oil painting, as "characteristic of a pretentious, self-satisfied world." But though Arp shared Dada's view that the art of the past has dried up as a source of inspiration, he never doubted the worth of art itself and never wanted to be anything but an artist.

The example of Arp shows that there was a side to Dada other than that of its "matadors"—a state of mind less socially aggressive but at least as radical in terms of sensibility. Dada was the crèche for the reborn of the First World War generation. (This significance of the infantile title of the movement is passed over in the arguments about who invented it and in the history of its scuffles with the public and within its own ranks.) In his rhetoric of mystery, Max Ernst has described the psychic effect of the war upon his own personality; he "died," he says, "the first of August, 1914," and was "resuscitated the eleventh of November, 1918, as a young man aspiring to become a magician and to find the myth of his time." Marcel Jean's *The History of Surrealist Painting* (Grove, 1967), adds that "after his *resurrection,* Max Ernst rallied to the Dada cause and became . . . the chief animator of the movement in the Rhineland." During the war years, Arp underwent a comparable transformation. In 1915, the year he arrived in Zurich, he tells us, "I produced my first 'essential' picture. [He was then twenty-eight.] I believe that I was playing with some children's blocks at the time." In this year occurred, too, "the most important event of my life"—his participation in the exhibition at the Tanner Gallery, in Zurich, where he met Sophie Taeuber, whose work, he says, descended upon his existence "like the leaves of a tree in a fairy tale." He at once became her collaborator, and later her husband. For Arp,

Dada was itself a fairy tale, of the detached and innocent world of childhood: "Revolted by the butchery of the 1914 World War, we in Zurich devoted ourselves to the arts. While the guns rumbled in the distance, we sang, painted, made collages, and wrote poems with all our might."

In his illuminated state ("Arp's hynotic language," wrote Ernst, "takes us back to a lost paradise"), Arp saw in Dada not a guerrilla attack on civilization but the recovery of art from "beneath the ruins of the centuries." "Dada," he explained, "was more than a kettledrum [probably an allusion to Huelsenbeck, who beat a large drum in Cabaret Voltaire performances], a big, noise, and a joke." Dada was the revival of the search for the natural man—the child who would "open his eyes forever." Its destiny was to produce an art that was "anonymous and collective," thus liquidating the egotism responsible, in Arp's view, for making both art and man "unreal." Arp dreamed of works "not signed by their creators," and situated "in the great studio of nature, like clouds, mountains, seas, animals, men." His often quoted statement on the origin of art—"Art is a fruit growing out of man like the fruit out of a plant like the child out of the mother"—invokes continuous organic renewal, as if Arp himself were constantly emerging from the stream of creation.

Perhaps his metaphysical interpretation of Dada as a shedding of self stemmed from his dual identity of "Hans" and "Jean," imposed upon him by his German-French heritage as an Alsatian. Everywhere but in his native Strasbourg, Arp found himself an immigrant—legally a German in wartime Paris, French in his feeling against the Germans—and this sense of estrangement and ambiguity is intrinsic to his poetry, drawings, reliefs, and sculptures. "The spectator," he observes, oddly, "always finds himself in a false position before a leaf." Books on Arp almost invariably omit his Christian name from the cover to avoid choosing between "Hans" and "Jean." The "Arp" isolates itself like the twang of a string. "For Arp," writes Mme. Carola Giedion-Welcker, his biographer (*Jean Arp*, Abrams, 1957), "man is not the crown of creation but simple, lost, transient, like a leaf in the wind." Arp's sense of encountering a universe of unidentified, or only partly identified, persons and things has

about it something Whitmanesque, of being without a past and needing to start from scratch on a newly discovered continent. Arp's Dadaism is, to borrow Gertrude Stein's Dadaist phrase, a "beginning again and again."

With his vision of collective and anonymous creation, Arp turns the position of anti-art Dada inside out. Instead of wishing to subvert art, Dada releases it from the burden of its exclusive history in order to discover it everywhere. "We declared that everything that comes into being or is made by man is art," Arp wrote. "Art can be evil, boring, wild, sweet, dangerous, euphonious, ugly, or a feast to the eyes. The whole earth is art. To draw well is art The nightingale is a great artist. Michelangelo's 'Moses': bravo! But at the sight of an inspired snowman the Dadaists also cried bravo." If even art is art for Arp (as it alone is not for practitioners of Camp and for current art *povera* and conceptual artists), it is because works of all times coexist with present-day things as phenomena that are open to the innocent eye and to the mind purged of self. To remove the art object from a preferred category in order to exalt the processes of creation, natural and human, was the interpretation of Dada that led Arp to his formal innovations. Speaking of his destruction of his early work (a practice common among artists "awakened" to a new vision), Mme. Giedion-Welcker declares that "it is only with the beginning of the Dada period in Zurich, from 1916 to 1919, that Arp's work takes on a distinctively personal note." With creation itself as his paramount objective, all media attract him; he writes books of poetry, illustrates magazines and pamphlets, does embroidery, engravings, drawings, paintings, collages, sculptures, reliefs. His concept of the self-negating artist impels him to experiment with chance—with the scattering of bits of paper and with found objects. In Arp's scheme, Duchamp's ready-mades and Schwitters's finds are art intended "to cure human beings of the raging madness of genius and return them modestly to their rightful place in nature." The spirit of an informal art, transitory and blended into nature, induces him to condemn frames for pictures and pedestals for sculptures as "useless crutches"; later he envisions his sculptures as stones "formed by the human hand," ideally to be found lying by the

side of a stream. Discovering some of his collages in a state of deterioration, he is at first oppressed by a sense of death, then embraces transience by integrating the inevitable destruction of the work into its creation through torn (instead of cut) paper, careless pasting, cracks—ephemeral art representing "the dribbling away, the brevity, the impermanence, the fading, the withering, the spookishness of our existence." In keeping with his poetry and the importance of extending his creative processes from one image to another, he accompanies his works with interpretations of their meanings: "Often the interpretation was more important for me than the work itself."

Undoubtedly, Arp's reliefs, begun in the Dada period, are his most surprising invention. Flat wooden cuts superimposed upon one another or upon a background plane, they draw their imagery from the free-verse poetry he kept producing all his life. Arp's jammed metaphors ("the burning banner hidden in the pigtail of clouds," "flying Cyclopean mustache"), in the tradition of Rimbaud's deliberate derangement of the senses (a mode later practiced by the Surrealists as "automatic writing"), are materialized into plastic forms as elementary as a coat hanger or a roll of tape. Sculpture makes Arp's arbitary verbal images exist as things. (The most nearly direct descendant of the Arp of the early reliefs is Oldenburg, while that of the Arp of the later sculptures "in the round" is Henry Moore.) The subjects of the reliefs, which tend to mix humor and "spookishness" in a childlike yet elegant and often metaphysically suggestive simplification, are matched by the even painting of their surfaces in whites, yellows, blues, and blacks, like painted toys or boats. The rhythmically contoured forms derived by Arp from mustaches, navels, shirtfronts, forks, and mountains, and their meticulous spacing upon a rectangular or irregularly shaped ground, have inspired a generation of designers of "free-form" furniture, wall decorations, and swimming pools. The distribution of the flat cutout pieces often causes the reliefs to resemble a game of checkers or shuffleboard suddenly interrupted, while their caricatured personages and their objects in irrational juxtaposition evoke masks or wraiths haunting one another. In thus supplanting the representation of nature with absolute creations, Arp liked to think he had achieved a "mystical reality."

Jean Arp, *Egg Board*, 1917, painted wood relief. Private collection.

A similar combination of play and metaphysical search animates Arp's series of collages entitled "According to the Laws of Chance," begun in 1916, the year of the first abstract reliefs. Arp "made of chance an almost religious presence," wrote Richter. Resorting to chance is another way of negating the self and the will, as well as a means of seizing the present in the fullness of its content and possibilities. Arp conceived of his experiments with chance as carrying him beyond accident into the occult. (Interestingly, he later claimed that dropping torn papers to see how they would compose themselves was an anticipation of the dripping of pigment by "stain" painters.) Like Klee, Arp emerges as a pioneer in techniques for purging the imagination of preconceived patterns by submerging the consciousness in a sea of blended words and images. As Arp develops his methods, the interaction between his poetry and his plastic conceptions becomes more direct: his "sky clock," or "square cloud with a pendulum of blue smoke," is a mental contrivance ready to be added to nature in material form.

In Arp's Dada formulation of an "anonymous and collective" art, the anonymity was contingent on the collectivity; when the group cohesion dissolved, its members were bound to relapse into individualism. Dada collaboration broke down very quickly—by 1922 it was being described by its leaders in the past tense. Yet Arp retained for a remarkably long time his ability to stand aside from the givenness of self—to find himself "in a false position before a leaf." At length, however, his personal dissociation, with its accompanying lightness, flimsiness, irony, and fantasy, gradually gave way to a desire for permanence and place. Mr. Robert Melville, a British critic, writing in the catalogue of the Arp retrospective at the Museum of Modern Art in 1958, made the ingenious point that whereas in the first printing of Arp's declaration that "art is a fruit growing out of man" the artist refers to himself in lower case, a later version of the statement has been revised by the artist in the direction of solemnity and conventionality, and the "i" has been changed to "I." "The amended version," Melville concludes, "was made by a man who was shouldering the burden of an artistic reputation." Committed to art, Arp found himself forced toward a method of

creation in which he could foresee and control his product rather than simply wait for the gifts of chance and illumination. However much it is resisted, the destiny of art is to turn into craft.

By 1930–31, Arp had entered his post-Dada phase—that of the in-the-round sculptures, which he called "concretions." The term, which he had used formerly to distinguish his ideal of "mystical realities" from the abstract and mechanical art of the Futurists and the Constructivists, now became literally descriptive of solidification of hybrid entities. "Our very first concrete works made a final break with change," wrote the former pioneer in techniques for building time and deterioration into his paintings and collages.

In Arp's solid sculpture—some monolithic, some with "empty spaces in the marble nests"—the visionary metaphors of the reliefs are replaced by ambiguous forms related to forms of nature: a torso that can also be a leg, a vegetable turning into an animal, a star that might be a starfish, buds that are breasts. (Henry Moore's monument to the atomic bomb at the University of Chicago—a head shape that is a skull and a helmet—follows the principle of Arp's later sculpture, which converts forms found in nature into representations of two or more possible motifs.) In Arp's concretions and free-standing flat cutouts, the poetry consists of expressive gestures, in which Arp continues, on occasion (e.g., "Owl's Dream"), to be capable of surprising finds.

Few of Arp's figures of arrested metamorphosis—the concretions in bronze and stone—match the revelations (at times laced with humor) and the compositional intensity of the early reliefs and collages. The surfaces of some of the painted reliefs have become dirty or worn, but this gives them the added attractiveness of a fragment of children's furniture or a toy found in a backyard. It is difficult not to prefer Arp's cosmic clocks, rope figures, and torn papers to his later evocations of classical figure sculpture. Yet Arp's poetry occurs in the latter, too, and in the reliefs and collages of his late years. "Three Graces," "Animal Conscious of Its Beauty," and "Ambitious

Jean Arp, *Mountain, Table, Anchors, Navel*, 1925, oil on cardboard
with cutouts.
Collection The Museum of Modern Art, New York.

Concretion" go beyond his metamorphosed Venuses ("Demeter," "Demeter's Doll") into an idiom of gestural dance.

Arp's pieces are modest in scale and unspectacular in color. They are meant for contemplation, not shock to the senses. The pleasure in Arp's best work is that of reflection and wonder; one tends to appreciate his forms in terms of his titles—that is, to apprehend his images within the universe of words. The sculptural concretions, in contrast to the poetry-derived reliefs, exist in silence, the condition of traditional sculpture. The career of Arp is exemplary; his autobiographical notebook *On My Way* (Wittenborn, 1948) could have been entitled "On My Way to the Museum." Art is the preserver of childhood, and its betrayer. For the nonmilitant avant-gardist, maturity consists in passing from games in the garden of the imagination to the inventions of a professional in the world of institutionalized values. Pro-art Dada (now revived in the Dada of Johns, Arman, Rauschenberg, and other Dadaists of the sixties) has not escaped this development.

7 / Primitive à la Mode

Jean Dubuffet

Primitivism is a major stylistic discipline in twentieth-century art. Looking at some children's drawings, Picasso is reported to have said, "When I was a child I drew like Michelangelo. It took me years to learn to draw like a child." Jean Dubuffet, too, probably spent a long time putting behind him the kind of tight, detailed limning represented by his portrait of his grandmother. Between this art-student opus and the figures of his mature style —hands without arms, hats that don't touch the head, heads without ears, and animals with four legs on one side—more than two decades elapsed. At the age of forty-one, Dubuffet finally decided to devote himself to painting, and he made his debut as a de-trained academic draftsman. In acquiring his "crudeness" he had as models not only Picasso but Expressionists, Dadaists, Surrealist "Exquisite Corpse" drawings, aspects of Miró and Ernst, and—above all—Klee. To the formal devices of primitivism —besides awkward drawing, arbitrary color and details, absence of perspective, imitations of the pictographs of savages and children, doodling, and visions of amateurs and the deranged— Dubuffet added "primitive" substances, emulsions that give the effect of crumbling or rot, pastes resembling mud or shale, a stockpile of dirt debris, imprints of leaves and banana skins. In contrast to Klee, Dubuffet has never hesitated to arouse unpleasant sensations. His nudes of the nineteen-fifties undoubtedly comprise some of the most revolting images in art. Having made

his debut as a painter at the close of the Second World War, Dubuffet understood that the art public was ready for the strongest of doses. His immersion in disagreeable substances marked him as a prophet of postwar "object" art, and it has led to his being associated with the "thingish" fiction of Sarraute and Robbe-Grillet, the numb protagonists of Beckett, and the inexpressive "realities" of the Minimalists and Neo-Dadaists. Effects produced by his materials play a large part in his creation, as they do in the various theories of depersonalized art, from "color painting" to sculpture linked with engineering and electronics. In *Loss of the Self in Modern Art and Literature* (Random House, 1962), a historical-metaphysical examination of the condition of man in contemporary civilization, Wylie Sypher chose Dubuffet's art as the supreme embodiment of brute matter from which all human presence has been eliminated. "The dehumanizing of art is not, however, so thorough in the *chosiste* novel," wrote Professor Sypher, "as it is in Dubuffet's painting, where man becomes anonymous and both painter and figure are absorbed into a turbulent geography that has the quality of mineral or mud. Dubuffet reaches a 'zero degree' of painting."

Being absorbed in mud has not, however, prevented Dubuffet from producing paintings, reliefs, assemblages, drawings, lithographs, children's books, and, lately, sculpture at an astounding rate; in his first twenty years as a professional artist he completed more than five thousand works, or almost one a day, while delivering lectures, interviews, and exhaustive "position" statements as well. Among his contributions to primitivism are his aggressive formulations of its theoretical premises. "Convinced that ideas and intellectuals are enemies of art," wrote Peter Selz in his catalogue for the huge Dubuffet retrospective at the Museum of Modern Art in 1962, "he began a systematic search for 'true art,' untouched by artistic culture and unspoiled by contact with the Western classical tradition." Dubuffet's career has included becoming a collector of *art brut*, or naive art—paintings by butchers and postmen and inhabitants of mental institutions. Dubuffet proposes to substitute this art for that of the advanced cultures. He is a one-man movement, with his

absent innocents as clients and collaborators. He complements his prolific output of artifacts by verbal propagation of his pseudo-tribal faith; working in series that carry a theme through many mediums—drawing, painting, relief, collage, watercolor, lithograph—he completes the package by supplying a synopsis of his current views. It is not uncommon for present-day artists to instruct the spectator on how to "read" their creations; directing his thoughts reduces the risk that he will merely respond to what he sees. Dubuffet fences off his thematic groupings in literary settings that include explanations of their meaning, bits of autobiography, technical recipes, and aesthetic and philosophical meditations. In the opinion of Dr. Selz, Dubuffet "is probably the most articulate and lucid artist writing on art since Delacroix and Van Gogh." While one might object to comparing Dubuffet to these masters, or find more affinities with them in the writings of Klee, there is no disputing Dubuffet's articulateness. I have chosen some examples that illustrate the verbal ground of his paintings as well as the degree of his originality:

> The artist must be harnessed to chance [he writes] . . . but with flexibility [he] applies himself to making the best of every accident as it occurs, forcing it to serve his ends.

> I have given to an insignificant detail . . . enormous and completely arbitrary importance, even to the point of making a legendary hero out of the hairs in the ear.

> Ambiguous facts have always a great fascination for me, for they seem to me to be located at just those intersections where the real nature of things may be revealed.

> What to me seems interesting is to recover in the representation of an object the whole complex set of impressions we receive as we see it normally in everyday life, the matter in which it has touched our sensibility, and the forms it assumes in our memory. . . . The method of drawing as taught in art schools can only add to the natural difficulties of such an enterprise, and the only successful results will be found among completely ingenuous individuals, such as children or those persons who have never taken lessons, but like idly to trace a design, with a stick perhaps, in the wet plaster of a wall.

. . . the vague idea, which has haunted me for a great many years, that such an excessively rapid way of drawing, brutal even, and without the least care, eliminating as it does all affectations and mannerisms, might bring into being a sort of innocent and primordial figuration that would be most efficacious.

I feel a need that every work of art should in the highest degree lift one out of context, provoking a surprise and a shock.

Creation through controlled accident, exaggerating a detail, seizing the total impression (as opposed to the academic copying of parts), imitating the presumed ingenuousness (despite Freud?) of childhood and the unconscious, getting around the mind by dashing things off, aiming to provoke surprise and shock—none of these ideas are exactly new, though they are not commonplace, either. Dubuffet's perceptions strike the middle ground between modernist platitudes and the accumulated insights of twentieth-century art. Perhaps the adjective for them is "sound." Or, better still, "traditional." He is a practitioner of traditionally sanctioned shock, like wearing a still shorter miniskirt. Much of his writing sounds as if he were delivering a lecture on vanguard schools of the past hundred years, and much of his painting is an enactment of that lecture. His attitude of antagonism to women and his strategy of assault are revivals of a turn-of-the-century dandyism. His brown putty pâtés, mashed minerals, salads of leaves and fruit skins could be illustrations of Rimbaud's "I have an appetite for earth and stones, I dine on air, rock, coal, iron." Not that Dubuffet may not have had experiences of disorder and defiance, but he had them after they had been aesthetically legitimized. Crudeness, spontaneity, surprise were, at the time he began to practice them, no longer leaps into the dark. They had become a set of certified propositions belonging to the rhetoric and ruses of modern art. Dubuffet's debut, in 1944, coincided with the opening of the period in which modernist modes were to become the accepted conventions in painting and sculpture and flow over into commercial design. In this new era, earlier acts of revolt and repudiation of Western culture were to be transformed into ceremonial gestures. If Dubuffet's paintings and reliefs often look like a mess, they are a mess that leaves

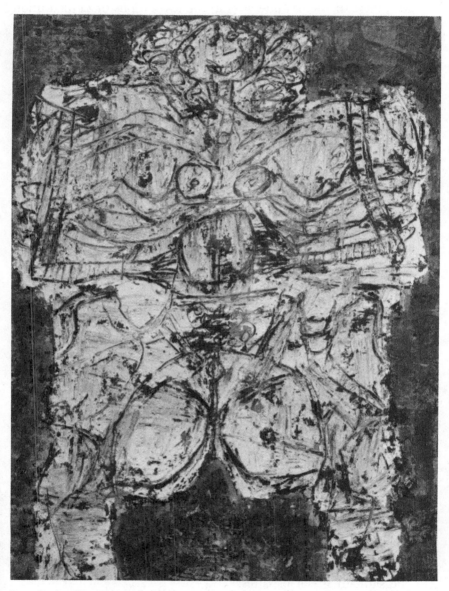

Jean Dubuffet, *Corps de Dame Gerbe Bariolee*, 1950, oil on canvas.
Collection Mr. and Mrs. Martin Fisher, New York, courtesy Pace
Gallery, New York.

no doubt that they are art. With maximum ingenuity, they take advantage of the latitude won in the revolutions of de-definition in art that constitute art's main current since Impressionism. Who could have failed to recognize, at the first sight of a Dubuffet female, that this was art that is repellent by design, and whose creator, fully aware of the aesthetic of the least artistic, was prepared, for reasons of art, to go to the limit of offense?

From the start, Dubuffet evoked the conventional moves to be expected in response to a conventional vanguard challenge; he was attacked by champions of art and taste in exactly the terms he had called for (Selz cites their use of the words *"merde"* and *"cacaisme"*), defended by avant-garde regulars, and sold out without delay. It was as if Dubuffet had refrained from committing himself to art as a career until he had formulated a campaign based on the typical reflexes of the postwar art world. Dubuffet, says Sypher, characterizes his paintings as "an act of sabotage . . . of the past, of academicism, of the Louvre, of the Greeks." Considering how many times the "academy" and the past had been destroyed by the art movements of the last hundred years, to "sabotage" them again would be as effective as sabotaging a pile of rubble. Dubuffet's solemn affiliation with this celebrated destructiveness carries the hint of cold-blooded irony, and much of his art is an extension of that irony, directed at the pieties of the art public—for instance, his series of landscape reliefs produced by making impressions in pastes of household utensils, such as cake molds, soap dishes, and rubber mats. At times, Dubuffet appears tempted to see how far he can carry his straight-faced monologue without arousing the suspicions of his audience, as when he explains that the sight of cows fills him with "calm and serenity" and that a pasture "and even merely the color green—because of the cows, I suppose, by an unconscious association of ideas—has a comforting and soothing effect on me. I wonder if people who are especially subject to anxiety and restlessness experience a happy feeling of relief at the sight of green pastures."

Once an orthodoxy has established itself, it is no longer necessary to believe in its principles; they need only to be put

into practice. In the past, primitivism in art had to do with the longing for faith and feeling, such as Gauguin and Melville found to be still alive in the South Seas. Twentieth-century artists have attached to their forms and materials something akin to the magical powers of the aboriginal world—Klee conceiving the dot as energizing itself into a line, or Hans Hofmann seeing the picture surface as a vibrating field. Traces of this animism no doubt survive in Dubuffet—"painting manipulates materials which are themselves living substances," Sypher quotes him as saying—and he is alert to take advantage of the chemical quirks of his pastes and fluids. But seeking by means of accident pictorial effects and resemblances to nature is not the same as experiencing the sense of being guided by transcendent forces, as Pollock at times felt himself to be. When, in the manipulation of his materials, a shape and texture suggesting a beard appear, Dubuffet gives vent to his "barbarism" by doing a series of "barbe" compositions in mediums suggesting rocks, gravel, and ancient icons (and recalling also Klee's painting of his father on glass in which the uniform hatchings make the old man's head all beard). And Dubuffet accompanies his beard series with an André Breton-like apostrophe:

> Your beard is my boat
> Your beard is the waters on which
> I navigate
> Beard of flux and influx
> Bath of beard and rain of beard

and so on. Here, exploring primitive states gives way to a professional combination of pun, accidental affects, art references, and rhetoric. With Dubuffet the "savage" obsessions of his predecessors have become operative concepts. In his catalogue, Dr. Selz notes that Dubuffet derives his verbal notions from what he has been doing—that "he becomes aware of his ideas during the very act of painting." In short, the processes come first and are not affected by theoretical aims. Thus, though he associates his art with hallucination—"madness lightens man and gives him wings and helps him to attain visions"—he wastes no time with incantations or waiting for inspired encounters. How

could he with his one-a-day output? His rejection of Western culture merely amounts to a license to resort to the anti-art tradition within that culture for such use as he can make of it. With Dubuffet, Dada and Surrealist irrationalism has been reorganized on an efficient basis. The principle of the "chance encounter" expedites his work processes, rather than representing the hope for a heightened state of being that might enter into his creations. Regardless of which technique he employs, there is a dry, matter-of-fact and transient quality in Dubuffet's painting, as of things passed on the edge of an empty lot. Perhaps this is what Professor Sypher had in mind in classifying him with the "object" novelists.

Though Dubuffet is indubitably a virtuoso of devices for making art, things that look like art, and things that force their acceptance as art by analogy with existing art, his work inclines toward monotony. Its formal impoverishment is consistent with Dubuffet's anticultural ideology. His drawing, whether loose to the point of doodling or "brutal," lacks distinction of line, and he is not an originator of interesting shapes. His color is often that of the substances he uses as grounds, or is aimlessly high-pitched like newly painted flower pots on a window sill. Above all, the individual works lack tension—in them, process has replaced the struggle of the artist with the particular work.

His last exhibition at the Museum of Modern Art offered, in keeping with previous Dubuffet presentations, observations by the artist on art, artists, and himself. Among other things, Dubuffet mentioned the "barbs" of criticism that wound the artist "who is an innovator . . . engaged in the experimental and the unknown"; he "laughed" at "the very idea of the good and the bad, the beautiful and the ugly"; he identified himself as a person who "won't eat for days in order to be able to buy a drawing or a print"; and he concluded by advocating "permanent revolution" and declaring his hostility to institutions and especially to awards for artists, since the "true aim of art is subversive." These revelations, which won the enthusiastic assent of Mr. Bates Lowry, then Director of the Museum of Modern Art, were reminiscent of the days when members of the School of Paris used to survive economically by initiating American patrons into the higher clichés.

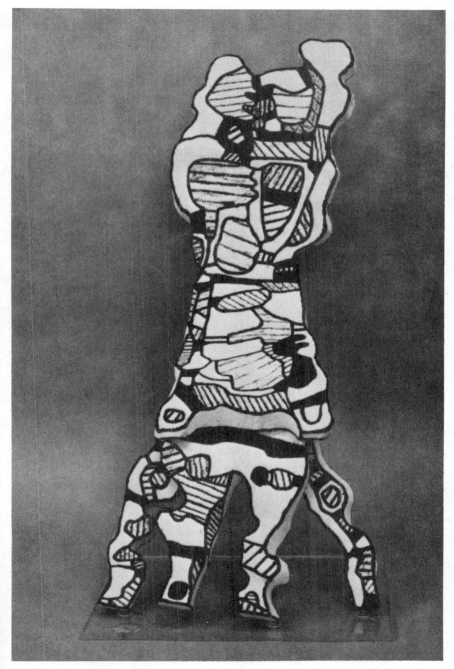

Jean Dubuffet, *Chaise III*, 1967, cast polyurethane.
Pace Gallery, New York.

The exhibition itself was a satisfactory survey of the different phases of Dubuffet's work, with particular emphasis on the enormous series of lithographs entitled "Phenomena," which he executed between 1958 and 1961 by varieties of accidental and transfer techniques. Early paintings, such as "Grand Jazz Band (New Orleans)" and "Wall With Inscriptions," held up well as "primitives" of a novel kind, though they somewhat seemed cramped in scale; "Arab," done in colored chalks, is close to some of Klee's Arabian compositions; and the 1950s nudes have lost none of their repulsiveness, which is perhaps some kind of triumph. "Place of Awakening," made of sand, pebbles, and plastic paste on a board, is a segment of made terrain, as if a few square feet of earth were ordered from a landscape gardener; this blankness is typical of Dubuffet's "texture" exercises.

It is to the artist's credit that his most attractive work is his latest, the painted sculptures of the "L'Hourloupe" series on which he has been engaged since 1964. Made of cast polyester resin and decorated with irregular abstract shapes in red, white, blue, and black vinyl paint, they are fresh and cool in hue, and their pleasingly textured surfaces are modulated by a flow of hollows and ridges. Some have been in the shape of furniture, the large "model for a tower" that was shown at the Museum of Modern Art was a combination of monument and idol. In these sculptures, Dubuffet no longer relies on an unpleasant or disconcerting first impression—he has, apparently, set aside his principle of shock. The works are original and sophisticated aesthetic objects sure to be eagerly acquired. There was no need to add heat to them by postulating, as did Mr. Lowry, that Dubuffet in his furniture and towers "is involved with creating a setting for a new social order, not with providing a new look for the establishment." Where, after all, was that show taking place?

8 / Icon Maker

Barnett Newman

The late Barnett Newman worked with emptiness as if it were a substance. He measured it, divided it, shaped it, colored it. He might even be said to have had a proprietary interest in it; when Rauschenberg, some years after Newman's first exhibitions, at the outset of the fifties, showed four unpainted canvases joined together, the older artist commented, "Humph! Thinks it's easy. The point is to do it with paint." Newman's is the kind of painting currently known as "color field," and much has been written about the responses of the eye to his expanses of red or blue divided by bands of contrasting hue or value. Essentially, however, Newman's art is not concerned with sensual effects, and he consistently dissociated it from paintings to which it bears formal affinities. He was after bigger game than providing stimulus to the spectator's retina. His program was to induce emptiness to exclaim its secret. In short, he wished to paint the absolute, and he knew that the absolute is neither red nor blue. The aim of a Newman is to exclude nature, not to insert into it a field of color. For him, color effaced itself and became the hue of undifferentiated substance. One might say that it is red or yellow because it must be *something*. Thus, throughout his career Newman's purposes engaged him in war with the interpretations of critics and art historians; three of the paintings in his last show were entitled "Who's Afraid of Red, Yellow, and Blue?"

Newman was confident that his metaphysical matter would prevail against his means. For this to happen, the expressiveness of the means had to be reduced to a minimum. His handling of his surfaces, edges, and joinings of forms was meticulously simplified to a point approaching crudeness, as in *haute couture* and certain liturgical chants. It was in pursuit of simplification that he arrived, for example, at "The Moment," a painting that consists of two vertical yellow stripes absorbed into the canvas—out of which has emerged so much of what is sometimes designated as "the painting of the sixties." Plainness is essential, since the prime attribute of Newman's absolute is an absence of qualities. His paintings strive toward a vision akin to that of Wallace Stevens in "Notes toward a Supreme Fiction":

> How clean the sun when seen in its idea,
> Washed in the remotest cleanliness of a heaven
> That has expelled us and our images.

The concept of an art without visual appeal was put forward by Newman in a document written more than twenty years ago and published for the first time in *Barnett Newman*, by Thomas B. Hess (Walker, 1969). Though European art had become abstract, Newman contended, it was still based on "sensual nature"; even "Purists" like Kandinsky and Mondrian, who had achieved an art of geometrical forms, were committed to equivalents of trees and horizons. By Newman's reasoning, a square painted on a square becomes a figure matching a building outlined against the sky; that is to say, a landscape. Against this naturalism embodied in the European sensibility, a new group of American painters, Newman asserted, were creating a "truly abstract world." For these artists (among them, in addition to him, were Gottlieb, Rothko, and Still), he claimed an art entirely liberated from residues of visual experience. These American abstractionists, he declared, were "at home in the world of pure idea" (as the Europeans were among the objective correlatives of sensibility). Their minds rejected pictorial harmonies built of fictional images and signs. They preferred to begin in the "chaos" of feeling and sensation—Newman might have been thinking of the jumbled American landscape of gas stations, drive-ins,

abandoned railroad tracks, billboards—and they struggled to evoke out of this chaos "a memory of the emotion of an experienced moment of total reality."

In sum, what the American artist sought was not a better or newer fiction but reality. (See Chapter 1, "Redmen to Earthworks.") And this could be attained only through a systematic exclusion of the flimsy presences of what Stevens called "this invented world." Newman was saying, in effect, that for the American painter there was no world, only a world to make—a thought reminiscent of Whitman—and that for the new abstractionists the universe of things, places, people, events had ceased to be a source of forms, even when it was subjected to the abstracting powers of the intellect. Everything had to be created anew, and out of nothing. Merely nonrepresentational art was a meaningless disguise for the old naturalism. Art had to achieve the idea that could make new *being* possible. Newman might have repeated the concluding thought of Dostoevsky's *Notes from the Underground*: "Soon we shall contrive to be born somehow from an idea." But he would have repeated it without Dostoevsky's depression or his nostalgia for "men with a real individual body and blood." For Newman, the chaos of modernism was a prelude to revelation, to an act of creation modeled on the Book of Genesis. In this optimistic response to the "Pagan Void" —the title of an early (1946) painting—and to the "Death of Euclid" (1947), Newman called upon his rabbinical heritage, as he did in his desire to transcend chaos without resort to representations, symbols, or "graven images." Were it not for the inevitability of misunderstanding, one might describe his canvases as the first Jewish religious paintings (his recent sculptures have the aura of an altar in the desert). Purged of imagery (though the triangular "Chartres," with its powerful apex, violates Newman's standard by coming close to symbolism), they proclaim his faith in creating substance—a faith confirmed in his critical writings and by the titles he gave to such works as "Genetic Moment," "Genesis," "The Beginning," "Onement," "Abraham," "The Name," the series of paintings called "Now," and the sculpture series called "Here." Once again, Stevens comes to mind:

Barnett Newman, *Chartres*, 1969, acrylic on canvas.
M. Knoedler & Co. Inc., New York.

> To find the real,
> To be stripped of every fiction except one,
> The fiction of an absolute.

The art world today is dominated, as it has been in the past, by the academic principle that the philosophy of an artist is of no account; what matters is his product. Such splitting apart of substance and form distorts the actual process of creation, however convenient it may be to art historians, critics, and the art market. Still, Newman's metaphysical claims would have been meaningless had he not discovered a revolutionary format by

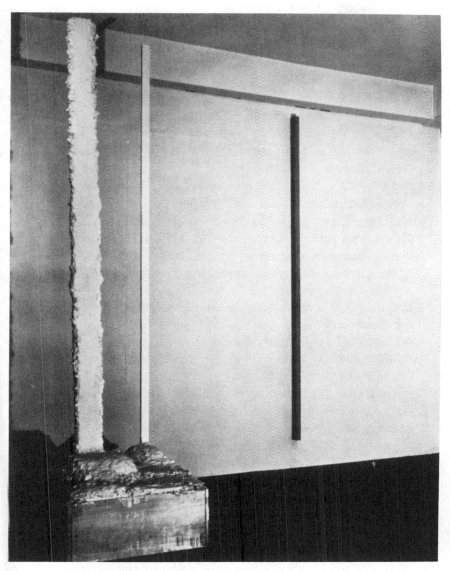

Barnett Newman, *Here I (to Marcia)*, 1950, bronze.
Collection Mr. and Mrs. Frederick R. Weisman.

which to convert the recent past of art to his visionary ends. Formally, he placed himself in the line of Mondrian's organization of rectangles separated by bands of different widths. Yet it was clear to him that Mondrian represented a direction opposite to his own; with Mondrian, Newman wrote, "the geometry (perfection) swallows up his metaphysics (his exaltation)." Mondrian was the "Euclidean Abyss" (another early Newman title) into which abstract art fell and mixed with the debris of the art of the past. Now, geometrical forms were no longer to be conceived as static elements of design, in the manner of the Neo-Plasticists and the Bauhaus. For Newman, a square or a circle was "a living thing, a vehicle for an abstract thought-complex, a carrier of awesome feelings . . . the abstract shape was therefore real." His intuition that the rectangle of the canvas is an active entity to wrestle with led him to rank himself among the Action painters rather than with the Geometrical Abstractionists or the more recent Minimalists influenced by him. For him, painting was not an organization of shapes, color, and line; it was celebration, a "sublime" event, an evocation of the unknown. So he avoided imposing squares or rectangles *on* the canvas, as Albers, Mondrian, Rothko, and some of the "color" painters have done; his innovation consisted in transforming the canvas itself into two or more rectangles by means of his stripe, or band, of color, his "zip." No figure is represented on the canvas, and the canvas becomes an "object," like a votive monument in a sacrificial grove. The chief characteristic of a Newman is that it is there, an entity that keeps nature at bay. Bare of qualities, it excludes emotional confusion and defines itself through the austere realization of quantitative measure: size, proportion, multiplicity, singularity, muteness, radiance. Tactically, Newman's aesthetic relies mainly on expanse; a quantity of red or white is present, and it rises and/or spreads, propelled upward and outward by the bands that also restrict it and keep it in place. Because of the major role of quantities of height and width in them, the large Newmans are usually the first to be appreciated.

It is a hardship of the times that before an artist can fashion an icon he must compose the theology that his icon will rein-

force. Newman began by speaking in the name of a group of artists, but it soon became evident that in this epoch each individual creates (or assembles) his own culture. Newman's most pressing problem was to fight his way out of the historical continuum of art forms by laying bare the philosophical substructure of those forms, then to prevent that history from closing in on his work and carrying it off in a direction of its own. For Newman, analysis and polemics logically preceded a painting and interacted with it (the "Who's Afraid" paintings). The machinery of ideas grinds on endlessly, and the act of painting was this artist's way of moving past his ideas to the wordless realization that he called awe and the sublime.

Compared with other paintings that have sought to capture the "spirit" in geometrical shapes, Newman's rectangles are the simplest, most neutral, and least engaging to the eye; they lack the soft seductiveness of Rothko's floating blocks of color, the emblematic suggestiveness of Gottlieb's cosmic vistas; by contrast with a Newman, Reinhardt's black squares and crosses reek of an asceticism that is almost theatrical. Newman goes farthest toward the purely conceptual, and in themselves concepts have no style, any more than magnitude has, or an expanse of color, or a pile of rocks. A field of gray would express itself in sound as a monotonous hum or cracklings of static. Painting based on the "pure idea" and rigorously purged of sensibility comes close to not being painting at all. Yet Newman was never interested in anti-art; indeed, he could logically have conceived his work as an antidote to it, and attributed anti-art to the Europeans as a final stage of sensibility. In pushing painting as near as possible to extinction, Newman showed it to survive as an act of faith rather than as a normal attribute of modern culture. His search for a reality evoked through the act of painting was a return to the foundations of art in ritual and magic. It was the extreme to which he pursued this metaphysical purpose that makes his work difficult for the spectator. Yet how can the absolute be sought except absolutely? Not anti-art but metaphysics makes Newman's paintings ambiguous. An idol, a sacred object, has a "second self," an immaterial form that invests it but that appears and disappears like the clicking on and off of a pale light. When

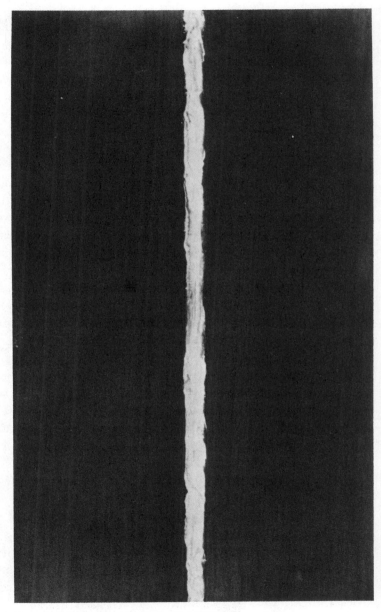

Barnett Newman, *Onement I*, 1948, oil on canvas.
Collection Mrs. Annalee Newman.

the wraith is gone, one cannot be sure it has been there. Nor can its presence be demonstrated to those who fail to apprehend it. Something similar is characteristic of masterpieces. Hamlet's "Do you see nothing there?" echoes throughout the history of art. Newman's early defense of the metaphysical element in painting occurred in a letter to a philistine critic who had denied its relevance; in his reply Newman refused to surrender the conviction that a Cézanne "adds up to more than the apples, that the two-faced heads of Picasso are more than two heads, or that the strict geometry of Mondrian is more than the sum of its angles." The issue is to see with the whole being a totality partly invisible—that is, to believe.

Standing before a Newman, the spectator may experience exaltation, or sensations akin to those projected by an orgone box; "that black draws you into it." The next moment, the painting will be simply a colored wall with a stripe—"any house painter could do it." This shifting of the effect of his paintings between sublimity, self-hypnosis, and cold, visual fact is evidence that Newman has achieved his ritual purpose. In all belief, the potency of the object is both real and unreal. In *Joseph and His Brothers*, Thomas Mann observes of the members of the cult of Adonis that they knew that the figure of the god was a wooden carving but that in the festival it was Adonis. "Some of them have hidden the figure in the shrubbery but they search with the others, they know where it is and know it not."

Newman is said to have basically influenced the art of the sixties through pioneering in one-color painting, in paintings of mammoth size, in his manner of dividing and shaping the canvas. This may be true, but more important to me is that he indicated the exact position of art today, insofar as it is ambitious for greatness. I mean that it must run the risk, apparently unavoidable, of not seeming art at all.

9 / Rothko

Mark Rothko, who committed suicide in February, 1970, belonged to a wing of Abstract Expressionism whose art was based on the idea of one idea. This was an aspiration toward an aesthetic essence, which the group of artists to whom Rothko was close sought to attain not through acts of intuition but by calculating what was irreducible in painting. The movement began in the middle forties, as an accompaniment and antithesis to Action painting, with its psychological and formal openness; it is ironic that the two movements should have emerged together under one label—Abstract Expressionism. The one-idea painters excluded both nature and self, as manifested in the randomness, induced accidents, and associationism of Gorky, de Kooning, and Pollock. Seeking a universal principle, most of them looked back to Mondrian, though not for the quality of his sensibility, which they found too mathematical, but for the rigorousness of his aesthetics of exclusion—as remote as could be from Kandinsky's early improvisations, which beguiled Gorky and Hofmann. One might say that Rothko and his friends constituted the theological sector of Abstract Expressionism. Together with Still, Newman, Reinhardt, Gottlieb (the names suddenly translate themselves into characters of a miracle play), Rothko sought to arrive at an ultimate sign. To this end, he and the other theologians conceived painting as a kind of marathon of deletions—one of them got rid of color, another

of texture, a third of drawing, and so on. By the mid-forties, Rothko was able to dramatize the crumbling of subject matter in a succession of compositions suggesting jungles and submerged landscapes, whose creatures, habitations, and implements had been scraped or washed away. His blanched surfaces and un-identifiable biomorphic shapes conveyed an effect of the archaic that in its effect of distance corresponded to Gottlieb's picto-graphs and Newman's cosmic spheres of the same period. Pic-torial content had been reduced to vague psychic reverberations.

Rothko's next move was to obliterate subject matter en-tirely. This was done through a series of acts of subtraction, to which he devoted four or five years. During this development, drawing vanished, horizons melted into diffused masses—Rothko's "No. 24," done in 1947, has much in common with "Moonlight Marine," by that other seeker after "something out there be-yond," Albert Pinkham Ryder—and movement finally came to a standstill. But Rothko would not rest with simplifications of observed phenomena, as exemplified by the paintings of Milton Avery, which he admired, or with projections of the uncon-scious, like those of Gorky or his own earlier work. Even simpli-fications so extreme as to make their models unrecognizable violated the ideal of an absolute art. The idea of one idea demands a format that can stand for the inexpressible through being de-nuded of all particulars and associations and detached from the contingencies of nature, like Mondrian's "unchangeable right angle."

By 1950, Rothko had conceived his conclusive insigne of a disembodied absolute. This icon consisted of the rectangle of the canvas as a one-color ground visible along the edge of—and occasionally through an opening between—three or four horizontal blocks of color with brushed surfaces and furry borders. For the next twenty years, Rothko's work consisted of reanimating this pattern with the substance of his emotional life. It was as if he had conceived a latter-day, visual version of the sonnet or the *haiku*. Except that (and this is decisive in regard to the situation of the one-idea painter) his format was private—almost, one might say, the framework of another self, or of him-self in another form—and unavailable to others.

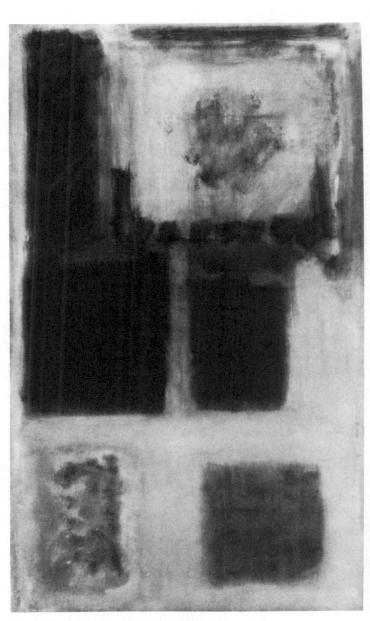

Mark Rothko, *Untitled*, 1948, oil on canvas.
Estate of Mark Rothko, courtesy Marlborough Gallery.

Rothko had reduced painting to volume, tone, and color, with color as the vital element. His paintings, many of them huge and intended for display in public places, range from floating masses of tinted air, like influxes of breath, to closely packed slabs of dense, glowing pigment, resembling segments of metal or stone tablets that once carried inscriptions (the latter canvases reawaken the archaic overtones of Rothko's submerged cities of the early forties). With the overall figuration kept intact from canvas to canvas, emotional content is determined by the hue, pitch, weight, and expansion and contraction of his oblongs of color, as these are affected by the shape and size of the whole. The psychic tensions evoked by Rothko are at once extreme and featureless, mythical without mythic personages or events. An upward drift, as of levitation or the weightlessness of grace, stimuates a flux of inhalation and opening out, and draws the spectator into the orbit of the artist's inward flights. Materiality is overcome—at least, until the walls reassert their presence—an effect that has led some observers to speak of Rothko's paintings as enveloping the onlooker or transforming his environment. In contrast, his brooding, dark, reddish-brown canvases, which had emerged as early as the fifties but appeared more frequently, and growing blacker, in his last years, tower over the spectator in a blank foreboding, like ancient testaments kept intact in a shrine or a grotto of some dour barbaric cult. Both the uplifting and the heavy, dark nights of Rothko's compositions have been identified as embodying religious experiences. Peter Selz has said that his paintings "really seem to ask for a special place apart, a kind of sanctuary, where they may perform what is essentially a sacramental function." Rothko's last commission was for an ecumenical chapel in Houston.

Whether or not Rothko's paintings require a "sanctuary," the artist found his own sanctuary in his studio. His reductive idea closed its door against the world and sanctified the studio as a site for rituals of death and rebirth. There he carried on his program, announced in 1943 in a joint communiqué with Gottlieb, of making his art "an adventure into an unknown world," an adventure of which his suicide in the studio was the con-

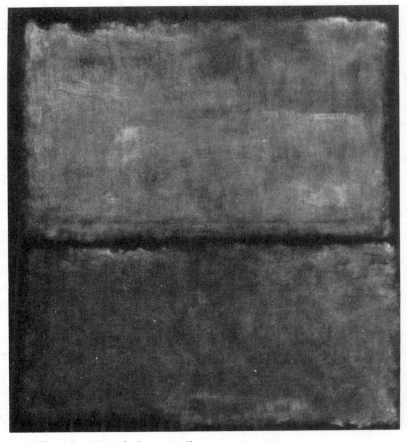

Mark Rothko, *Untitled*, 1956, oil on canvas.
Estate of Mark Rothko, courtesy Marlborough Gallery, New York.

cluding act. Rothko's art was "escapist" in the deepest tradi-
tional sense—rich in the romance of self-estrangement and of
nostalgia for communion. Emotionally, he took less away from
painting than any of his early companions. Compared to New-
man's, his canvases are passionate rediscoveries of a state of being
rather than detached affirmations of an objective truth. It can
be argued that Rothko was never "really abstract," in the sense
of canceling subjective qualities in favor of his idea. He deleted
the particulars of which a human self is made, but he did not
exclude the sentiment of his own absence. Restrained and sedate,

his art was essentially soft, that is to say, humanly susceptible, with a susceptibility that his color-area imitators of the sixties did their best to banish. His were the first "empty" paintings by an American to make an impact on the public, perhaps because his emotionally charged reds, blues, browns, black-greens succeeded in stirring up feelings—awe, anguish, release—too deeply buried to be brought to the surface by visual metaphors.

Rothko spoke often of tragedy, Greek and Shakespearean, and of myth and ritual. It is not easy to grasp the connection he had in mind between his mats of color and Orestes or Macbeth. It must be presumed that the very blankness of his canvases vis-à-vis persons and things carried the reference to torment and purgation. It was another self that Rothko sought—the kind of illuminated, memoryless alter ego that emerges out of conversion rites. But it was an anonymous self, identified with a hero, saint, or god not yet named. In his genial, matter-of-fact manner, he whispered to me at a party, most likely because the subject of Expressionism had been raised, "I don't express myself in my painting. I express my not-self." I had long had the impression that he was not much attracted to what he had found in his personality. On the other hand, he had no wish to put his wounds on parade, like some of the Middle European Expressionists. It was in transcending himself that his hopes lay, in building a life independent of day-to-day facts. He decided that he could do most for his art by evicting himself from it, and that art could do most for him by providing occasions for acts of catharsis that he could have before him later. Compressing his feelings into a few zones of color, he was at once dramatist, actor, and audience of his self-negation.

The drama of purgation was not, of course, visible in each of his paintings; often the spectator saw only combinations of pinks, whites, and purples. Something similar is true of van Gogh: yellows and greens that for him were imbued with sinister drama have aroused pleasure in onlookers. The emotional effects of color cannot be calculated precisely—except, possibly, in the art of century-old cults, in which their meaning has been fixed by tradition and doctrine, such as the Hindu Tantric designs. Yet an artist's intended emotional content need

not communicate itself in every painting; if it comes across once, the spectator is justified in accepting something like it as the potential content of all the artist's works. With Rothko, the poetry and agony of self-displacement established itself as the note of his paintings, and if some of them failed to speak, one felt that they might at some other time.

As against the self-creators among his contemporaries—de Kooning, Hans Hofmann—Rothko posed the anti-self. His purged paintings affirmed the purged ego—or, rather, the act of purging. Each work was an evidence of the mind's approximation to zero, an image of the not-seen. The effectiveness of such cleansing events lay in their reiteration. Rothko was not deterred by the realization that for two decades visitors to his exhibitions would know in advance what they could expect to see. Theoretically, the artist who has attained his ultimate image ought to reproduce it without change, like the order of a ceremony. Reinhardt, a drier logician than Rothko, advanced to this practice in the all-black paintings of his last period. The glint of color below his unchanging squares of silence emphasize that all differences in individual sensibility amount to nothing more than a scarcely perceptible nuance against the massive truth of death and nothingness. Rothko, for whom reductionist aesthetics was also the vehicle of primordial moods, avoided the finality of Reinhardt's summation. With him, too, however, the drift was toward black, as representing both heaviness of feeling and the fading of the visible world.

No doubt Rothko drew much strength from practicing painting as a ritual of self-purification. Yet the art of one idea is full of painful contradictions. It transforms the studio into a sanctuary but also into an isolation cell. The symbolism of a cult unites its members, though it separates them from nonbelievers. The symbolism of the contemporary artist-theologian is that of a one-man cult, and it separates its creator as its sole communicant. The absolute images of Rothko, Newman, Gottlieb, Still, Reinhardt can coexist in a picture collection but could not coexist in the minds of their originators. Each was the proprietor of a sacred enigma, whose authority had to exceed that of all others. The fate of Rothko's original group of artist-companions

was to disperse and become in most instances implacably hostile to one another. Nor could Rothko, whose passionate anti-self engaged him so totally in his paintings, win the devotion of the bland professionals who in the sixties adopted some of his technical innovations. To the reductive theologian of painting, his work represents ultimate meaning. To others, its appeal is to taste. His all-embracing symbolic format was arrived at by difficult routes; once conceived, it could be reproduced at will— Rothko was one of the first to declare, no doubt ironically, that he could order his paintings made over the telephone. Nullifying himself was his discipline of exaltation; fame surrounded him with himself in countless mirrors. In the end, his anguish was loneliness and the thought that his poetry had not been received. In this loneliness and sense of futility, he achieved the universal that was his ambition as an artist. But he was compelled to experience this universal as a single individual, without consolation. He had been depressed for at least five years, yet no one knows why he took his life. Like his paintings, his act of self-annihilation is a deeply affecting blank. The art world turned out en masse for his funeral.

10 / Marilyn Mondrian

Roy Lichtenstein and Claes Oldenburg

Pop Art is thought to be the art of everyday things and banal images—bathroom fixtures, Dick Tracy—but its essential character consists in redoing works of art. Its scope extends from Warhol's rows of Coca-Cola bottles to supplying the Mona Lisa with a mustache. All art is based on earlier art, either consciously or by absorption, but no movement has ever exceeded Pop in alertness to aesthetic cues. Works reproduced in *Pop Art Redefined* (Praeger, 1969), by Suzi Gablik and John Russell, evoke, among others, the following: Leonardo, Duchamp, de Kooning, Mondrian, Manet, Monet, Matisse, Picasso, Delacroix, Magritte, Demuth, Pollock. In addition, more than twenty paintings and sculptures by a dozen artists include the word "ART" in block letters, depictions of art materials, and portraits of earlier artists, contemporaries, art dealers, and curators. If we count as art the comic strips, lettering, posters, sign paintings, and industrial designs adapted by Pop artists, the Pop movement takes on the character of an exhibition in an art school that combines courses in fine art and applied design. In Pop, America's two cultures, highbrow and popular, meet on the neutral ground of technique.

The Pop mode came into prominence around the beginning of the nineteen-sixties, when the American art world had commenced to consolidate itself on a mass-audience basis, and it inaugurated a decade of pedagogy. From the start, the leading Pops declared that their primary interest was in formal qualities

and that their representations of pinups and hamburgers were a sideshow put on to get the crowd moving into the lecture hall. "Artists," said Lichtenstein, "have never worked with the model —just with the painting."

At the close of the decade, the underlying abstractness or formalism of Pop was being passionately urged upon the attention of the art world. In view of art historians and critics, and some of the artists, too, Lichtenstein, Oldenburg, Warhol, Tom Wesselmann have been engaged in much the same enterprise as the painters of color areas and bands, such as Ellsworth Kelly and Kenneth Noland. Popeye, Marilyn Monroe (I almost said "Marilyn Mondrian"), and "Red, Blue, Yellow" are equally valid occasions for advanced exercises in line, color, and form. "Our intention," writes Miss Gablik, is to "redefine Pop Art as having a more direct relation to Minimal and hard-edged abstract art than is frequently admitted." Alas, others got there first; the relationship of Pop to late-sixties abstraction was most enthusiastically "admitted" by Professor Robert Rosenblum and echoed by Professor Barbara Rose and by Miss Diane Waldman, associate curator of the Guggenheim Museum and director of its Lichtenstein retrospective, and it is a safe bet that the word was received in Los Angeles and Pasadena. "Lichtenstein," declared Miss Waldman, "has dematerialized the object and effected a new reconciliation with the picture plane." Comic-strip and advertising-agency artists have done pretty well in dematerializing objects, but it takes an authentic fine-arts artist of the nineteen-sixties to effect reconciliations with the picture plane. What Miss Waldman said (and her observation has been confirmed by Lichtenstein himself) was that, vis-à-vis the original Donald Duck, the function of Lichtenstein was to shift the image from the realm of the Sunday comics to the world of art —a shift comparable to the one carried out by the Navajos when they adopted the dollar bills and soup-can labels of the first Yankees in the Southwest as designs for blankets. With Pop, the tribe of the art galleries and museums "acculturates" the artifacts of the supermarkets, billboards, and women's magazines by passing them through an art-historical filter. The tool is the pedagogy of the picture plane, today in full swing in assimilating,

by reinterpretation and trimming, all art into what Professor Rosenblum calls "the formalist experience of our century"— surely one of the emptiest, and most contrived modes of "experience" ever conceived by the academic brain.

The aestheticism of Pop, its fixation on art-world values and art-world reputations, has been obscured by the common misconception that, as Miss Gablik has it, Pop is "based upon real things which are part of everybody's world, and not just a private world of the artist's." This roughly describes the aims of Pop in the heroic days of Oldenburg's "Store" on East Second Street and the exhibitions and Happenings at the Reuben Gallery —the period when young artists in New York felt obliged to break out of the grip of art history as represented by Abstract Expressionism. Unfortunately, there is no such thing in art as "everybody's world," just as, despite the easy formulas of art historians, there was no "private world" of Abstract Expressionists. The issue was, and is, style and creative method—and the adoption by some Pop artists of a set of mannerisms that were the opposite of the mannerisms of Abstract Expressionism was insufficient to exorcise art history and gain contact with real things. Bathrooms by Oldenburg, Segal, Lichtenstein, and Wesselmann, reproduced in *Pop Art Redefined*, lack the shared characteristics of the products of Kohler or Crane; they are individual restylizations of the art of the designers of plumbing fixtures. Oldenburg messes up a corrugated-paper toilet and washstand with drips of paint and stands his bathtub on end, evoking simultaneously Abstract Expressionist painting and the atmosphere of slums and loft-building studios. Segal and Wesselmann incorporate sections of brand-new tile walls and chromium-plated fixtures into stage sets that feature nudes reminiscent of Courbet and Matisse; Lichtenstein supplants the physical bathroom with a linear mail-order-catalogue illustration of it.

As for the motif itself, the bathroom comes close to meeting the test of being, at least in America, "part of everybody's world," but an attractive nude stepping out of a bathtub is hardly "everybody's" except in French paintings, and her incompatibility with bathrooms in slums caused Oldenburg to leave her out. In art, "everybody's" world is a style that is

opposed to minority styles, and Pop cannibalizes both majority and minority art for its own aesthetic purposes. In the social ambience of the gallery-goer, the "Mona Lisa" is almost as much everybody's as the bathroom, and Duchamp's and Warhol's Mona Lisas are today almost as much public property as Leonardo's. But the art audience as "everybody" narrows considerably when it reaches Demuth's "I Saw the Number Figure 5 in Gold" as re-created by Robert Indiana and the drawing by de Kooning that Rauschenberg partly erased. Taking into account such Pop staples as repaintings of Ingres, Delacroix, Rembrandt, and Picasso, a textbook analysis of Cézanne, and a chromium-plated version of Magritte's boots that turn into feet, as well as paintings that refer to art dealers and curators (e.g., Walter Hopps wearing a miniature de Kooning under his coat), one is forced to conclude that in Pop not everybody's world but the enlarged, self-conscious art world of the decade recently concluded has replaced the Abstract Expressionists' world of artists.

Pop Art reached out not to real things but to pictures of things, and its aesthetic discipline has consisted in seeing objects as pictures or sculptures, so that the Bowery or the suburban kitchen becomes for the Pop artist an art exhibition ready for shipment to the international chain of art showcases. Basically, Pop Art is "found" art; done over but preserving its original appearance; its most potent effect is the hallucination of mistaking the street for a museum or the astonishment of Molière's character on learning that he has been speaking prose. In becoming Pop Art, objects separate themselves from their functional reality and are changed into art-like equivalents of themselves—a condition best symbolized by George Segal's solid white plaster ghosts. The inherent detachment of Pop's aestheticized banalities prefigures the "pure" objects of Minimal sculpture and the "reduced" compositions of the color-field painters. misnamed "the art of the real." The extinction of content in Pop Art enabled it to treat in equal fashion a sunset by Turner and a Shell Oil sign, and thus to serve as a bridge between the art of latecomers to Action painting—to whom a de Kooning or a Pollock represented not a new psychic realization but a way of applying

paint to a surface—and the varieties of abstract modes that emphasize areas of color disposed on materials of a given size and shape. It might be added that the rising curve of aestheticism in the sixties, with its concept of the world as a museum, represented a withdrawal by the art world from the intensifying politico-social crisis and intellectual confusion in the United States.

The commercial artist or designer who has provided the bulk of "nature" for the Pop artist is an aesthete, too. Like the Pop painter, he converts all styles to his needs, and in illustrating an ad for ice cream he does not forget to shape the drop of chocolate on the sphere of vanilla into the perfect outline of a tear. In appreciating Lichtensteins, one is obliged to keep in mind that the comic strips on which they were based were created not by forces of nature, or by children drawing on sidewalks, but by artists who, as Larry Rivers pointed out near the inception of Pop, "went to art schools, traditional & bohemian, & . . . admired the Old Masters & still tell you about Picasso or perhaps Klee & they made lots of drawings. . . . When you meet them you are not in the presence of a brute." Craftsmen of the commercial workshops are, one might say, the avant-garde of art among the great public, as Lichtenstein and Warhol are the avant-garde of applied aesthetics in the art world. It is the overlay of the "high" and "low" aspects of contemporary art practice that characterizes Pop Art as a movement; "real things" have nothing to do with it. As the embodiment of classroom aesthetic dogmas of the sixties, Pop is, as Miss Gablik and the formalists maintain, linked with Minimalism and color-field painting. But it is linked equally with the commercial-crafts spirit of America's newly expanded art world.

The artist who best represents the basic motives of Pop Art is Roy Lichtenstein, an ex-Abstract Expressionist who has been both a commercial artist and a university art instructor. He began as a Pop artist around 1961 with paintings based on the comic strip, and though he continued in this vein only roughly through 1964, this image is the dominant one of his career. The

Roy Lichtenstein, *Modular Painting with 4 Panels, #5*, 1969, oil and magna on canvas.
Courtesy Leo Castelli Gallery, New York.

recomposition of a comic-strip "box" dissociated from the strip—the face of the blonde in the window saying, "I know how you must feel, Brad"—into a large-scale oil painting was Lichtenstein's primordial idea, the discovery that gave birth to him as a painter, and all his works look back to that exciting vision. Many of his paintings of the last five years—landscapes with temples, restyled Mondrians and Picassos, cloud formations that are exercises in spatial ambiguity—seem like random demonstrations of how pictures can be turned into Lichtensteins by the introduction of his comics-derived thick outlines, swimming masses of black, bright colors, and Ben Day dots (a result comparable to the one achieved

by Yves Klein through covering canvases and objects with his "International Klein Blue"). Lichtenstein's "Modern Painting with Division" (1967) and "4 Panel Modular 4" (1969) keep abreast of serial-pattern painting and Frank Stella's late use of arched elements but retain identification with Lichtenstein through heavy black contours, primary colors, and fillers of Ben Day dots. His sculptures of the last three years, however, which abandon his cartoon ingredients in favor of thirties-style "modernistic" metal coat hangers and theatre-lobby stanchions in polished brass, glass, and aluminum, seem to be searching helplessly about for art-world references. Perhaps the discs of David Smith will come to the rescue.

In formal terms, Lichtenstein is nothing if not consistent; his aesthetic reprocessing, which homogenizes "vulgar" art with high-art forms and high art with formal derivatives from the mass media, cancels the content of both and leaves only design. Formalist criticism, as represented in this instance by Miss Waldman of the Guggenheim, finds his work to be all of a piece. Comparing Lichtenstein to Ingres, she writes that "Lichtenstein is able to present us with a new vision, not one based on the comic strip but more probably based on his understanding of modern art. Starting with a specific subject matter, he arrives at a general or ideal image." Miss Waldman seems unaware that in attributing to Lichtenstein an art that is based on understanding art and that achieves the "ideal," she has described the modernist academician.

No doubt Lichtenstein understands modern art, at least as it has been discussed in the United States during the past twenty years, but it should be said in his favor that his aestheticized comics, far from arriving at an ideal image, are extremely uneven in the quality of their design. "Drowning Girl" and "Hopeless" are interesting Art Nouveau rhythmic compositions; "Takka Takka" and "O.K. Hot Shot" are so cluttered that the eye cannot rephrase them into satisfactory patterns; "Preparedness," a huge three-sectioned canvas done in 1969, is simply dull, in the manner of the poorer government murals of the thirties— the period with which Lichtenstein is at present engaged in his sculpture.

Roy Lichtenstein, *Image Duplicator*, 1963, magna on canvas.
Courtesy Leo Castelli Gallery, New York.

Apart from keeping up with art history and subsuming the comic-strip craftsman under the system of contemporary art ideas, Lichtenstein's paintings tend to reflect a gentle, professorial humor and a sincere liking for corny themes, colors, and postures. "Mr. Bellamy" is the cartoon of a resolute American naval officer who reflects, in a comic-strip balloon, "I am supposed to report to a Mr. Bellamy. I wonder what he's like." Done in 1961, the year Richard Bellamy assembled a squad of Pop artists at the Green Gallery, the painting is an excellent In joke.

The 1965-1966 "Brush-stroke" paintings, with their traces of drip and exposed (but Ben Day-dotted) canvas, are my favorite Lichtensteins, because of their wit in isolating and reducing to a "thing" the trademark of Action painting, and Lichtenstein's impeccable handling relates the Action brushstroke to Oriental calligraphy. The balloon of "Image Duplicator," a closeup of the eyes of the Mad Scientist, amusingly sums up Lichtenstein's aesthetics: "*What? Why did you ask that? What do you know about my image duplicator?*"

The comics are a path back to childhood. A prevailing mood of Lichtenstein, as of Rauschenberg, Oldenburg, and the majority of the Pop artists, is nostalgia; in their scheme, childhood represents reality before it became totally absorbed into art. Lichtenstein's "Composition I," a six-foot-high reproduction of the cover of a schoolboy's copybook, with a rectangular label in the center headed COMPOSITIONS, and decorated with an allover design of random black-on-white shapes vaguely reminiscent of Pollock and bordered on the left by a vertical black band à la Newman, is a brilliant synthesis of the artist's past innocence and present professionalism. Parodying the comics enabled Lichtenstein to reintroduce into painting heroic and romantic subjects—air pilots, cops, George Washington, drowning maidens. Though presented under the cover of aestheticism and Camp, the melodrama of such paintings as "Drowning Girl" ("I don't care! I'd rather sink—than call Brad for help!") and "The Kiss" (with an outline of the departing lover's plane in the background) helps, together with such gags as the "Image Duplicator," to save his work from monotony, thus having the formalist cake and eating it, too.

Nominally, Claes Oldenburg also is a Pop artist—one of the earliest and most forceful, who went through the pre-Pop mill of Happenings, environments, and prop-making. The subjects of his sculptures, constructions, and drawings are taken from the common sources of Pop: packagings (7-Up bottles), art lectures ("Henry [no doubt Geldzahler, a curator at the Metropolitan Museum] pulls out a rubber lecture"), ready-to-eat items, advertisements, cosmetics, kitchen equipment, tools. With Oldenburg, as with Lichtenstein, stereotypes in and out of art are equalized, and Lichtenstein's coolly conceived brushstroke is matched by Oldenburg's dripping paint pile turned into a plaster mass.

Oldenburg's practice of art and his attitude toward it are, however, radically different from those of Lichtenstein and the typical Pop artist, and to apply the Pop label to him tends to obscure the nature of his work. For Oldenburg, ex-reporter, poet, solitary walker in the city, and introspectionist, art has psychological and social objectives, and the aestheticism of the revisers of clichés, such as Lichtenstein, is as alien to him as the aestheticism of the Minimalists and color-fielders. If Lichtenstein's accomplishment is confined to nuances of "the formalist experience of our century," Oldenburg has educated himself in the strategies of modernism in order to animate—in the phrase of his *Store Days* (Something Else Press, 1967)— "a theatre of action or of things." Oldenburg, too, is absorbed in form—what artist isn't?—but he finds his forms in concrete objects and situations rather than by imposing on art a set of procedures derived from currently acceptable modes. Like de Kooning, though with essential differences, he is a "transformalist"—that is, one who uses the freedom won through modernist experimentation to cut across the history of styles by means of the unique creative act. His opposition to the ersatz Action painting that dominated New York art upon his arrival in it in the mid-fifties expressed itself not in submission to a system of antithetical recipes—impersonality, smooth surfaces, preconceived composition—but in slowly unearthing the creative principles of the pioneers of the movement. "Lately," he said in *Store Days*, "I have begun to understand Action painting that old thing in a new vital and peculiar sense as corny as the scratches on a NY

Claes Oldenburg, *Heel Flag*, 1960, wood, leather.
Collection the Artist.

wall and by parodying its corn I have (miracle) come back to
its authenticity! I feel as if Pollock is sitting on my shoulder, or
rather crouching in my pants!" An artist who has the feeling
of being "occupied" by a predecessor is able to extend the past
through his imagination and can dispense with recipes derived
by formalist analysis.

Oldenburg is the most inventive American artist of the
post-Abstract Expressionist generation. His career ranges across
Happenings, dramas, and environments: early East Side sculp-
tures of food, clothing, and women' legs, made out of newspaper
soaked in paste, and later ones of plaster-saturated muslin painted
with enamel; "flags" concocted in Provincetown out of drift-
wood and bits of rubbish; giant "soft" sculptures of toothpaste

Claes Oldenburg, *Proposed Colossal Monument for Park Avenue, New York: Good Humor Bar*, 1965, crayon and watercolor. Collection Carroll Janis, New York, courtesy Sidney Janis Gallery.

tubes, telephones, typewriters, electric mixers, fans, and models of the Chrysler Airflow, circa 1935 (the nostalgic element), made of stuffed canvas and vinyl; and a huge miscellany, done in the past five years, from the "Giant Soft Drum Set" to the

shining 1969 "Giant Saw," which flows from the wall onto the floor in hinged segments. Most of these pieces are extremely amusing in an eye-opening way; in them the familiar and man-made pass over into the natural, the absurd, and the abstract, as in the assemblage of cylindrical forms that turn out to be simulations of enlarged cigarette butts, and the row of pendulous organs that identify themselves, with some difficulty, as four Dormeyer mixers. Oldenburg has the offside mind and deadpan of the comedian-visionary. (Physically, he reminds me of Arp, who half a century ago unveiled the sculptural possibilities of an eggcup.) His natural attitude is antisocial in the bohemian tradition; he conceived his theatre as "a poor man's theatre." His attacks on society are potshots, as befits an artist; the forms he finds inhering in objects may "of themselves" become grotesque or savagely satirical.

That Oldenburg achieves his formal disclosures through a Swiftian isolation and blowup of detail inevitably associates his constructions with fun-house novelties and Hollywood dream carpentry, and this association is encouraged by his lapses into literalism, as in the huge light switches, mammoth shirts, and period-style West Coast motel bedroom. For those who know his work largely through his overpublicized, oversized, animated ice bag and twenty-four-foot lipstick designed as a monument, Oldenburg has probably defined himself as a maker of visual gags. I can think of no better way to correct this impression than to start with his drawings and water-color sketches. There the ideas of the artist appear in their inception, when the qualities of his draftsmanship and his thinking contend on equal terms with his subject matter, so that the study of a Good Humor as a monument, or a pack of cigarettes as a museum, is no more distracting than the drawing of an obelisk or of a figure on horseback. Throughout his career, Oldenburg's object-making, like his experiments with theatre and environments, has been accompanied by tireless sketchbook drawing and writing. His pencil, crayon, and water-color drawings, in their sensitivity of line and compositional clarity, put his poetry and his tactile imagination in first place, and relieve him of debt to either prevailing art concepts or the Pop ace-in-the-hole of aesthetic incongruity.

11 / Young Masters, New Critics

Frank Stella

With a retrospective at the Museum of Modern Art at the age of thirty-three, Frank Stella is an artist who wasted no time. The paintings in the exhibition went back to 1958, the year he graduated from Princeton. In the following year, he was included in the Museum of Modern Art's "Sixteen Americans" exhibition, along with Nevelson, Ellsworth Kelly, Jasper Johns, Rauschenberg. Thereafter, his career was one of counting successes. It would be fair to describe Stella as the young artist (Warhol belongs to a somewhat older generation) who came most prominently to the fore in the nineteen-sixties. As such, he reflects the aesthetic interests of that decade, or, at any rate, of those forces that were most effective in advancing reputations in it.

The retrospective at the Museum of Modern Art displayed a variety of sedate decorations, notable chiefly for their large size and surface finesse. Stella unquestionably possesses a childlike fascination with squares, diamond shapes, triangles, arcs, and, above all, parallel bands of color. His sense of rhythmic repetition tends to make his compositions monotonous for the spectator, though not necessarily for the artist. Stella understands, however, that regularity needs to be disrupted at times in a manner sufficiently unostentatious to require an act of perception by the viewer. "Jasper's Dilemma" is a pair of joined squares, each of which contains a series of boxes within boxes. Superimposed

upon these squares are four white diagonals that intersect to form a central diamond. But while two of the diagonals meet at the center bottom of the picture, the other two zigzag a bit in the middle of the squares and do not meet at the top. Thus the

Frank Stella, *Les Indes Galantes*, 1962, alkyd on canvas.
Courtesy Leo Castelli Gallery, New York.

central diamond is open at the apex, and instead of a box at the center of each square there are three triangles. The slightly asymmetrical placement of the picture-plane diagonals complicates the geometry of the composition, and the complication is increased by the fact that the square on the left is in color and the one on the right consists of gradations of gray, and this may stimulate the viewer's interest.

In regard to color, Stella seems to have followed his decorator's instinct. From the can't-go-wrong all-black paintings of his early period, he shifted to the seductive sheens of copper and aluminum paint, to the eloquent simplicity of unmodulated rust, yellows, and blues of some of his shaped canvases, and, finally, to the overluscious candy-box lavender, salmon, lemon, lilac, and apple-green fluorescent hues of his "protractor" series. With his delight in patterns, his cocktail-lounge taste in color, and his shrewd comprehension of how deviation and disruption add piquancy to repetition, Stella appeared in his retrospective as a gifted designer, of whom it could be said that, allowing for the fact that the edges of his shapes are not actually ruled, he has been working well within the tradition of geometrical abstraction.

Such a modest estimate of Stella's accomplishment would, however, ignore the new formalist aesthetics that overtook American Abstract art in the nineteen-sixties, and that, to quote Dr. William S. Rubin's catalogue of the retrospective, "has naturally encouraged a related mode of criticism." The role of ideology in Stella's painting is not a simple one, since the "related mode of criticism" constitutes not only the intellectual ambience of Stella's painting but his own thinking as well, and has thus entered into his paintings. (According to Rubin, Stella is even more formalist than Rubin.) In the dozen years he has been painting, Stella has managed, by means of ingeniously emphasized details (such as notching the rectangle of a canvas or allowing the oil of the pigment to "bleed" out on the surface), to link the noncommittal shapes of geometry and the methodical paint application of the signpainter to concepts, episodes, and personages of recent American art history and to set up a position of his own with respect to them. In short, Stella's natural talent for ornament is secondary to his aptitude for engaging in visual debate with predecessors and contemporaries. For example, "Jasper's Dilemma," with its illusion of receding boxes and its mirroring of colored bands in gradations of gray, translates the paintings of Jasper Johns into unresolved issues concerning the representation of three-dimensional objects on a flat surface, and Johns is presented with a "dilemma" that critics who admire his

paintings are invited to take into account. Thus Stella's exercises in harmonizing squares, diamonds, and triangles are at the same time painting as art criticism—an instance of the tendency in contemporary art to produce visual-verbal hybrids. (See Chapter 5, "Art and Words.")

Response to Stella's paintings is divided between those who grasp (and accept) their art-critical content and those who simply look at them as wall decorations. This is not unusual; a good deal of twentieth-century painting is painting as art criticism. What distinguishes Stella's work, in addition to its visual qualities, is the particular kind of criticism that the pictures represent. Stella's commentary art is far removed from such famous examples as Duchamp's Mona Lisa with a mustache, the historical pastiches of Dali, and Rauschenberg's erased de Kooning. Like Rauschenberg and Johns, Stella began with an inventory of the formal and technical characteristics of Abstract Impressionism, but instead of contradicting abstract art by resorting to popular images—as, for example, Johns's targets, flags, and numbers—he took the direction of pure abstraction. He wished to negate not only the content of Abstract Expressionism but its gesture, too, which Johns and Rauschenberg had imitated. Stella's response to postwar American art has been to reinterpret it in terms of strictly formal problems—such as depth and flatness, size, shape, texture, repetition—as if he were anatomizing de Kooning, Pollock, Kline, and Hofmann in a classroom. With Stella, the wit and destructiveness of Duchamp, the Dadaists, and the Surrealists are replaced by pedagogy. Even Rubin, himself a formalist and a professor, is somewhat taken aback by the rigidity of the artist's outlook. "To maintain Stella's own attitude in the discussion of his work," he complains in his catalogue, "would mean remaining almost entirely within the framework of formal criticism." Rubin had wanted to say that, confronted by the striped black pictures of Stella's debut, he was "almost mesmerized by their eerie, magical presence." Stella, however, would have none of this; he insisted that "in the striped paintings as a whole there 'aren't any particular poetic or mysterious qualities,'" and he ascribed their effects "to technical, spatial, and painterly ambiguities." If critics are going to talk

about being "mesmerized by eerie, magical presences" when they see a black surface with regular patterns on it, perhaps Stella is right to concentrate on the visible elements of the painting. A more disciplined use of metaphor by writers on art might prevent the starvation diet of formalism from seeming necessary.

In any case, each of Stella's decorations is also an illustration, in the sense of a textbook or lecture-platform diagram. To my mind, his only paintings that transcend chessboard aesthetics are some of the shaped canvases, such as "Effingham I" and "Moultonboro III." But to speak of drama in the collidings and penetrations of their masses and angles, comparable to those in the structures of Tony Smith, is to discover virtues in them alien to Stella's intentions. The ambitious element in his decorations lies not in their ability to move the spectator's imagination but in their exposition of conclusions about contemporary painting. Like formalists generally, Stella contends that "only what can be seen there [in the painting] *is* there. . . . What you see is what you see." It is on this ground that he rejects Rubin's "eerie, magical presences." But he does not reject equally invisible pedagogical "presences." On the one hand, he wishes "to make what is popularly called decorative painting truly viable in unequivocal abstract terms"; on the other, he maintains that his paintings are "so strongly involved with pictorial problems and pictorial concerns that they're not conventionally decorative in any way." Apparently there is decoration and decoration, and the difference between them is "pictorial problems and pictorial concerns." But though problems may arise in the way a line is drawn or the canvas is folded over the stretcher, the problems themselves have neither line nor form nor color. With Stella, "conventionally decorative" painting aspires to be something more through the invisible factor of the critical discourse that surrounds the paintings and provides the spectator with clues on how to "read" them; visually, they remain simply decorative. Depending on art-world discussions to raise them above ornament into art, Stella's compositions are the most professorial paintings in the history of art. The canvases of Albers may be more pedantic in exemplifying laws of visual perception; Stella's go further in expounding attitudes and pro-

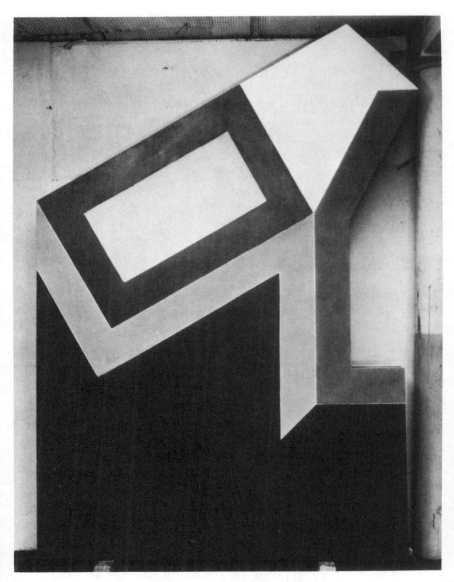

Frank Stella, *Moultonville II*, 1966, flourescent alkyd and
epoxy paint on canvas.
Courtesy Leo Castelli Gallery, New York.

cedures. "For a painting to be successful," he says, "it has to deal with problems that are always given to painting, meaning the problems of what it takes to make a really good or convincing painting." Artists of the past have said that there are no problems in painting, only solutions. Stella belongs to a period in which the problems of painting keep painting alive and make decorations into art. One step further and the paintings can be abandoned for the sake of the problems. Stella is a forerunner of conceptual art.

If words are part of Stella's paintings, Dr. Rubin's hundred-and-fifty-page catalogue, a staggering accumulation of the kind of formalist analyses that brought those paintings into being, is an essential part of the artist's work. In it, Rubin, appropriately, also exhibits himself; the voices of the artist and of the cataloguer echo each other, and they are joined by two other leading Stella experts—Professor Michael Fried, of Harvard, and Professor Robert Rosenblum, of New York University. Poring over each phase of Stella's activity with the attention that might be given to the Bill of Rights, the catalogue is the fabulous fourth dimension of the Museum of Modern Art retrospective. It envelopes Stella's calm and emotionally detached paintings in its obsessive purpose of appropriating the prestige and technical discoveries of Abstract Expressionism, purging it of the "Romanticism" and "rhetorical posture" of de Kooning, Pollock, and Kline, and converting it into a set of formal presuppositions that, according to Dr. Rubin, contribute "one of the few genuinely new paths for continued development of major non-figurative art." The most eloquent epithet for the new formalist discipline was supplied by Dr. Rosenblum, who spoke of a Stella painting as "a dizzying tour de force of aesthetic engineering"—a description which he meant to be flattering, and which could be accepted as such, except that, unfortunately, the phrase is reminiscent of Stalin's eulogizing of his academicians as "engineers of the soul."

Stella is inseparable from his critics. Yet in the last analysis the two species of aesthetic engineers, the art-critical

painter and the history-revising critic, contradict each other to an absurd degree. "All I want anyone to get out of my paintings, and all I ever get out of them," declares Stella, "is the fact that you can see the whole idea without any confusion." And again, "I wanted something that was direct—right to your eye . . . something you didn't have to look around—you got the whole thing right away." Of course, what goes right to the eye is Stella's simple patterns and colors, not his "pictorial problems." Artists, however, have the license to claim the opposite of what they have done, and if Stella's paintings are reduced to visual fact they are still often pleasing wall decorations. In contrast, here is a sample of how Rubin deals, page after page, with pictures the spectator is supposed to "get right away":

> "Conway I" is slightly more elaborate in conception than "Chocorua I." [Stella's titles are often embarrassingly "poetic" in the Sunday-supplement sense.] In the latter, the viewer is given some portion of all four sides of the rectangle and all three sides of the triangle in a *literal* manner—i.e., in terms of the framing shape of the field itself. The same is true for all four sides of the dominant rectangle of "Conway I." But of the smaller parallelogram that interpenetrates that rectangle, we see parts of only three sides in literal terms. The missing side is implied by those literally given, but exists *only* in depicted form. Seeing the silhouette of the picture alone, one would tend to complete the three-sided form at the bottom as a parallelogram. But the exact size of the parallelogram is not literally determined, as are the triangle and the rectangle of "Chocorua I." In fact, the eye might well assume completion of the parallelogram at a point less high than it is actually depicted in "Conway I."

This goes on for another page; then Rubin is joined by Stella, who discusses "color-value gradation." The viewer who may have thought he "didn't have to look around" would by this time have left. Obviously, looking, including "assumptions" of the eye, has become a professional matter, calling for at least as much skill as painting. Fried's rhetoric is even more impacted than Rubin's. He scratches away at a painting as if it were a bit of bone found in an archeological dig. Rubin credits Fried with having "distinguished between the 'silhouette of the support,'

which he characterized as 'literal shape,' and 'the outlines of elements in a given picture,' which he called 'depicted shape.'" In the face of a distinction between literal and depicted shapes, "eerie, magical presences" begin to seem like solid flesh. Our good doctors vie with each other in a professionalism designed to restrict forming opinions about paintings to those who have signed an aesthetic loyalty oath. Artists whom the new critics favor are credited with an incredible unerringness: "in this painting Stella succeeded in making ten different Day-Glo hues function together." I find it impossible to believe that any artist can be right to that extent—or that, except in the sixties, he would have wanted to be.

The basic dynamism of the "new path" in Abstract art is the clash of critical interpretations: Rubin's catalogue contains the amazing innovation of six pages of argument with another critic—an attempt to rebut Fried's theory about Stella's design and the influence of Newman upon it. Are the striped patterns constructed from the edges inward or from the center outward? With "pictorial problems" of this sort to solve, painting itself has become an adjunct of aesthetic theology. Most likely it was in an attempt to separate himself as a painter from his critical partners that Stella plaintively declared, "When I'm painting the picture, I'm really painting a picture. I may have a flat-footed technique . . . but still, to me, the thrill, or the meat of the thing, is the actual painting."

To go directly from the university fine-arts classroom to the museum is the common ambition of art students today. The secret of this passage, to judge by the example of Stella, is the capacity of the student to give body ("the meat of the thing") to the shared beliefs of his teachers of art history. Rubin notes the interesting fact that "Stella is one of the first major painters in the modern tradition to have been formed virtually entirely through the practice of abstract art," which amounts to saying that he skipped dealing with nature and the imagination and devoted himself entirely to problems. The peculiarity of the

pedagogical audience is that it has a quasi-official standing, comparable in its influence upon the production and acceptance of art to that of representatives of a cult or the state. It is this collective authority that sped Stella to the Museum of Modern Art.

The young master is a new phenomenon in American art—at least, in that portion of it known as experimental or avant-garde. For talent to find its form outright a tradition is needed; when this is present, the artist, as the sculptor Phillip Pavia archly put it in a recent talk, "can let his friends do his thinking for him." The United States, however, has had no tradition in painting, or too many traditions, which is the same thing. Its closest approximation to a tradition has been the academy and commercial art, and it is to these fields that gifted art students have in the past been attracted. The American, from Allston to Gorky, who searched for genuine art has been fated to spend half his life in blind alleys; often it required a second "birth" to get him out of them. One thinks of the radical break in the careers of Rothko, Guston, Gottlieb, Kline—a break with the decisiveness of a conversion. The indispensable qualification of the creators of American art has been longevity. Our national personification of the creative adventure has been not the genius in his teens, a Rimbaud or a Keats, but the "good gray poet," beard included, who wrote bad verses for Brooklyn newspapers until, in his early thirties, he heard the song of himself. In the "Nineteenth-Century America" exhibition, at the Metropolitan Museum in 1970, there was a painting by Elihu Vedder, called "The Questioner of the Sphinx," done in 1863, depicting a pilgrim with his ear to the lips of a giant Egyptian head half buried in the sands; it symbolizes the lifelong effort of the American artist to find out. In America, what Joseph Chiari wrote about Symbolism (that it calls for "the realization of the individuality of the artist through progressive self-discovery in action, without preconceived ideal or set purpose—social, religious or otherwise") applies to every artist who is more than a craftsman. With his confused culture and his training which is inevitably irrelevant, the American creator has needed, as Wallace Stevens wrote in his confessional "Comedian as the Letter C":

to drive away
The shadow of his fellows from the skies,
And, from their stale intelligence released,
To make a new intelligence prevail.

Self-discovery has been the life principle of avant-garde art
—not merely of Abstract Expressionism and Action painting
(which the new critics keep castigating for their "egotism")—
and no project can, of course, be more time-consuming than
self-discovery. Every step is bound to be tentative; indeed, it is
hard to see how self-discovery can take less than the individual's
entire lifetime. Stella seems to have been dimly aware that the
question of who the artist is plays a part in what he does. Ap-
parently, however, he has seen no connection between this
question and the need to make a "new intelligence prevail." In a
comment of astounding casualness, he considers that he solved
the problem of self after five years of work. "Up through the
purple paintings," he says, "my pictures were definitely involved
. . . with the problem of establishing a painterly identity—what
it is to be a painter and make paintings—and with the subjective,
emotional responses to that situation. I don't think any painter can
get around this. It has finally to do with the way you see your-
self. What you do, and the world around you." Having indicated
that the question of identity was disposed of by Stella in 1963,
presumably when he began to obtain recognition, Rubin goes on
to discuss the artist's decision to use metallic pigments.

It is inconceivable that Cézanne, Matisse, or Miró could
have qualified for a retrospective in a leading museum after their
first dozen years of painting; certainly Gorky, Hofmann, Pollock,
and de Kooning did not. For a coherent body of significant
paintings to spring directly out of an artist's early thoughts, a
new intellectual order had to be instituted in American art.
Rubin claims that Stella's paintings "have revealed their deep
and manifold roots in the tradition of modern painting." No
doubt he is speaking of this tradition as it is reflected in black-
board diagrams of postwar art history. But the tradition of
modern painting itself lies outside the classroom.

12 / Liberation from Detachment

Philip Guston

In his 1970 paintings of Klansmen, Philip Guston returned to picture-making; that is, to an art able to get along without words. After twenty years of Action paintings that evoke ambiguous shapes out of rhythms of brushstrokes and flakes of color, Guston offered an easily understood scenario of political doings. The setting is supplied by "City," a pink-and-red painting of a receding series of crudely shaped mounds with vertical dark flecks to indicate windows. This city rises out of an unlocated plain, and its color and desert look put me in mind of Dashiell Hammett's *Red Harvest*, which also dealt with a place where crime was mixed with politics. The buildings of "City" are a children's-drawing version of the Renaissance architecture in the background of Guston's paintings of the forties. Drawing like a child is a recently acquired talent for Guston, and his new crudeness has an important expressive function: it enables him to give a simple account of the simple-mindedness of violence. His metropolis is patrolled along its borders by "characters" who are triangles or pyramids (with pairs of parallel strokes for eyes) and who, by this association with peaked hoods, become members of the Ku Klux Klan—in accordance with the principle of converting abstract shapes into familiar presences by which the bands of Jasper Johns become the American flag. In "Outskirts" these figures seem to surround the city, and in "City Limits" and "Edge of Town" groups of two or three of them ride around

in automobiles that resemble those in sidewalk drawings. The Klansmen have thick hands that at times are heavy work gloves, and some smoke fat cigars, though their hoods have no mouths. The menace of the patrols is conveyed by the businesslike expressions of the masks, the massive hands, the complacent cigars, the pointing forefingers, the two-by-fours with protruding nails carried in the rears of the cars. Inside the city, the hoods hold meetings, conspire in closed rooms, confer with the sheriff, and achieve their daily quotas of victims—symbolized by segments of male legs and piles of shoes with their soles up. In the end, the Klansmen are confronted by evidence of their evildoing and are accused by a pointing finger. As usual with Guston the titles of the paintings are laconic—"Riding Around," "Bad Habits," "A Day's Work"—in the manner of old postcards or early movies.

In the new paintings, Guston has revolutionized both his style and his conception of painting to a spectacular degree. His earlier large exhibition in New York, at the Jewish Museum in 1966, consisted of reiterated interweavings of soft strokes of gray and black, occasionally lighted from underneath by touches of rose or blue. Guston's concern at the time was exclusively with questions of painting, from what creation in painting really means to the final question, "Why paint?"—an inquiry carried on through a continual erasing and repainting, until gray was the ultimate result. Yet to "return to the object"—that is to say, to recognizable images, as some former Abstract Expressionists had done—struck Guston as "intolerable." Only those forms were real, he contended, that came into being in the act of painting. To paint preconceived images was to paint interpretations, not realities. Thus Guston's introduction of political symbols into his compositions amounts to an about-face. In Action painting, the experience on the canvas is *the* experience. The work is not a means of communication; it is the event itself, a piece of history, a rival of social action. In contrast, the political subject is "out there," in society, and the painting is a second occurrence, which corresponds in the artist's mind with what has already taken place in the world. Put simply, Action painting is not *about* anything, while Guston's present paintings are.

The "scandal" is not that this leading Abstract Expressionist

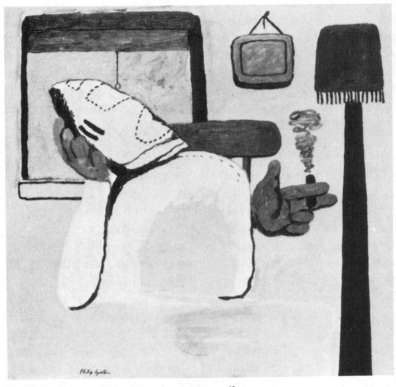

Philip Guston, *By the Window*, 1969, oil on canvas.
Marlborough Gallery, New York.

has introduced narration and social comment but that he has done his utmost to make problems of painting seem secondary. Line, color, form, even the tensions of creation, are handled, as it were, casually. In an interview in 1966, Guston declared, "I like a form against a background—I mean, simply empty space," but he added the reservation that "the form must emerge from this background. It's not just executed there." In the current paintings, the reservation has been discarded, and the forms are often inscribed on the surface in the manner of drawings on a fence or blackboard. Problems of space are reduced to shape and placement. Through this simplification—Guston has always been concerned with locating his figures—the scene, the action, even

the choice of house furnishings (clocks, light bulbs, wall hangings), are pushed into the foreground of attention, as in narrative painting generally. Yet the playing down of form is of course deceptive. A painting such as "By the Window," with its balancing of squares, triangles, and rectangles, and its distribution of reds, green, and gray, is a triumph of formal ordering. "Sheriff," with its impeccable arrangement of a few simple outlined shapes and some strokes and bands of color, is a far more abstractly conceived work than anything in Guston's earlier phases. Guston's overt treason against "painting as painting" (the title of a show in which he participated in 1968) is a ruse to spotlight his new conviction that painting needs more than itself.

For all their differences in aim, Guston's political paintings by no means represent the complete break with the past made by other Abstract Expressionists. If "Flatlands," a spatially indeterminate landscape littered with Guston's present repertoire of symbols, from the hoods to the upturned soles, resembles nothing this artist has ever painted before, many of the new canvases retain interesting continuities with his earlier work. In total impression, the paintings—especially some of the larger canvases—maintain, probably through Guston's unique bluish gray and his manner of paint application, what amounts to a family resemblance to their predecessors. "Blackboard" is one of his familiar abstract landscapes with a trio of Klansmen framed inside it. His nervous line reappears in the contours of his new figures. In terms of composition, perhaps half the paintings recall—despite the change in imagery—his characteristic bunching of forms toward the center of the canvas and his reduction of density along the sides. The hood figures of "Downtown" are modeled in Guston's customary loose brushing, and the distribution of lights and darks in this painting (though it is more spread out) is not dissimilar to his nineteen-sixties paintings. "Edge of Town" and "Dawn" are particularly remarkable incorporations of the new pictorial material into the old over-all image, and the formal tension between new and old adds to the drama of the revised style.

The idea of action has permeated Guston's work from the

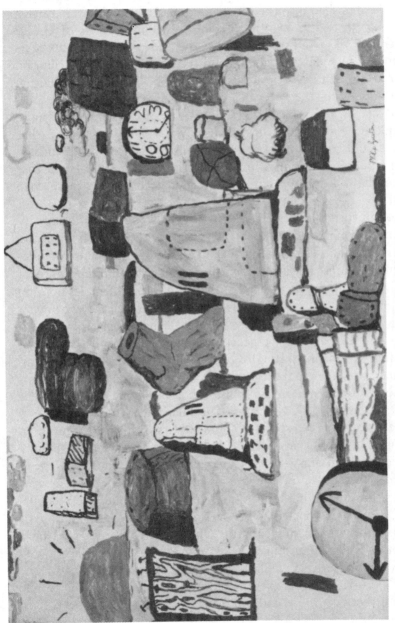

Philip Guston, *Flatlands*, 1970, oil on canvas.
Marlborough Gallery, New York.

start; two of his earliest paintings are of Klansmen with whips, and his major compositions of the nineteen-forties represent children in masks playing heroic roles. In his Action paintings of the sixties, Guston thought of the black rectangles floating

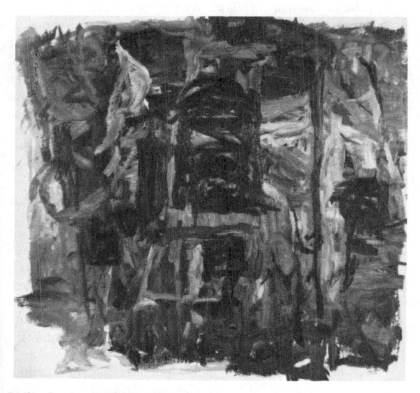

Philip Guston, *Close Up III*, 1961, oil on canvas. Collection Mr. and Mrs. Lee Eastman.

in smoky-gray fields as heads, or personages, engaged in obscure adventures, as is indicated by such titles as "The Tale," "Stranger," "Accord," "The Actors," "Traveller." The Ku Klux Klan triangle-pyramids decorated with dotted squares convert those poetically animated rectangles into insignia of actors with a

specific identity and social history. With Guston, the transition from Action painting to political painting occurs through the substitution of the socially defined mask for the unique sign evoked on the canvas.

To fill the gap between metaphysical and political art, Guston has drawn on several modes of descriptive draftsmanship —Pop, the comic strip, *art brut*. Aspects of his Klan series (for example, the raw, shapeless landscape of "City") converge on Dubuffet, others (the big shoes and skinny striped pants of "Courtroom") on Red Grooms's puppet movies. The most vital new element, however, comes from Guston himself—from the extraordinary caricatures he has been producing for years but until now has excluded from his paintings. By such examples as Goya, Daumier, Rodin, Picasso, caricature is the supreme art form for political comment, and in calling on this resource Guston has got together with himself. Perhaps this accounts for the lightheartedness of the paintings, despite the grimness of its theme. Guston's gift for caricature endows his triangles with a comically expressive mimicry: the hoods are determined, menacing, reflective, noncommittal. In "Meeting," they incline toward one another and can almost be heard whispering. In "Daydreams," one covers his eyeholes with his fingers, smokes a cigar, and projects a comic-strip-balloon fantasy of his booty of shoes. Guston's massive forefingers point, meditate, accuse. The main figure in "Sheriff" is a rounded outline of a large square head, seen from behind, that resembles Guston's caricature of Ad Reinhardt done a dozen years ago.

Guston's temperament is not a political one. His natural bent is toward sensitivity and elegance, toward the artistic, though with a conscious, strong-minded resolve to resist facility and seductive painting. In the social-realist thirties, Guston's paintings touched politics only at a tangent; they avoided picket lines and dust bowls and translated combat into myth. I suspect that it is for refreshment as an artist, rather than as a partisan of social ideals, that he has abandoned his Abstract Expressionist experiments, which had become increasingly austere. The Klan is not a central issue in politics today, and Guston's reversion to it as the personification of violence and tyranny puts politics at

a distance. This separation makes the Klan more manageable as a symbol of terror than would be such contemporary manifestations as Vietnam, the Black Panthers, and the Chicago police. The Klan hood exists on the border of myth as at once symbol and fact. If art and politics are to meet, it must be in some such mid-region. In regard to aesthetic timing, Guston's Klansmen are analogous to the nineteen-thirties Chrysler Airflow, which Oldenburg chose as a motif, and the outlived "modernistic" design adapted by Lichtenstein.

Nor do Guston's new political reveries eliminate his ancient debate with painting, its reasons for being, its probabilities of survival; the artist himself humorously confesses his inability to escape this obsession through a canvas of a Klansman painting a self-portrait. (He has even done a painting of a paw holding a brush, as if to say, "Under any conditions, still a painter.") It might be argued that finding art problematical is itself a form of political thinking, in that it considers the kind of society which makes art difficult to practice and value. In the last analysis, Guston's paintings are political by way of their thinking about art and do more for art than for politics. They appear at the beginning of a decade in which a pressing need has arisen for a new outlook on art—one that will end its isolation from the crises of the time. The recently influential formalist conception of High Art, pledged on principle to refuse to take note of the destruction of the planet, seems thoroughly played out, and with it the dialectics of an increasingly self-purifying abstraction. On the other hand, the anti-form earth and raw-materials projects that have been presented as the antithesis to color fields and minimal sculptures have reduced themselves to an endless lecture on counter-aesthetics.

In the face of the mounting pace of social and political upheavals, the program of shunning political fact in art has resulted in increasing frustration. Artists stirred by social indignation have found themselves locked in a medium that has lost its voice. Politics among artists has consisted of accepting a package of ready-made issues—peace, civil rights—while renouncing the ability to contribute to an imaginative grasp of the epoch. Artists have protested, but not their art—they have signed the

attendance record but have been present in name only. Both in the United States and abroad, art has been denounced by the New Left as part of the system for preserving the status quo. (See Chapter 18, "Confrontation.") Guston's Klansman painter may hint at a similar charge; the assassin, too, is an artist. As in the thirties, there have been calls to abandon art in favor of political action. In 1970, in connection with Art Strike, the sculptor Robert Morris felt obliged publicly "to underscore the need I and others feel to shift priorities at this time from art making and viewing to unified action within the art community against the intensifying conditions of repression, war, and racism in this country," and he voiced the suspicion that Abstract art is probably middle-class and racist. Radical youths abroad have attacked international exhibitions of painting and sculpture as phenomena of the consumer society, and confrontations, rock festivals, and guerrilla theatre have seemed more pertinent than ideas and works conceived in the studio.

The separation of art from social realities threatens the survival of painting as a serious activity. Painting has, of course, other interests than politics, but a too-long immersion in itself has infected art with ennui. Painting needs to purge itself of all systems that place so-called interests of art above the interests of the artist's mind. Abstract Expressionism liberated painting from the social-consciousness dogma of the thirties; it is time now to liberate it from the ban on social consciousness. Guston has demonstrated that the apparent opposition between quality in painting and political statement is primarily a matter of doctrinaire aesthetics. He has managed to make social comment seem natural to the visual language of postwar painting. Other contemporaries have done political pieces for special occasions—Newman for an anti-Daley exhibition in Chicago; Segal, Grooms, Elaine de Kooning, and others, for a politics-today exhibition at the New School. Guston is the first to have risked a fully developed career on the possibility of engaging his art in the political reality. In doing so, he may have given the cue to the art of the nineteen-seventies.

Part Three / America and Europe

13 / Europe en Route

An exhibition of "European Painters Today" in 1968 at the
Jewish Museum was typical of current survey shows in which
trends and personalities are spotlighted as representative of a
given time and place. Smaller than the usual international exhibi-
tion, "European Painters" was perhaps for that reason slightly
superior in quality. Some fifty artists were included—not exactly
a handful, but a modest sampling by the 125-150 which is
standard for an American annual at the Whitney. Besides cov-
ering many countries, the Jewish Museum exhibition postulated
that "today" includes artists born before the beginning of this
century—and four who are no longer alive. To choose a
relatively small number of painters from such an extensive span
of time and nationality required an impressive authority. The
Mead Corporation, an American business firm that sponsored
the "European Painters," obtained for this most ambitious of its
artistic ventures the services of four leading museum directors of
Europe, plus two former officials of the Jewish Museum itself.
The exhibition was therefore at least as representative of
museological thinking about art today as it was of European
painting today. Three of the Europeans—among them K. G. P.
Hultén, who organized "The Machine" exhibition at the Museum
of Modern Art (see Chapter 14, "Past Machines and Future
Art")—were cited in an article by the French avant-garde critic
Pierre Restany as personifying the new "dynamic museum"

that is destined to rescue art from extinction by replacing the old repositories of masterworks with laboratories conducting experiments with up-to-date technology and information techniques. It is this concept of the museum as both participating in the life of the times and reflecting the times in its mirror of machine-aesthetic enlightenment that had been responsible for the disastrous "Harlem On My Mind" display at the Metropolitan.

Fortunately for the Mead Corporation and the Jewish Museum, the "living museum" idea was held down in their exhibition to one neon-light composition, and the combined avant-gardism of the six museum representatives resulted in nothing worse than aimlessness. As an indication of what is happening in European painting, it neither opened any new doors, nor was it convincingly typical of the best that was being done. The familiar advanced modes were sampled, mainly in works by artists who had been shown regularly in the United States for years: Kinetics (Bury), Op (Riley and Vasarely), reflected light (Mack, Jaquet), shaped images (Stroud), Pop (Arman, Raysse, Fahlström), Surrealist (Magritte, Yves Klein, Matta), Abstract Expressionist (Soulages, Tapiès, Appel), Geometric Abstraction (Soto, Dorazio), Minimalist (Richard Smith, Denny). Some of the less well-known artists, such as Monory, Dado, Raynaud, could easily have been left home and half a dozen better ones brought in their stead. A large percentage of the "European Painters" were actually sculptors, makers of free-standing pieces, assemblages, and reliefs.

The exhibitors were chosen as if deliberately to arouse disagreement: if outstanding dead artists like Magritte, Fontana, and Klein were included, why not Giacometti, Duchamp, Matisse? If Sugaï (born in Japan), Kitaj (born in the United States, and at that moment working on the West Coast), and Soto and Matta (born in Latin America), are "Europeans" why not Le Parc, Riopelle, or even Joan Mitchell, who had been painting in Paris for more than a decade? And why not such totally indisputable, living Europeans as Picasso, Miró, Masson, Hélion, Chagall, Balthus, Matthieu, or—to take an example from the younger generation—Bauermeister? Such strictures, however, are as futile

Arman, *Accumulation Renault, No. 118*, 1967, object, wood, plexi-glass.
Galerie Ileana Sonnabend, Paris.

Lucio Fontana, *Concetto Spaziale*, 1960, oil on canvas.
Marlborough Galleria d'Arte, Rome.

as they are inevitable. "European Painters Today" did not stand for anything except the pictures in it. It affirmed no particular values and conveyed no sense of direction; anyone who derived a "message" from this assembly of works would have to assume responsibility for it himself. Indeed, the absence of a ruling concept might well have been the show's chief virtue; it reflected the uncertainty in the situation of painting today. By including Surrealist and Expressionist painters, the exhibition overcame the rigidity of comparable surveys of contemporary art by American museums.

Among the interesting items were Magritte's "La Folie des Grandeurs," done in 1961, which is a reverse visual play on the phrase "too big for his britches;" here it is the "britches" that are too big: the central figure of the painting is an earth-colored nude Venus divided into three graduated segments stacked like flowerpots while the *folie* consists of the "*grandeurs*," or enlargements, that take place in the descent from the neck to the groin; grandeur as a concept is symbolized by huge geometrical blocks in the background.

By far the largest painting in the exhibition (almost ten feet high by thirty-three feet long) was Matta's "Watchman, What of the Night?" in which this artist, one of the few contemporaries to affirm a conception of modern man, elaborates his pungent comic-strip drawing and furnace-room colors into a block-long inferno, or underground concentration camp, of hostile mechanical processes; the huge expanse of the canvas somehow manages to intensify the sense of confinement generated by Matta's cavernous space (appropriated by Gorky in his great *grisaille* "The Diary of a Seducer"), as if his robot factory, in growing bigger and busier, had also become more crowded.

Another painting in a scale usually regarded as "American" is "Painting, May 9, 1968," by Pierre Soulages, an artist well-known in New York. Soulages is related to American art through sharing the potent magical formula of the Action Painters ("What I am making teaches me what I am looking for"); as against the force and tension generated by this search in Kline and de Kooning, it brought forth in Soulages an image that is

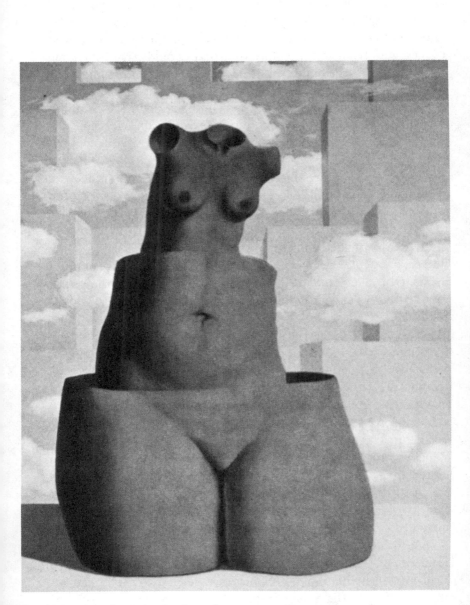

René Magritte, *La Folie des Grandeurs*, 1961, oil on canvas.
Galerie Alexandre Iolas, Paris.

noble, gentle, and meditative. The bands of Soulages's earlier paintings function as planes that build a structure inward from the picture surface, rather than as trackings of energy, as in Kline, and the brownish sheen of his blacks suggests building beams and blocks in an interior light, in contrast to Kline's ragged flights across empty space. In "Painting, May 9," the artist has abandoned his band constructions for a lateral progression of five flat vertical black masses on an almost effaced white ground (it would be interesting to compare this work with the serial paintings of Toti Scialoja, an Italian artist not included in the show).

Fontana's perforated, painted canvas is also an unusually large one; although the artist (who had died the previous year) called himself a "spatialist," his gouging holes in his canvases has always seemed to me a Dadaist nose-thumbing at the formalist dogma of "preserving the integrity of the picture plane." With his punctures Fontana transformed his paintings into a species of relief (they are sometimes referred to as sculptures). Another non-painter in the exhibition was Arman, who specializes in assemblages of familiar objects. His entries consisted of an arrangement of plastic handles on a board and an example of his attractive series of blocks of Plexiglas containing dripping paint tubes. Sculptures rather than paintings are also Uecker's circular compositions of nails driven into canvas on wood; they arouse the pleasure of recognizing a familiar image produced by unfamiliar means. Raysse, seen frequently in New York, is a Pop gimmicker who has tried everything from inflated rubber tubes to real bathing beauties on artificial sand: his "Double Portrait," a free-standing cutout of a wall of simulated bathroom tile in the shape of a head on which hangs a bath towel bearing the portrait of a woman, was an imaginative advance over his earlier work. Karel Appel, who went through a period of unbelievably bad Pop assemblage, happily returned to painting in "Personnage," which has an affinity with Dubuffet's "L'Hourloupe" series. (See Chapter 7, "Primitive à la Mode.") Bacon's "Henrietta Moraes," Bridget Riley's and Vasarely's eye-teasers, Fahlström's untitled panorama, Klein's all-blue painting, Kitaj's abstraction-*cum*-Symbolism, Bury's tangle of nervously twitch-

ing wires, Dorazio's patterns of interlaced color strips, Richard Smith's shaped canvases, and Peter Stroud's patterns on angled masonite were typical examples of these artists' recent showings. Friedrich Hundertwasser, a Viennese Expressionist who favors strong reds and blues, had not been seen much in New York. Horst Antes is a German who paints curiously curtailed human figures in colors close in feeling to Hundertwasser's. Among the newcomers, Dado was a horror fantasist in the mode of Ivan Albright, and Jacques Monory in "Murder II" offered indifferently painted filmstrips in which a man, his eyes banded to prevent identification, falls to his knees clutching his stomach. Konrad Klapheck, a German who was also included in the Museum of Modern Art's Dada-Surrealism exhibition, paints precisionist machines whose meaning he attempts, ineffectually, in my opinion, to enhance by the Dadaist device of suggestive titling. (The catalogue weakened his effort still further by translating "Der Wille Zur Macht" as "The Wish for Power.")

In sum, "European Painters Today" was an exhibition of mixed value, worth seeing, while one wondered whether six experts were really needed to assemble it. No doubt, the answer lay in the "Europe" *of the title*, which created the need for a weighty authority, not only to make the choices but also to have the power to assert that a specifically European art exists, as referred to above, distinct, for example, from American art— to declare that Europe today is more than a mere address where certain artists can most frequently be reached, as others can in New York.

One of the organizers of "European Painters," M. François Mathey, chief curator of the Museum of Decorative Arts of Paris, undertook in an introduction to the catalogue to suggest what made the exhibition European. He succeeded only in demonstrating that the subject is one he would have preferred to let alone. In that opaque rhetoric of speculative half thoughts which the official art world has fabricated as a substitute for analysis, M. Mathey, recalling that "the richness of current art depends on its seeming contradictions and antagonisms," concluded that it is precisely these contradictions that are "the permanent sign of the humanism" (the word "humanism" was

unaccountably omitted from the translation of his piece in the catalogue) that is "the salt of the European spirit." Since European art has no monopoly on contradictions, their presence is hardly sufficient to differentiate it from art elsewhere. M. Mathey also spoke of an "invisible Europe," independent of geography, which believes in an "undivided heritage"; and he pointed out that no matter what their differences and conflicts, artists everywhere recognize one another—which would suggest that continents don't count. Reverting to the "dynamic-museum" theme (M. Mathey is one of the vanguard curators mentioned by Restany), he declared that the artist accepts his time and does not condemn industrial society or rebel against it. and that his wish to take part in the development of the world is confirmed by the "encounter," of the European and American vanguards. By this account, there is nothing to prevent European art from blending into anything that is technologically advanced.

In a weighty article entitled "Europe, With and Without Europe," which recapitulates the story of avant-garde art since the nineteenth century, M. Marcelin Pleynet, in *Art International*, took issue with the relaxed vanguardism of the "European Paint- ers Today" exhibition. To Pleynet, the show was of the first importance as a symptom of what is wrong with contemporary art as well as with contemporary art criticism. The vice of "European Painters" lay not in its eclecticism—on the contrary, Pleynet discovered in it an almost perfect coherence—but in its shallow concept of "Europeanity." If the organizers of the exhi- bition did not hesitate to include in it artists who had been born outside of Europe, who had studied and worked elsewhere, and who had been influenced by non-European "researches," it was because they made their choices according to an aesthetic alien to the traditions and schools essentially European. In that aes- thetic, shared by most of the painters, works are conceived apart from the theoretical currents in which they originated, as if each were a meaningless anecdote devoid of intellectual force. The chief inspirer of "anecdotalism" in art is the United States, whose history of vanguardism is too brief for it to have absorbed

the basic principles of modern art values—Mondrian, Pleynet reminded his readers, arrived in New York on October 3, 1940. For Americans, Cézanne, Matisse, Kandinsky, Picasso, Mondrian are pre-history; for Europe they are "its most recent production." A "European aesthetic" would find its way back to European art history in order to grasp the theoretical basis of its accomplishment, which consists in its evolution of "pictorial space."

Instead of applying this European standard, the "European Painters" exhibition embraced a consistent anecdotalism. Therein lay its failure, and the emblem of this failure was placing Magritte, who had he lived would be seventy, at the chronological head of the list of painters today, while omitting Miró, who is still alive. For Pleynet, the elevation of Magritte represented a decisive aesthetic choice by the Six, and a perverse one. According to formalist doctrine, Magritte, since he contributed nothing new to pictorial space, is a mere painter of irrational picture postcards, who not only has no place in the art of the late sixties but hardly deserves to be accredited to the twentieth century. The aesthetics that accepts Magritte, Pleynet maintained, is consistent in excluding not only Miró but other artists—such as Giacometti, Hartung, Ernst, de Staël—who had carried the weight of the European cultural heritage in painting. The choice of Magritte, he concluded, was made "against Miró," in order to "program a 'today' of European painting seen from a place which is no longer Europe. The Europe with which we are presented is already dreaming, if one may say so, of its planned trip through America."

Pleynet's "anecdotalism" is a significant way of describing the tireless variations on the artifacts of modernist styles which constitute the great bulk of contemporary painting and sculpture, particularly the work prominent in the past ten or fifteen years. The term has the additional virtue of evoking the garrulousness of old age recollecting events of its livelier days—the condition now reached by advanced art after sixty years of revolt. Most of the items in "European Painters Today," as in almost any other contemporary group show, amounted to nothing more than recent episodes in the history of ideas long accepted in

twentieth-century art. The same kind of directionless fabrication is evident in new art throughout the globe, it is undoubtedly an effect of the deluge of reproductions of works, new and old, unaccompanied by the thought that went into the creation of their originals.

Pleynet was not content, however, to charge anecdotalism to modern conditions and modern culture. In his attempt to formulate a "European aesthetic" qualitatively and intellectually different from that which governs art everywhere, he found it necessary to palm off the universal superficiality of anecdotalism on American art (which is certainly not immune to it). Through reasoning he himself recognized as "labyrinthine," he found a way to hit America at a point within his reach; that is, by an attack on European painters. His attribution of the weakness of "European Painters Today" to American, or at least non-European, qualities, while he complained that the majority of European painters suffer from the same weakness, is in effect a resurrection in aesthetic terms of the old idea of the European cultural tradition and its corruption by transatlantic Coca Cola culture. What Pleynet overlooked is that it was the Europeans who introduced anti-art as a disintegrator of European traditions, and that the predicament of European art today is that not even the negation of European art values is any longer exclusively European. If younger American vanguardists, in their freshman enthusiasms, are inclined to forget that art as they know it originated in Europe and is not an invention of Rauschenberg, Judd, M.I.T., or even Jackson Pollock, and that therefore some kind of continuity with European thought is postulated as a condition for the survival of art, the European avant-garde has not ceased its striving to shed inherited values in all forms, including M. Pleynet's pictorial space circa Cézanne-Mondrian. "This year," boasted Otto Hahn, Paris critic, commenting on the French entries in the Venice Biennale the previous summer, "the French pavilion has eliminated everything, near or far, that could remind one of the School of Paris. . . . The modern era has erupted in the French pavilion."

Pleynet's "Europeanity" disregards European fact. It is nothing more than the familiar rewriting of art history accord-

ing to the ideology of formalist aesthetics. Ironically, the formalist approach today carries more authority in the U.S. than it does in Europe. (See Chapter 11, "Young Masters, New Critics.") Because of the semi-defection of the organizers of "European Painters Today" (through including Surrealists and Expressionists), Pleynet may have felt the need to shore up the crumbling simplistic dogma that painting is synonymous with handling of pictorial space. Granted that painting today consists in the main of episodic creations projected by principles no longer thought about, "spatial" painting is as anecdotal as any other kind, in being derived from Cubist, Constructivist, and Neo-Plastic artifacts detached from the social philosophies of these movements. (It is significant that Pleynet dates the beginning of American modernism from the arrival in New York of Mondrian, who had almost no influence in the forties and fifties, instead of from Breton, Ernst, Duchamp, Miró, Matta, Léger, Masson, whose outlooks affected the mainstream of postwar American art.)

Whatever one thinks of the inclusions and omissions in "European Painters Today," the organizers of the exhibition deserved credit for resisting the temptation to impose a factitious unity or a single direction on current European art. Acceptance of any degree of confusion is preferable to efforts, such as Pleynet's, to translate the imaginative variety of art into a single *problem*. ("The problem of ground/form-surface/volume," writes Pleynet, "is the key to every critical approach to contemporary painting.") The notion of an opposition between Magritte and Miró is an absurdity—a polemicist's fantasy of lining up art on right and wrong sides of an argument. Magritte and Miró have more in common than can be revealed by analysis of their handling of formal elements. One can prefer Miró to Magritte (and wonder why he was not included in "European Painters Today") and still appreciate the aesthetic validity of Magritte's bull's-eye coordination of surprising metaphors (the segmented Venus) into an affective image.

There may be occasional discernible differences between European and American art today, but there is no definable difference, particularly since art on this side of the Atlantic has

turned its ambitions toward the global museum. The same in-
gredients are being blended everywhere, though in dissimilar
quantities (the Europeans, for example, seem less interested in
semi-Pop spectacles and more dedicated to complex engineering
and electronics projects). The inattention to the philosophies
and outlooks behind modern styles, European and extra-Euro-
pean, the dissipation of yesterday's vanguard ideas into aesthetic
episodes, have provided the basis for the rapid growth and
consolidation of an international vanguard academy, placeless
and timeless, and inspired by the fiction of continuing revolt and
novelty. Art is situated today in a mid-region of professionals,
to whom "Europe" is simply a theme around which to build
still another exhibition. Using alertness to prevailing tastes as a
substitute for an idea, the vanguard academy can dispense with
an aesthetic, or shift easily from one aesthetic to another. "They
are lost," says M. Mathey of his six *gens de musée*, "if they follow
museological criteria, which are cultural criteria and conse-
quently false." The twelve-eyed connoisseur who "personally"
chose "European Painters Today" was secure in the knowledge
that any choice he made could be justified, if on no other ground
than that it defied all intellectual frames of reference. To say
that an international academy exists may thus be another way
of saying that the modes of Western art have stabilized them-
selves beyond the need for theoretical identification. Having
attained this stage, works in these modes may confidently be
sponsored by government and business.

14 / Past Machines, Future Art

The latest object to achieve the status of an icon of twentieth-century art, alongside such ineluctable items as Duchamp's "Nude Descending a Staircase," Dali's "The Persistence of Memory," Man Ray's "Flatiron with Metal Tacks," Oppenheim's "Fur-Covered Cup, Saucer, and Spoon," Picasso's "Guernica," de Kooning's "Woman I," Rauschenberg's "Erased de Kooning Drawing," is Tinguely's "Homage to New York," the machine construction that destroyed itself in the Sculpture Garden of the Museum of Modern Art in the spring of 1960. Philosophers of culture may find significance in the fact that so many of the creations sacred to modernism embody destruction, either of objects or of earlier art. In this respect, Tinguely's contraption of wheels, pulleys, motors, smoke- and noise-making devices is not only the most recent of the elected aesthetic representatives of the century but the most nearly perfect: it has succeeded in not existing. What was left of it after its single performance was carted off as souvenirs by the Museum audience or returned to the dump whence it had come. Today, "Homage" lives on in the photographs made of its self-demolition, and these appear in book after book dealing with avant-garde art. Its latest manifestation was on the inner covers of the catalogue of the Museum of Modern Art exhibition, "The Machine as Seen at the End of the Mechanical Age." There it would seem to have achieved its fullest significance, since, obviously, nothing could more fittingly

serve as a monument marking the termination of the epoch of the machine than a machine built for no purpose but to commit "suicide" by smashing itself, blowing itself up, and drowning itself in the pool of the world's leading museum of modern art. Out of the world into art, and out of art into the avant-garde gesture.

Except for the suggestion provided by the Tinguely photographs, I am not sure I grasp what Dr. K. G. Pontus Hultén, the Stockholm museum director who organized "The Machine" exhibition means by "the end of the mechanical age." In his foreword to the catalogue, he asserts that "technology today is undergoing a critical transition"—a statement that seems indisputable but that would have been equally true when gas began to replace whale oil, or electricity steam. It has been argued that today's computer-managed presses and calculators are not machines in the old sense or are something more than machines, but even those who hold this view do not go so far as to deny that machines are still an important feature of the times. If the mechanical age is ended, we ought to be told precisely what it is that has ceased to be. Dr. Hultén finds it sufficient to observe that machines, which do the work of the muscles, are losing out to "electronic and chemical devices which imitate the processes of the brain and the nervous system." This McLuhanism is a rather flimsy basis for dismissing a whole epoch. My suspicion, after having seen the show, is that Dr. Hultén was not much concerned about whether the title of it is historically accurate; his purpose was aesthetic; his exhibition set the machine in the perspective of the past. Standing at the end of the mechanical age, the spectator was compelled to look backward at cameras and motorcars, even those of today.

The prevailing atmosphere was nostalgia. Following a chronological scheme, the exhibition presented drawings of early flying machines, eighteenth-century mechanical toys and robots, models demonstrating Archimedean principles, nineteenth-century posters and colored prints illustrating popular fantasies of speed and levitation—in sum, a kind of Patent Office display of technological progress. This appeal to the collective memory served as an introduction to works of twentieth-century art that took the

machine as their theme or model. Most of these paintings, drawings, and constructions emanated from the Futurist, Dadaist, and Constructivist movements, and they had been so repeatedly on display in recent retrospective exhibitions that, like the prints of early inventions, they aroused the feeling of another encounter with the past. Duchamp, Picabia, Ernst, Schwitters, Grosz, Hausmann, Man Ray were featured in the Dada-Surrealist survey at the Museum of Modern Art the previous spring; in "The Machine" show, works by them reappeared like acquaintances home from vacation. Another mode that has been receiving much emphasis is Constructivism, and the motorized, electronic, and lightand-sound items in "The Machine" recalled the roomful of similar contrivances in the Museum's "The 1960's" exhibition a year and a half earlier. Some of the Ballas and the motor-driven mobiles of Alexander Calder of 1932-34 had been less frequently seen in New York, but the exhibition as a whole was, and as if intentionally, as charged with memories as a family album. The mood of times gone by was enhanced by the catalogue's brilliantly conceived tin covers, which carry a picture of the Museum in metallic colors—like an old-fashioned candy box—and its format of double columns of block type and illustrations, which begin with Leonardo's drawing for a man-powered flying apparatus, symbol of technology's youth and hope, and conclude with Tinguely's smoke, chaos, and collapse.

In projecting the machines into a Proustean *temps perdu*, Dr. Hultén guaranteed them a quality of aesthetic expressiveness that automatically blended them with the works of art. The huge tires and flaring mudguards of the 1931 Bugatti, which was the outstanding presence in the show, seemed to have been designed as sculptural or even architectural ornaments rather than for use, and the narrow slits of its windshield and rear window summoned up a countryside in which it was less necessary to watch out for other speed demons than for meandering oxcarts. Floating through this landscape, the automobile could egocentrically admire itself as the peak of human inventiveness; Dr. Hultén celebrated the Bugatti Royale as "without doubt the culmination of the heroic period of the automobile, when optimism and confidence in this machine were still unclouded." The Bugatti

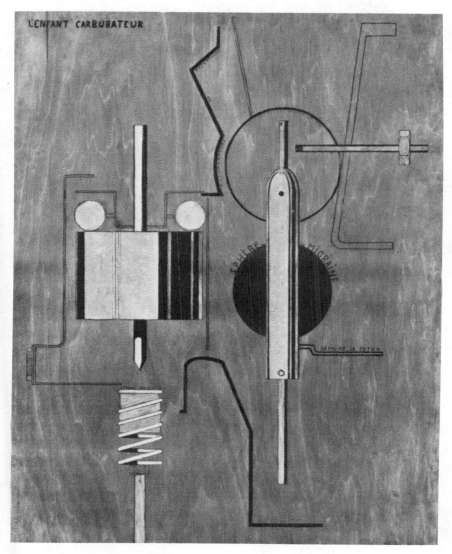

Francis Picabia, *Child Carburetor*, 1919, mixed media on wood.
The Solomon R. Guggenheim Museum.

Umberto Boccioni, *Untitled (Speeding Automobile)*, 1901, tempera.
Collection Automobile Club d'Italia, Rome.

brought to the Museum a vanished state of being as well as a vanished environment, and so did, even more explicitly, the 1901 painting by Boccioni in which a racing car careening at full speed is barely able to keep ahead of a pack of foxhounds and of hunters on horseback. Removed into memory, the automobile overcomes the handicap of its usefulness. By a process similar to that of the dream, it has been transformed from a machine into an aesthetic creation—an effect confirmed by the forty-year-old Bugatti's brand-new look, as if it had been kept on a pedestal from the beginning. One might risk the thought that in a museum, where their only function is to be seen, all machines exist at "the end of the mechanical age."

The history of the machine in art consists largely of the responses of artists to mechanisms of fantasy and to devices that are out of date or broken down or have changed into something else. Contemporary examples of such negations of utility are the vinyl typewriters and fans of Oldenburg, the corollary of which is the artist's emotional identification with the Chrysler Airflow of the mid-thirties. By crushing a new automobile in a press, the sculptor César has demonstrated that a factory product can be returned to the condition of raw material and reconstituted as a Cubist assemblage. Another idea of an art-making machine—Tinguely's "Meta-matic No. 8," which paints abstractions—harks back half a century to the sun-powered brush-wielding apparatus in Raymond Roussel's Surrealist novel, "Impressions of Africa," which turned out perfect copies of nature. In the vein of the machine that suffers breakdown, Dr. Hultén's catalogue pairs a photograph from the Surrealist magazine *Minotaure* of a locomotive decaying in a covering of vines with Ernst's painting "Garden Airplane Trap," in which the wings of an aircraft are being metamorphosed into vegetation. Dr. Hultén even adds an extra dimension of time to Duchamp's mechanistic "The Bride Stripped Bare by Her Bachelors, Even" by quoting an ingenious theory of his compatriot Professor Ulf Linde that traces the painting to the lore of alchemy in which undressing the maiden represents the transmutation of mercury. Artists have conceived

machines as metaphors for persons and for human actions—
Picabia's mechanical drawings labeled "Stieglitz" and "Marie
Laurencin" and his diagrams of amorous clockworks, Stein-
berg's drawings of machines dreaming of later models. The
humanization of the machine, in the form of mechanisms that
behave like human beings or of human beings that behave like
mechanisms, provides a major current of farce, terror, irony,
and mystery in modern art.

The Museum of Modern Art exhibition appealed to the
sentiment of yesterday. It also endeavored, however, to link it-
self to the future—to what must, I suppose, be called the post
mechanical era of technology. Dr. Hultén seemed disappointed
in the machine but hopeful about its electronic successor (this
again seems to carry a tinge of the McLuhan state of mind). A
section of "The Machine" was dedicated to a selection of items
that included the prize-winners produced by teams of artists and
engineers in a competition sponsored by E.A.T. (Experiments
in Art and Technology), an organization founded "to establish
a better working relationship among artists, engineers, and in-
dustry." This aspect of the exhibition raised the general question
of the status of art today in relation to technology—the question
to which Bugatti gave one answer at the beginning of the twen-
tieth century when he abandoned painting to devote himself to "a
new kind of art, the mechanical." Another answer was Baude-
laire's still earlier one—his contempt for the notion that art or
man could be the automatic beneficiary of technological prog-
ress. In our century, technology has often put in the claim to
be not only a collaborator of art but a rival of it or a substitute.
Apart from the reactions, pro and con, of artists to machine cul-
ture, the presence of an ever-expanding technology has inspired
an independent aesthetic of the machine, with values that com-
pete with those of traditional art and the traditional conception
of the artist. The most fully developed form of this aesthetic has
been Constructivism and its successors. Constructivism has prom-
ulgated a no-nonsense acceptance of the machine as such; that
is, not as a comical mimic of man or as his oppressor but as a
power by which art and man can be uplifted. Rejecting the
romanticism of the Futurists and the slapstick of Dada, the Con-

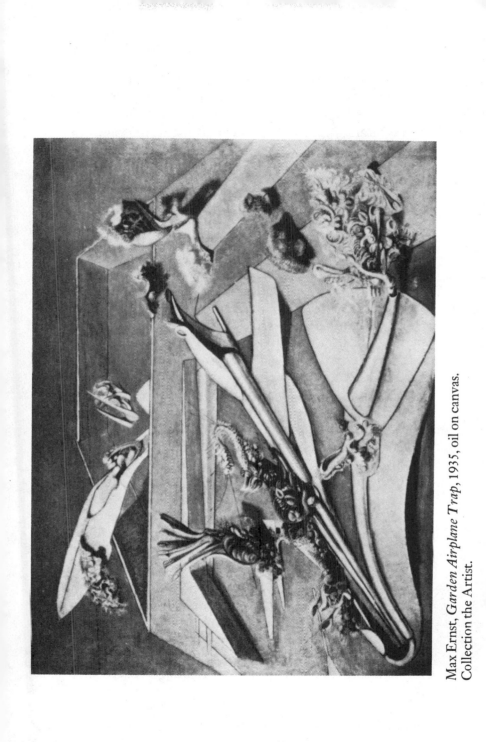

Max Ernst, *Garden Airplane Trap*, 1935, oil on canvas. Collection the Artist.

structivists came to terms with the *new* machine, stripped of metaphor and sentimentality, and with its rationale of utility. Their movement brought to a head the doubts about the continued survival of art, with its historical affiliation to the handicrafts, in an age of modern production. "Art is dead—long live Tatlin's new machine art," declared a sign carried by the ex-Dadaists George Grosz and John Heartfield at a Dada fair in Berlin in 1920.

With the Constructivists, in contrast to the Dadaists, being anti-art was a prelude to a new machine aesthetic. For fifty years, art in this tradition has sought the systematic alteration both of the concept of an art work and of the artist himself. It has introduced the myth of the super-aesthete as organizer of society, community planner, designer of the mass-produced implements of daily life, formulator of new rhythms and instruments of sensation. "What the Bauhaus teaches in practice," wrote Gropius, "is the equality of all types of creative work and their logical cooperation within the modern world structure." In pursuit of this all-embracing aim, the Constructivist artist cultivates clarity, impersonality, and disciplined objectives, including the aim of directly affecting both the environment of the public and its inner condition. It was from Constructivism that Stalin, though his regime crushed Constructivist art in the U.S.S.R., derived his concept of the poet as "an engineer of the soul," resurrected in modified form to describe American formalist painting. (See Chapter 11, "Young Masters, New Critics.") The inspiration of machine art is problem-solving; its chief aesthetic principle is the logical adjustment of means to end. Under the guidance of this principle, it has eliminated decoration from architecture and industrial products, and nonfunctional elements from painting and sculpture. Its concept of an art reduced to essentials has spread far beyond its own mode into seemingly unrelated art movements of the past fifty years. Aesthetic reductionism—that is, conceiving painting in terms of color, sculpture in terms of scale, poetry in terms of words or syllables—owes much to the machine ideal. A painting reduced to a minimum is a machine for converting paint into art.

The "classicism" of machine art, in which the light of the laboratory eliminates subjective shadows, exerts a powerful attraction upon the twentieth-century mind. By contrast, other

concepts of creation appear disorganized, vague, and outmoded. At present, the linking of art to technological processes and purposes is the most influential trend in avant-garde painting and sculpture both here and abroad. With extraordinary energy, the Los Angeles County Museum of Art signed up leading artists (among them Oldenburg, Rauschenberg, Vasarely, Dubuffet, Robert Morris) to work in some twenty industrial plants through the Museum's Art and Technology program, thus obtaining access to "sophisticated heating apparatus, electronic systems, and experimental sonic devices." Abroad, "the poetics of the machine" is perhaps even more in the ascendant than in the United States; for example, all four artists chosen to represent France at the 1968 Venice Biennale were engaged in some aspect of light, chance, motion, or technical experimentation. In these programs, every barrier to innovation had been removed and no invention needed any longer to be legitimized by reference to traditions in art. Speaking of the French Biennale selections, a sponsoring critic warned that the public would make a mistake if it looked at them in aesthetic terms; the artists, he explained, were interested only in "presenting problems in the most simple and obvious way." One seemed forced to conclude that whether or not "art is dead" or the mechanical age is ended, the age of "the new machine art" has arrived.

The difficulty is that the works that have so far emanated from the art-technology partnership tend to look as if they belonged to the past. The most ambiguous word in regard to style has proved to be "new." With its computer tapes, transistors, high-intensity lights, plastic sheets, projectors, blowers, electromagnetic animators, and programmed rhythms, an E.A.T. exhibition at the Brooklyn Museum succeeded in resembling a Wonders of Science pavilion at any fair since the building of the Eiffel Tower. Lights flashed on and off, discs circled, children lined up to enter a black booth, spectators made faces at themselves in distorting mirrors, a nude painted on moving panels disintegrated and recomposed herself, sculptures in a variety of woods were turned out by a Rube Goldberg device, and there was even a conveyor belt on which standing-still pedestrians could move as they would on the animated sidewalks of the future. Those who remembered the Coney Island of long ago no

doubt missed the Belgian glassblower and the Witching Waves, but the latter was compensated for by a plastic sack heaving in a tidal rhythm. To enhance further the traditional experience of the machine environment, many of the electric and motor-driven items had, as is usual in such exhibitions, broken down and were waiting, in a pall of silence, to be repaired. Despite Dr. Hultén's new "electronic and chemical devices which imitate the processes of the brain and the nervous system," the mechanical age was behaving as usual, and the nostalgia of his Museum of Modern Art exhibition was being duplicated across the river in Brooklyn.

Advancing technology seems incapable of carrying art into new realms, any more than flight to the moon could bring a new vision to its TV audience. If art is dead, it will stay dead if machine art has to resuscitate it. Style is determined not by the artist's materials or the apparatus he uses but by the quality of his mind. The sensibility from which machine art derives was set in the nineteenth century by the intellectual passion for science, invention, and deterministic philosophies. When Dr. Billy Klüver, once a Bell Telephone research physicist and now president of E.A.T., remarked to me at the Brooklyn Museum that all the artist-experimenters, with the exception of Tinguely, were utterly lacking in humor and regarded their products with "deadly seriousness," he was describing this machine-shop mentality. Advances in technology have not prevented the technological outlook from remaining inherently static. The mistake of the Constructivists lay in imagining that they were entering a new era of creation when actually they were reflecting a desire for Russian industry to catch up with developments that had taken place in the West before the First World War. Discipline is inseparable from creation, but the discipline of the machine is different from the discipline by which a culture is formed. Nor is any machine new except in its way of doing its job. Set aside as an object of admiration, the newest device blends into inventions that go back to the wheel—a point emphasized by Duchamp in declaring that it would be "disgusting" for his "Rotary Demisphere" to be exhibited as a sculpture. Tinguely was right: in a museum a machine has no alternative but to destroy itself, leaving behind a memory of forms that at times resemble those of art.

15 / Paris Annexed

The "Four Americans in Paris" exhibition at the Museum of Modern Art of the collections of the Stein family was aptly named. It was a presentation of the collectors in terms of the works they assembled. The show had the absoluteness of biography: here were Gertrude Stein, her brothers Leo and Michael, and Michael's wife, Sarah, all active in the art capital of the world during the early decades of this century. The adventure of accumulating a hundred Picassos, more than eighty Matisses, ten paintings by Gris, plus Cézannes, Renoirs, a Bonnard, a Manet—canvases, sculptures, drawings, prints, souvenirs, scribbles—gave shape to their lives. "The painter," wrote Gertrude Stein, "does not conceive himself as existing in himself . . . he lives in the reflections of his pictures." Substitute "collector" for "painter" and her observation fits her brothers and sister-in-law; perhaps even more than the painters, they lived in the reflection of the works they collected. But not Gertrude Stein, who, as everyone knows, lived in her own reflection.

Even for Gertrude, however, part of her reflection was her Picassos, particularly the celebrated portrait of her that required, she said, eighty or ninety sittings. "Portrait of Gertrude Stein," done in 1905–1906, dominated the Museum of Modern Art exhibition; it was hung alone on a panel that jutted out into the main gallery. Unable to complete the canvas from life, Picasso painted out the head and left for a vacation in Spain.

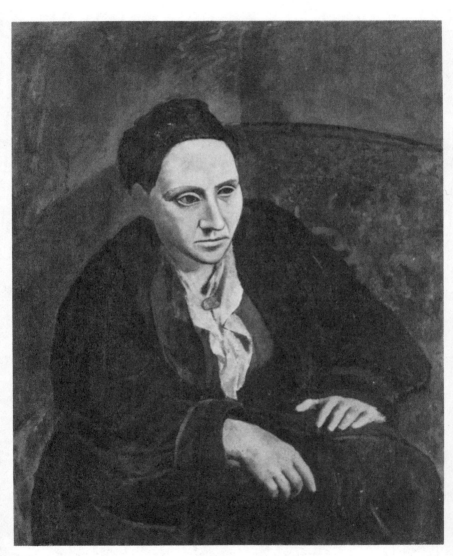

Pablo Picasso, *Gertrude Stein*, 1905-1906, oil on canvas.
The Metropolitan Museum of Art, Bequest of Gertrude Stein, 1946.

After experiments there based on pre-Roman Iberian sculpture, he returned to Paris and, without having Gertrude sit for him again, finished the portrait. For the face of his plump, genial-looking young American patron he substituted an intense, sharply contoured mask with formalized eye-holes and features of an indeterminate age. *The Autobiography of Alice B. Toklas* relates that Picasso told Alice that people said Gertrude did not look like the mask, "but that does not make any difference, she will, he said." Evidently, Picasso saw the author of *The Making of Americans* (she began this work the year the portrait was finished) as a person in the process of redefining herself, and he took the risk of prefiguring what she would become.

Portraits of Gertrude Stein in painting and sculpture by ten artists reverberated throughout "Four Americans in Paris," and they are echoed in the photographs in the exhibition catalogue (*Four Americans in Paris*, Museum of Modern Art, 1970), and in the reissue of her writings on Picasso—*Gertrude Stein on Picasso* (Liveright, 1970). Under the rigid stare of the Picasso portrait, which through the years confronted her in different places in the house she shared with Leo on the Rue de Fleurus, the smiling American girl with a taste for shirtwaists and slouch hats—and with a glance at times sly and a bit ingratiating, especially when she was flanked by her bearded big brothers—changed into the self-possessed, commanding proprietress of the renowned salon for talents from the United States and all over Europe, and finally into the close-cropped, monumental vestal of modernism posed in country gardens or across the living room from her faithful Alice.

In addition to the works in which Gertrude Stein could find herself, the collections of the Steins provided similar opportunities to Leo, Michael, and Sarah. Matisse painted heads of the young couple and made studies of their son Allan. Picasso painted Allan and Leo and did whimsical sketches of Leo walking that make him seem like an illustration for Diderot's *Rameau's Nephew*. The exhibition at the Museum of Modern Art differed from other exhibitions of early Matisses and Picassos by reason of the presence of the Steins in it; when the items were redistributed to their current owners their effect was bound to be different.

Much of the extraordinary exuberance aroused by the Museum of Modern Art exhibition came from seeing the works as the Steins saw them; that is, as new creations about which it was necessary for the collectors to make up their minds without any knowledge except knowing the artists. The same Matisses and Picassos in a historical survey exhibition or a retrospective would have appeared less fresh, because of being pushed back in time and loaded down by information and opinion about them. The aging of art is an effect of perspective; seen from the angle of the Steins in Paris, the works had the look of being new. The Steins chose among paintings and sculptures that were being created before their eyes, and their collections had the liveliness of individual enthusiasms and uncertainties—in contrast to collections that are the result of buying the right things.

The Steins came to Paris as typical Americans in search of culture; since the Civil War the European art capital had been flooded with art lovers from the United States. Leo was the family connoisseur. He had studied art history in Italy, and he bought his first Cézanne on a cue from Berenson. He meditated about the new work he encountered in Paris and scrutinized paintings for formal factors that might relate them to Renaissance masterpieces. He admired the Picasso of the blue and rose periods, but Cubism stopped him; he saw nothing in it but ingenuity used as a cover for shallowness. By 1910 Leo had almost ceased collecting, and his differences with Gertrude over the new directions in art resulted in a bitter break between them. Michael and Sarah, less learned than Leo, became attached to Matisse and continued to buy his work for several decades.

Gertrude was the exception among the Steins—and a new kind of American in Paris. She was there, she discovered, not to absorb culture or to copy it but to make culture. Where Leo saw traditional art values, she saw the new. As against Leo's aesthetics, she looked for the meaning of contemporary painting in the forms of contemporary fact—social and psychological. For her, the paintings she and her family were acquiring represented more than the latest manifestations of European art. A revolution was taking place, she was convinced—a gigantic shifting of cultural sites; through this revolution, the role of the American

in Paris was being transformed. Twentieth-century art was not a continuation of European art; it was to a great degree an affirmation of what Europe was not. "Painting in the nineteenth century," she began her monograph on Picasso, "was only done in France and by Frenchmen, apart from that painting did not exist, in the twentieth century it was done in France but by Spaniards." The "Spaniards" are, of course, Picasso, plus, in an occasional nod of recognition, Juan Gris. But the Spaniards, according to Gertrude Stein, are distinguished by the fact that they are not Europeans. "One must never forget that Spain is the only country in Europe whose landscape is not European, not at all, therefore it is natural that although Spaniards are Europeans even so they are not Europeans." Throughout her discussion of Picasso and Cubism, she returns repeatedly to this theme. But the same is true, she contends, of Americans as of Spaniards: they, too, are Europeans but not Europeans. Thus, Spaniards and Americans in Paris have an affinity with one another. It was this affinity, she conjectures, that led Picasso to do the "ninety-sittings" portrait of her. Art in the twentieth century belongs to non-Europeans or semi-Europeans, and sensing this draws them together.

In *Picasso*, she stresses that she is speaking of *Spanish* Cubism—that is, the art of the outsiders; French Cubism belongs to a different universe. She is tempted by the idea that Cubism originated in Picasso's portrait of her; this would make the painting the seal on an intercontinental alliance. Though it was begun during Picasso's blue period and finished at the end of the rose period, the portrait belongs to neither. The somber composition of rounded volumes in deep brown and red is in keeping with the brooding, thrust-forward mask inspired by the art of ancient Spain. In both its earth tones and its formalization, the portrait anticipates the dozen masklike heads and "Studies for Nude with Drapery" of 1907, that provided the most spectacular wall of the "Four Americans" exhibition. And in these forerunners of "Les Demoiselles d'Avignon," the heavy masses of the Stein portrait were replaced by planes, hatchings, and linear rhythms in a radical departure from nature that led directly into Cubism.

The transition from the theatrical naturalism of Picasso's blue period—the magnificent array of posed nudes, mother-and-child compositions, clowns, acrobats, lonely beggars that, together with the early Matisses, the Cézannes, the Renoirs, the Daumier, and the Bonnard, introduced the "Four Americans" exhibition—to the monochromatic fixity of the Stein portrait parallels, in Gertrude's view, the transition from nineteenth-century to twentieth-century painting. To her, Cubism was the visual language of a human condition unlike any that had ever existed before. Her rejection of Leo's historicity in art was based on her quasi-political insight that all forms had in the modern world been overtaken by a fatal instability. Leo had plotted the evolution of painting from Cézanne through Matisse and Picasso. Gertrude had no faith in evolution—whether in art or in anything else. Continuity itself, she asserted, is a nineteenth-century notion related to science and belief in progress, which is now no longer respected. In the twentieth century, "everything destroys itself . . . nothing continues," and she heroically embraced this era of breakdown as "a more splendid thing than a period where everything follows of itself."

The fragmentation of history and the consequent gap between the present and the past nullify notions dear to art historians, such as the "modernism," revealed by formal analysis, of nineteenth-century painters, Turner, Géricault, Monet. Even the art of Cézanne and Matisse fell short, Gertrude felt, of grasping the present. Picasso in his Cubist period was, she insisted, "the only one who felt it, the only one." The destiny of the modern movement was "to kill the nineteenth century," which Picasso was especially equipped to accomplish because Spain does not trust visual reality or believe that science makes for progress. "While other Europeans were still in the nineteenth century, Spain because of its lack of organization and America by its excess of organization were the natural founders of the twentieth century."

Obviously, much of what Gertrude Stein says about Spain-America is mythologizing. But her message is clear: European culture is being superseded by world culture, and Europeans in Paris are no longer the most original sources of creation. In

Henri Matisse, *Bronze with Carnations*, 1908, oil on canvas.
Nasjonalgalleriet, Oslo.

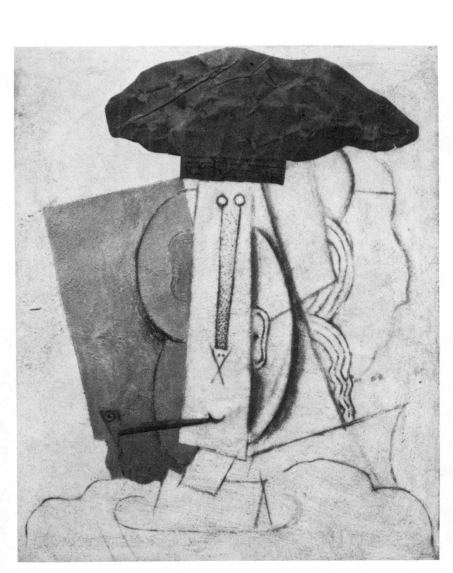

Pablo Picasso, *Student with a Pipe*, 1913-1914, oil, charcoal, pasted paper, and sand on canvas.
Private collection, New York.

extolling Picasso she also claims for the American in Paris the privilege of leading in the formation of a new epoch. The Steins' pioneering collections constitute the first stage of this project.

With the history of art set aside, her criterion for judging works is modern reality. There is no art talk in *Picasso*, no formal comparisons, no analytical weighing of qualities. The vision is all, though the vision is a vision of forms. With Picasso there appears the "reality not of things seen but of things that exist." The artist is no longer seduced by objects as they commonly appear —surrender to which, she believed, diminished even Cézanne. Nor is the object used in Cubism as an occasion for subjective statements or to create a mood. Each entity preserves its own integrity, and in the decentralized compositional scheme of Cubism all images and all parts of the canvas are equal in importance. This equalization is also carried out, she might have added, by the monochromatic earth tones of such Cubist classics as "The Architect's Table" and "Still Life (Journal)." The spatial concepts of Cubism correspond to the form of modern fact: "Really, the composition of this war, 1914-1918, was not the composition of all previous wars, the composition was not a composition in which there was one man in the center surrounded by a lot of other men but a composition that had neither a beginning nor an end, a composition of which one corner was as important as another corner, in fact the composition of Cubism." In the experience of modern man, phenomena have no particular dimensions and belong to no pattern or hierarchy. In Cubist painting, "a thing . . . existed in itself without the aid of association or emotion." Image and thing are fundamentally indistinguishable, so real objects can be introduced into paintings—a concept that led to the Cubist invention of collage. (Two insufficiently noticed masterworks of the "Four Americans" show—in comparison, for example, with the much larger Matisse masterpiece, "The Blue Nude," and Picasso's "Boy Leading a Horse"—were Picasso's "Student with a Pipe" and "The Violin"; the latter, done in 1912, already achieved the finest "musical" effects of geometrical abstraction.) Leo Stein's objection to Matisse was that his paintings had begun to seem "rhythmically insufficient"—an aesthete's complaint. Gertrude

Stein's criticism went beyond aesthetics to Matisse's apprehending nature "as everybody sees it" and his dependence on decorative harmonies.

With Cubism, as Gertrude understood it, aesthetics had become irrelevant. Or a new aesthetics had been promulgated, based on the exclusion of artifice. In her remarks on the Cubist object stripped of association or feeling, she spotted, decades in advance, the ideal of the Minimalist "art of the real" and the "thingish" novel of the nineteen-sixties. Her "it is everything if it is what it is" is a dictum that might have been applauded by Barnett Newman. The intuitions of one moment introduce no shadings into the next. The artist does not reach a conclusion and then organize his material in accordance with it. In Cubist creation, there is no beginning and no end—only an accumulation of statements and restatements resulting from a persistent, searching return to the object. The creator, since he cannot foretell the outcome of his activity, will make art that is ugly; only those who imitate can produce beauty. In her adaptation of Cubism for her "word portraits," Gertrude Stein seems deliberately to arrest the motion of her ideas toward a concept in order to revert to first statements again and again. As illustration, here are the famous opening lines of her word portrait of Picasso: "One whom some were certainly following was one who was completely charming. One whom some were certainly following was one who was charming. One whom . . ." and so on. The author keeps springing back to her model as if drawn by a magnet.

"The final test is always the portrait," she wrote, having in mind, perhaps, as had Henry James, that in the midst of disintegrated traditions beauty is secondary to grasping the identity of things. Cubism is no doubt the most enigmatic mode of painting in our age of enigmas, and intrinsic to it is its conversion of objects into signs of themselves, as in Gertrude Stein's face changed into a mask. Discovering the Who was the ruling axiom of her aesthetic, both as writer and as collector of art. She became interested in Picabia, Toklas reports, "because he at

least knows that if you do not solve your painting problem in painting human beings you do not solve it at all." To Gertrude Stein, Picasso was essentially a portrait painter; whatever he did in still-life and landscape she considered to be preliminary to his painting of faces. What he saw in her she also saw in him—an individual engaged in bringing himself into being—and she worried constantly about his losing his true self. For the European, a self came ready-made. For the Spaniard and the American in Paris, it had to be formed by actions, and culture meant detecting the emergent form.

Gertrude proclaimed the historic role of the Steins in Paris by presenting her own card of identity. "America is my country," she announced, "and Paris is my home town." The French had not realized that their capital had been annexed—that the building on the Rue de Fleurus where Gertrude and Leo assembled their cultural contraband was the headquarters of an international force of occupation over which flew the banner of the twentieth century. Collecting Matisses and Picassos, the Steins brought into play the American cult of novelty, which Gertrude provided with the theoretical foundation drawn from the most extreme insights of the Paris vanguard. Until the First World War, it was rarely suspected that "School of Paris" meant the opposite of French art. Since that catastrophe, which, like all wars, brought to light changes that had already taken place, art has abandoned its "home town" and has become world art—and the pickings of the Steins, in an ironic defeat of Leo's judgments based on art history, have become treasures of the world museum.

16 / The Thirties

Art museums have borrowed from journalism the practice of packaging history in ten-year bundles—exhibitions entitled "Art of the Forties," "Art of the Fifties," and so on—as if modes in painting and sculpture were conveniently born and expired in the cycle of decades in order to make memorizing them easier. Since, however, such arbitrarily marked-off time segments fail to fit the span of significant styles, it is customary to squeeze into both ends of the exhibition works from earlier and later decades before tying up the art-historical package with New Year's streamers.

This finagling with time spans happens to be unnecessary in the case of the thirties; that decade almost coincides with a genuine historical epoch. Only the other day, an economist writing on financial stability referred to "the horrible thirties"— an indication of how vividly the decade has identified itself in his field. In art, too, the thirties have a distinct physiognomy, though one not sufficiently unambiguous to be called horrible; for instance, the era brought an advance in American mural painting. From the financial collapse of 1929, which drove American artists home from Europe, to the opening of the Second World War, which drove European artists out of their homes to America, the thirties were an interval in which history openly revealed its power to tamper with art. The Depression was a common situation, even for those not in need, and a

Charles Burchfield, *Old House by Creek*, 1932-1938, oil on canvas. Collection Whitney Museum of American Art, New York.

creation took place with a consciousness of the disturbed public presence—as today its awareness is of the frivolous art-world presence. Before the thirties were half over, the public presence had extended itself into the government presence and, particularly with artists in the large cities, into the presence of the political Left. In the thirties, the avant-garde of art gave way, step by step, to the political avant-garde. The financial predicament of the artist and the issue of social patronage of the arts took precedence over aesthetic problems. American painting was produced on the borderline of social action; those who wished to restrain it from crossing that line had to dig in and defend their positions.

One effect of the social offensive was a pervasive mood of sobriety and constraint; a Warhol or a Rauschenberg is inconceivable in the thirties. The key word was "discipline." In painting and literature, "discipline" represented a spiritual position, like that of Mondrian or Eliot; in politics and political art, it meant submitting to direction by the Party. For wider currency, "discipline" was translated into "responsibility." Art felt obliged to make its purposes clear and its images publicly significant. It responded with countless landscapes and with depictions of local scenes and types and historical episodes. The artist reached past easel painting and figure sculpture to media for the many—murals and sculptured friezes on public buildings, prints, documentary photographs and films. Painters of social themes hunted through museums and files of reproductions for an appropriate style. Masters of narrative and dramatic situations—El Greco, Bosch, Brueghel, Velázquez, Goya, Degas, Picasso—were naturalized again and again under scores of American names. The advanced art movements of the twentieth century had lost direction, though a tiny minority of artists continued to reiterate the teachings of Cubism, Surrealism, and Neo-Plasticism.

Formally, the thirties were a drop-out; though there appeared an immense effusion of craft skill, not one new aesthetic idea emerged. Even when prophetic moves were made, they remained hidden or were nervously abandoned, as if in fear of offending the reigning utilitarian spirit. The murals of the thirties are sometimes credited with providing the starting point

of bigness in the paintings and sculptures of the fifties and sixties. But to see the thirties as inspiring largeness amounts, in my opinion, to forcing the hand of art history; many of the murals were fairly small—sections of panels and borders around entrances. But regardless of size, almost all were cramped in scale because of overcrowding with visual data intended to convey the social message. Overloading the picture space went hand in hand with rigidity of composition and drawing and with conventional use of color. In both its realistic and its abstract genres, American art of the thirties revealed an absence of freedom, a lack of assurance, and the hesitations of aesthetic apprenticeship. The saving feature of the period was its intellectual conscience—a virtue that was also its handicap. Non-objective painters were challenged to indicate what their circles and squares contributed to social progress; the usual reply was to draw an analogy between their work and that of the pure scientist engaged in advancing his specialty without regard to immediate practical application. But if the demand to adjust creation to utility was stultifying, it had the merit of discouraging the arrogance, cuteness, and clowning of artists who perform for an audience unmoved by issues beyond art.

The exhibition at the Whitney Museum entitled "The 1930's: Painting and Sculpture in America" approached the decade as a source of works capable of satisfying the tastes of today. In effect, history was turned inside out to make the thirties an extension of the sixties. The assumption of the exhibition was that whatever the decade may have meant to itself, it is significant to art only through the "good" works it has left behind. The perspective of the Whitney was that of an art collector of the late sixties who might be interested in acquiring an abstraction by John Graham before that painter abandoned abstract art, or a Man Ray assemblage, or a pre-homage-to-the-square Albers. In sum, current fashion had the last word. Not only was there no effort to reflect the social situation of the thirties (one indignant reviewer suggested that the show ought to have greeted visitors with the figure of an unemployed person peddling apples) but, more to the point, there was no resemblance to an art exhibition of the era the

Ben Shahn, *The Passion of Sacco and Vanzetti*, 1931-1932,
tempera on canvas.
Collection Whitney Museum of American Art, New York,
Gift of Mr. and Mrs. Milton Lowenthal in memory of Mrs. Force.

show pretended to represent. The mass of American landscapes and scene paintings omnipresent in that time had been reduced to a sampling of the most unavoidable names—Benton, Burchfield, Curry, Evergood, Gropper, Levine, Shahn, Marsh—while considerably more than half the items consisted of abstract and Surrealist art, some of it by visitors to America, like Léger and Matta, some by Americans who worked in Europe until late in the decade, like Holty and Patrick Henry Bruce, and who exerted no influence upon it. (Bruce, the exhibition list informed us, died in New York three months after his return from Paris, where he had been working since 1904.) Artists who were either too young or too obscure to have had any effective role in the thirties, or who later changed their styles (e.g., Balcomb Greene), or who attained their true stature under the influences of a subsequent period (e.g., Gorky, de Kooning, Pollock, Hofmann) were included in order to swell the volume of thirties abstraction. On the other hand, dozens of personages who, for better or worse, are fused into the history of the period were omitted from the exhibition, among them—to name but a handful—Alexander Brook, Cameron Booth, Francis Criss, Isabel Bishop, Henry Schnakenberg, Maurice Sterne, Louis Eilshemius, Leon Kroll, Eugene Speicher, Boardman Robinson, Karl Zerbe, Anton Refregier. There was one painting by Raphael Soyer, none by Moses and Isaac Soyer. And one work by Jack Levine and two by Ben Shahn hardly did justice to the ubiquitousness of these artists in the art life of the decade.

To justify this distortion of focus, the catalogue knocked down the straw man of a conception of the thirties as "a monolithic period" whose art was "almost exclusively 'socially conscious,'" which is not the issue at all. The idea of Beauty, in capital letters, played as important a role in the art of the thirties as the idea of Revolution; painting today is separated from that of the earlier period by what happened to both these ideas. The issue in replacing exemplary figures with ones calculated to promote values alien to the time is the issue of the falsification of history, an issue which American museums and curators had better learn to take seriously. To use the past as one likes is a crime against the dead, a species of grave robbery, that prevents

the living from understanding themselves. The Whitney interpretation of the thirties was equivalent to describing Czarist Russia in terms of the Diaghilev ballet and the Moscow Art Theatre. By the standards of the sixties, the "The 1930's" was a good show—much better, indeed, than the thirties deserve (except that the first thing anything deserves is itself). But "a

Raphael Soyer, *The Flower Vendor*, 1935 (repainted 1940), oil on canvas.
Collection Mr. and Mrs. Emil J. Arnold.

good show" is only an occasion for enjoying what we have learned to like and for confirming what we already believe. To go beyond present-day aesthetic parochialism we need to understand the thirties, not tap some syrup out of them. Without an awareness of that endless mass of mill runs, fields with scarecrows, white barns, and distant windmills, railroad tracks, crowded evening streets, housewives undressed to the waist staring earnestly into the spectator's eyes, marble mother-and-

child themes in Cubistically simplified forms, it is impossible either to apprehend the burdensomeness of American painting and sculpture in those days or, what is much more important, to appreciate the desperate creative force that it took to break into new ground in the years that followed.

As conceived by the Whitney, American painting had a style in the thirties—almost the style it has today, albeit somewhat submerged. But to link works to the present because they are abstract or Surrealist, without considering the quality of sensibility embodied in them, is to judge art by format, in despicable disregard of fact, feeling, and imagination. The fact is that the thirties' only common style was a backward-looking eclecticism; even the most advanced works of the abstractionists and Surrealists at the Whitney were based on memories of the avant-garde movements of the earlier part of the century. Examples are the two excellent abstract paintings by John Graham done in 1931 and 1932; they represent the thirties not in being Abstract but in that soon after painting them Graham denounced these residues of the twenties in his attack on abstract art. The peak of America's formal advancement in the thirties is represented by Stuart Davis, who, appropriately, had the largest painting at the Whitney. Davis, a post-Cubist who geometrized the American scene, had established his style in the twenties, and he held to it without change throughout his career; his radicalization in the thirties was entirely on the political side. He was the editor of the *Art Front*, organ of the Communist-dominated Artists Union, and he allowed his friendship with Arshile Gorky to lapse because Gorky, despite the political situation, "still wanted to play," as Davis put it; that is, to devote himself to problems of painting. Davis's vanguardism was in sum a conservative adaptation of School of Paris painting to an ordered picturing of the American scene. The watchword for American avant-garde style in the thirties is the prefix "semi"— semi-abstract (Davis), semi-Expressionist (Hartley, Dove); that is, half-commitment to new ideas, a continuation of the aesthetic timidity and respectability already evident twenty years earlier in the Armory Show. Given the social presence, to go even this far took a good deal of independence. (See Chapter 1, "Redmen

to Earthworks.") Yet in contrast to the unadventurous van-
guardism of the thirties one prefers Hopper and is inclined,
despite the high quality of Davis, Dove, and Hartley, to regard
him as the finest American painter of the period.

The linear abstractions of Mark Tobey had a legitimate
place in the Whitney exhibition; he is unquestionably a "forties
artist" already matured in the thirties. The inclusion of early
de Koonings, Pollocks, and Gorkys was, however, an obfusca-
tion. The thirties creations of all three need to be seen in terms
of the decade rather than, as at the Whitney, having the decade
seen in terms of them; that is, of their later works. The de
Kooning 1931 composition of rectangles and ovals and his later
figure of a man are, in their sparkling tightness, Renaissance
color, and polished surfaces, products of the ascetic discipline
that in the thirties served as a personal code and a social ideal.
They are paintings in the spirit of Mondrian—the figure painting
as much as the abstraction—and while they represent stages in
the development of de Kooning, they have more in common
with the era in which they were created than with, as the
catalogue puts it, "a more painterly and Expressionist vein [that]
was rapidly developing under the influence of Matisse, Cubism,
Miró, and Surrealism." De Kooning in the thirties was on the
dark side of the moon as far as his later "Expressionist" experi-
ments in self-liberation were concerned, and, except for the
mystery of temperament, he could have remained on that side,
like Diller and half a dozen others.

If the de Kooning canvases are neither Expressionist nor
painterly, neither is Gorky's "The Artist and His Mother," a
work with which the artist struggled for almost ten years and
whose surface he polished to a mirror hardness comparable to
that of the de Koonings—as convincing a symbol as one might
find of the self-conscious and constricted impulses of that era
of crisis, combat, and public scrutiny. Another Gorky that was
in the exhibition belongs to the phase between his Picasso-
Braque imitations and his adaptations from Miró; despite its
attempt to animate its forms, they are locked in by the com-
pressed scale of the canvas and its heavy layers of pigment.
The Pollocks, entitled "Birth" and "The Flame" (translatable

into claustrophobia and eruption), are equally confined and heavy. Freedom, lightness, and instantaneity of execution were to come to these artists in a later day and under the influence of different forces. Even Hans Hofmann, whose unique role in the thirties as a bridge between the past and the future cannot be overestimated, is held down to a formal demonstration, though he managed to make one of the compositions shown come to life. It was only after American art had, in the postwar years, painfully fought its way out of the inhibitions imposed by its past and by the public presence that freedom in painting and sculpture could give rise to a style.

An authentic exhibition of the thirties, even without apple peddlers, would appear almost as remote stylistically from the light shows, Pop parodies, Kinetic sculpture, and Minimal constructions of the current art world as from an exhibition of the eighteen-thirties. In a sense, the nineteen-thirties, with their semi-isolation from Paris and their rediscovery of the American landscape and of American social fact, constituted a peculiar pocket in time, a kind of prerevolutionary stasis in which psychological frustration was accompanied by impressive quantitative leaps (e.g., the sudden great rise in the number of practicing artists) and institutional innovations (public support of the arts). Aesthetically, it was both backward and straining forward—the last period in American art before the avant-garde styles took over. The meaning of the thirties lies not in the artifacts they contributed to the store of vanguard American art but in the reality and pertinence of their problems—above all, the problem of the relation between advanced art modes and an advanced public consciousness of the cultural situation of modern America. The thirties asserted the vacuity of advanced art forms when they are separated from a radical response to public events. In recent protest shows artists continue to repeat the unsatisfactory "solution" of Stuart Davis, which separates the artist from the citizen and art history from the history of mankind. The present period overlaps the thirties intellectually, and the Whitney's attempt to mix the creations of both into an aesthetically acceptable mash obliterates the real nature of both the past and the present.

17 / École de New York

The exhibition of "New York Painting and Sculpture: 1940-1970" at the Metropolitan Museum of Art purported to display the wealth of creation that—according to the catalogue, by Mr. Henry Geldzahler, curator of contemporary arts, who directed the show—had made "the New York School the historical successor to the School of Paris." That art in New York is today on the same plane art was in Paris during the seventy or eighty years before the last war is a momentous proposition, in regard not only to New York but to contemporary world culture and to the status of America in it. Successor to Paris as "the dominant center of world art," New York, in the view of the Metropolitan's curator, has attained intellectual preeminence, the right to state the problems and to propose the solutions for artists everywhere, and by the magnitude of its creations it has arrested and reversed the decline of the West. As Geldzahler puts it, "something magnificent has happened." Nor does the question of the qualification of New York to carry out its historical assignment trouble Geldzahler, since he apparently takes it for granted that the centrality of New York in the current production, exhibition, and marketing of paintings and sculptures automatically confers upon the metropolis qualities of imagination, inventiveness, and intellectual depth equivalent to those of the City of Light. In his summation of New York's greatness in art, there appears not the slightest hesitation

in assuming that "we" are every bit as good as "they" ever were.

Indeed, so dazzling is his belief that he fails to notice the oddness of the premise on which his faith is based: that art in New York 1940-1970 represents a single development and point of view. "By reason of its own achievement," he writes, "and the clear and indisputable effect it has had throughout the world, the art of the New York School stands as the most recent in the grand succession of modern movements from Impressionism through Cubism and Surrealism." New York art has become a "School" and is comparable to European art *movements*. Geldzahler has mistaken a place for a style and for an idea. The history of American imitations, revivals, individual and shared idioms, rotations of modes and subjects during the past thirty years—Expressionist emblems, Action painting, figure painting, romantic sculpture, Pop Art, Optical painting, Kinetic constructions, assemblages, stripes, E.A.T., shaped canvases, Happenings, Minimal sculpture, mathematical abstraction—has suddenly been amalgamated into a purposeful collaborative development on a par with the Cubist and Surrealist revolutions and deserving a place in history alongside the sum of Paris modernist experiments. In Geldzahler's reverie, which the thirty-five-gallery exhibition at the Metropolitan was designed to buttress, Gorky, Warhol, Albers, and Still are aesthetic and intellectual blood brothers. Or, in terms of the New York–Paris succession, a totem pole consisting of Still standing on the head of Albers, who stands on Warhol, who stands on Gorky, tops the Eiffel Tower.

While the relation of New York art today to that of prewar Paris is worth discussing, the Metropolitan exhibition of the nonexistent New York School is not, except perhaps as a phenomenon of art-world power politics, chauvinism, and institutional reputation-building. "New York Painting and Sculpture: 1940-1970" was merely the latest and largest in a series of history-falsifying survey exhibitions in which works of art have been employed to serve the career strategies of the curators who assembled them or to call attention to their mental fixations. (The Metropolitan exhibition was commonly referred to in the press as "Henry's Show.") To engage in arguments about the

inclusions and omissions of Geldzahler's extravaganza was to fall into a trap prepared in advance in order to provide meat for "Henry's" public relations—a field in which he had been doing sufficiently well. "Henry" is an entertaining talker with an attractive manner, and given to costumes suggestive of gone-by periods of middle-class elegance. In general makeup, he belongs to the age of the Goncourts, and had he contended that he, rather than the "New York School," was the successor to Paris, or to someone in Paris, I should have made no objection. The press kit for the show contained a glossy of Geldzahler in shirt-sleeves, as if he were a movie director on location; flanked by an assistant, he was explaining an installation to one of his favorite artists. No doubt was left as to who was in charge. In the past few years, art in America has given birth to a new type: the Swinging Curator. I have in some of these chapters discussed museum art-historical spectaculars as "creative" undertakings—such as the European painters today, the machine, and the art of the thirties exhibitions by representatives of the Museum of Modern Art, the Jewish Museum, and the Whitney. With "Henry" and his show, the Metropolitan leaped to the forefront in this form of theatre.

Each of the theatrical art surveys has been the biggest in its category to date, and the Metropolitan's "1940-1970," with more than four hundred paintings, sculptures, and drawings, and covering three decades in a single roundup, outnumbered them all. It was billed as "the most monumental showing of contemporary American art ever to be brought together anywhere," which bit of Barnum magniloquence was undoubtedly supportable by the facts. When, however, Geldzahler went on to claim that his project was the first chance people had had "to see . . . paintings and sculptures in large numbers by the major figures" in New York art, he was talking rubbish. Many figures more "major" than some he had chosen were not included in his show and its catalogue, and among those who were included most had had much more satisfactory representation in individual retrospectives, had been exhibited again and again in predecessor survey exhibitions, and could be seen nearly any time in galleries around Fifty-seventh Street;

several can be seen more often than almost anyone would want. In making his show so big, Geldzahler served no useful purpose; he employed quantity to force assent. Indeed, it was by the frequency with which they had been displayed that the artists in his show presumably met Geldzahler's criteria: that the works shall have "commanded critical attention or significantly deflected the course of recent art." Works that command critical attention have not remained unseen in New York, and unseen works do not "deflect." At the Metropolitan, more works than ever before by contemporary Americans were offered in one place at the same time, but whatever might have been the advantage of encountering forty-two Ellsworth Kellys, it was offset by the fatigue that this experience induced, particularly in a spectator disappointed by the quality of the nine Pollocks that represented that artist's share in Geldzahler's "vital tradition."

"Critical attention" and historical "deflection" were Geldzahler's sententious terms for confessing his adherence to the star system. What he was actually saying was: I have been going through museum catalogues and art magazines, and from the artists most talked about I have picked the ones I like best. (Had this approach succeeded, he no doubt planned to introduce starlets of his own discovery.) In choosing a cast for his show from this pool of talents certified by magazine lineage, Geldzahler was at liberty to play down or exclude artists who were responsible for the international prestige of postwar American art but who, since they were no longer a novelty, were not talked about as much as they used to be. Putting on museum mammoths has become a competitive enterprise, and Geldzahler's views are not appreciably different from those of rival curators; he belongs to the "formalist" orthodoxy that is centered on "the problem of the picture surface," and it is the formalist reading of American art history as a progressive handling of problems of surface and depth inherited from European modernism that enabled him to see American painting and sculpture of the past thirty years falling into place as a single art "movement." Given the fact that Geldzahler's heroes were predictable (Dr. William Rubin had followed the same line in his "New American Painting and Sculpture" exhibition at the Museum of Modern Art), it seems

likely that the numerical unbalance of his choices and the blatancy of his omissions were deliberate; his aim seems to have been a *succès de scandale*, in order to distinguish himself by his boldness and avoid being outdone by the denunciations and high attendance of the Metropolitan's earlier "Harlem on My Mind" exhibition. If this was Geldzahler's purpose, he carried it out expertly. The arbitrariness of his representation of American art tempted even the most ungifted and conformist reviewers to put on a show of strength by attacking Geldzahler's errors of judgment and, from a list of omissions obligingly supplied in his catalogue by Geldzahler himself, by recalling the names of well-known figures, from Baziotes to Larry Rivers and Marisol, whom he had cast into the void. With the assistance of its creator, the Metropolitan exhibition managed to achieve an almost universal disapprobation; approaching the vast area set aside for the show through a corridor flanked by rows of Cyprian votaries, I fancied that I saw them grinning into their marcelled beards.

Only Mr. Thomas Hoving, director of the Metropolitan, seems to have been convinced that "Henry's Show" was grounded on unassailable values, supported by his curator's "formidable visual talent." In a statement that turned itself inside out before the reader's eyes, Hoving declared that Geldzahler's choices were inevitable. "Although it is conceivable," he said, "that no two people would have picked anywhere near the same works of art from the New York School, 1940-1970, it is highly unlikely." Actually, *nobody* but Geldzahler would have put together this show, and he himself, I am convinced, would be the first to say so. Just what Hoving had in mind by his "no two people" sentence is difficult to figure out—could it be that any two people would have picked the same works? Perhaps he meant to imply that the "New York School" has attained the absolute, and that its virtures are so clearly manifest that all men of good will would joyfully assent that in the Metropolitan exhibition "the highest quality of this exciting time has been fully captured."

European avant-garde art had exhausted itself before the war; the last three in Geldzahler's "grand succession of modern

movements," of which the "New York School" is presumably the heir, were anti-art. Futurism, Dadaism, Surrealism had renounced continuity with the art of the past in favor of protest and of "research" into the social and psychic peculiarities of the modern world. By the nineteen-thirties, advanced artists were in flight from Central Europe and were trying to form combinations against war and fascism. It is this fatal and irreversible breach of historical continuity that the Metropolitan's critical guides are endeavoring to conceal in their glorification of the "New York School" as the heir of "a continually vital" tradition.

The legacy that New York artists inherited from Paris consisted of the tradition of overthrow, of unlimited formal experimentation and parody, and of fragments of radical ideas. It was on the basis of the consciousness of loss and renunciation of support by the past that a new creative principle was sought by New York painters. The genius of the wartime generation of Abstract Expressionists, veterans of the Works Progress Administration art projects, lay in their ability to get along on nothing—aesthetically as in other respects. In Whitman's phrase, they had "all to make." Out of this pioneer situation, forced upon them by world catastrophe, came the great, flawed art of Gorky, de Kooning, Pollock, Rothko, Gottlieb, David Smith, Still, Newman, Hofmann, Kline, Guston, and a dozen others—individuals bewildered, uncertain, and straining after direction and an intuition of themselves. No description could be less relevant to these artists then Geldzahler's reference to Gorky, Pollock, and Smith as "giants." Giants do not paint pictures, they roll boulders down hills.

It is in the American artists' will to art that the continuity lies between New York and European modernism. Nineteen-forty-six to 1952 or 1953 was a remarkable period in American art, and no period since has come close to equalling it. In that period, art began to flourish in this country through the powerful impetus of the myth of the artist—a myth that, although it was inherited from Europe, proclaimed America's independence of Europe and turned to an art of symbols drawn from Africa and pre-Columbian America and to self-explorations through action on the canvas. The continuity of New York art with the School of Paris thus consists in the recognition that besides the

model of the artist as witness to the predicament of contemporary creation, Europe had no longer anything to offer but a mixture of memories. Despite the efforts of Geldzahler's mentors to prove that American paintings and sculptures "breathe naturally in the history of art," alienation from the past remains the inescapable condition of American creation, as was evident even in the schoolmaster art of the sixties, built upon one traditional element of painting, such as color or shape, which overcrowded the Metropolitan galleries.

New York artists have been compelled to confront the predicament of art in this century with reduced resources of consciousness—philosophical, political, psychological. The question of the survival of art under these conditions remains open. Not only does New York lack the intellectual attributes required to assume the role of Paris, but "School of Paris" itself was close to being a misnomer. Style in modern art is determined not by place but by ideology. There are, for example, decisive differences between a Fauvist and a Cubist painting executed at the same time on the Paris Left Bank, and there are similar differences in the work of an individual who has shifted from one concept to another—recall, for example, the reaction of Leo Stein to Picasso's immersion in Cubism. (See Chapter 15, "Paris Annexed.") The open structures of Giacometti the Surrealist are stylistically remote from the impacted portraits and walking men of Giacometti the "Realist." In the United States, the most notable phenomenon of the art of the forties was the artist who was "cut in two"—individuals, such as Rothko, Guston, Gorky, who after years of working in one vein underwent a crisis out of which emerged a new artist with a new approach. The "conversion" phenomenon has continued to manifest itself, though it is almost entirely suppressed in museum survey exhibitions. Among the artists presented at the Metropolitan, Lichtenstein, Noland, Louis, and Olitski were ex-Abstract Expressionists, but apart from two extremely poor Action paintings by Olitski, done only ten years ago, no hint was given of these artists' aesthetic biographies. This submergence of the artist's experience is of itself sufficient to distort the image of art by presenting it as a craft for illustrating ideas that seem ordained by the history of art. Such ideas are, of

Kenneth Noland, *Trans-Median*, 1968, acrylic on canvas.
Collection Mr. and Mrs. David Mirvish, Toronto.

course, the specialty of critics and art historians, and the basis of their status in the art world; in contrast, the artists are under the handicap of being compelled to expend some of their energies in handling physical substances. This handicap is eliminated by conceptualism, which puts the artist on the same level as the critic and historian. Geldzahler's fantasy of a "New York School" comes from seeing all art in terms of a single idea of development; what but ideology could cause him to elevate Louis and Judd and exclude Held, Sugarman, and Nevelson?

Morris Louis, *Alpha-Delta*, 1961, acrylic on canvas.
Everson Museum of Art, Syracuse, New York.

"It is the fate of every myth," wrote Nietzsche, "to creep by degrees into the narrow limits of some alleged historical reality, and to be treated by some later generations as a unique fact with historical claims." The myth of the artist that inspired Pollock, de Kooning, and their contemporaries has undergone precisely the destiny described by Nietzsche. Geldzahler's absurd account of uninterrupted advances from Pollock into higher and higher realms of excellence in a New York School now centered on Noland, Stella, Kelly, and Judd represents the kind of institutional history that confers the stature of European art on New York and the invention of baseball on the Russians. If, despite the ideologies of modernism, "School of Paris" is a term not altogether devoid of meaning, it is because the ancient city diffused its aura upon creations there regardless of their intellec-

tual and aesthetic divergence. The aroma of Paris, debased in perfume advertisements, was present in the paintings of Matisse and Braque and in the tube of "air of Paris" that Duchamp packed in his suitcase when he emigrated to America (imagine anyone carrying off air of New York except to a laboratory). But the kind of ephemeral influence that binds responses together beyond the antagonisms of minds is lacking in New York.

Art movements in America challenge each other on dogmatic grounds, with a challenge to the death and with a poverty of sensibility that is often appalling. Sensibility has never been the strong point of painting in the United States; even the best of American nineteenth-century landscapes and genre paintings tend toward the tightness and literalness of an art based on painstaking scrutiny untempered by style. Barnett Newman stated the issue prophetically in the forties by demanding an art denuded of sensibility and "truly abstract" if American painting were to liberate itself from the seductiveness of the Paris schools. Whether or not one accepts Newman's program, it is a fact that sensibility in New York is an individual acquisition and not a collective poetry of place. Americans tend to substitute recipes for the fluctuations of thought and Proust's "intermittences of the heart." Geldzahler's stars of the sixties—Louis, Kelly, Noland, Olitski, Stella—are all recipe painters. The recipes were supplied, or authenticated, by critics. To these critics, New York's continuity with Paris is established through carrying forward such "issues of Modernism," to quote Michael Fried, one of the critics, as "the need to acknowledge the literal character of the picture-support." Here, Minimal and color-field art is exposed as the product of an interpretation of modern culture in elementary terms.

Geldzahler seems dimly aware that his "New York School" is less a communion of artists than a congeries of artifacts and forces, including the force of prevailing official opinion. He speaks of the "climate of discussion, theory, and technical advance" that makes New York today's world center, but he concludes that "perhaps most important of all [are] the museums and continuing gallery exhibitions." It seems evident that for him the significant ideas are those of curators and dealers, and he goes

as far as to express the astonishing belief that the fall of the School of Paris was brought about by the absence of enterprising museum personnel. "One of the reasons French art weakened so considerably after World War II was that the key paintings and sculptures of the first half of the century were not on view in Paris." The decline of Europe could, it seems, have been averted, after all had there been sufficient gallery space. As for American vanguardism, it is today safely in the hands of competent art managers and communicators. America's contribution to the 1969 São Paulo Bienal was to have consisted of works in light, inflatable forms, and Kinetics by anonymous artists organized in teams by a professor of M.I.T.; the vast collaboration between artists and industry, arranged by the curator of the Los Angeles Museum has been referred to; the chief curator of the museum of the Rhode Island School of Design obtained the services of Andy Warhol in mounting an exhibition of basement discards that mixed paintings and sculptures with old shoes; someone in *Artforum* discussed an exhibition arranged by a female critic that achieved a "total style" and thus led to the conclusion that it is the critic who "is in fact the artist and that her medium is other artists, a foreseeable extension of the current practice of a museum's hiring a critic to 'do' a show and the critic then asking artists to 'do' pieces for the show." In the movies and TV, a critic-artist whose medium is other artists is called a producer.

With the myth of the artist brushed aside by the showman who fits paintings and sculptures into his schemes, the only aspect of modern art that has steadily advanced in New York is its crisis. For obvious reasons, the curator-producer who covets the spotlight will favor artists of nontemperamental character and works in which personality has been reduced to a minimum. At the Metropolitan, the major displays were by so-called object-makers—"post-painterly" canvases; that is to say, smooth-surfaced, cool, and tending to blend with their setting. The largest work, Stella's mammoth, shaped canvas, ten by forty-two feet, was not a picture on a wall but a wall; one can imagine a building constructed around it. It is composed of joined segments set at angles to one another, and the contours of each segment are emphasized by the parallel lines that constitute the painting. The result is

Frank Stella, *Sangre de Christo*, 1967, metallic powder in polymer emulsion.
Collection Dr. and Mrs. Charles Hendrickson, Newport Beach, California.

comparable to the kind of rhythmical patterning with which bricklayers decorate a facade by setting bricks in contrasting directions. Using pieces of this sort, Geldzahler has created some rooms with brilliant decorative effects. But the exhibition was tone-deaf, and, in its indifference to the personages, from de Kooning to Nakian and Saul Steinberg, who reduced the gap that separates New York from Paris of the past, "Henry's Show" made art in America seem in an even more precarious position than perhaps it is.

Part Four / The De-definition of Art

18 / Confrontation

> During the events of May and June, 1968, culture and art no longer seemed to interest anyone. Drawing the unavoidable conclusions, the museum curators closed their cemetaries of culture. Infected by this example, the private galleries locked their doors. . . . During the May Revolution, the city once again became a center of games, it rediscovered its creative quality; there instinctively arose a socialization of art—the great permanent theater of the Odéon, the poster studio of the ex-École des Beaux-Arts, the bloody ballet of the C.R.S. [police] and students, the open-air demonstrations and meetings, the dramatic reports by Europe No. 1 and Radio Luxembourg, the entire nation in a state of tension, intensive participation and, in the highest sense of the word, poetry. All this meant a dismissal of culture and the arts.

The death of art has been declared for half a century, but the above statement by French critic Michel Ragon forecasts what will replace it. Against art Ragon poses the political demonstration as a superior form of creation; the model of aesthetic expression becomes the public event. Whatever the merit of this view, its effect is to discredit the anti-art artist, who in demonstrating the death of art has continued to present himself as its heir. From Mondrian to Dubuffet, this is the century of "the last painter," whose formulas of negation have promised to defy further reduction. Painting divided by zero has, however, proved to equal infinity: art might be coming to an end but there has

been no end to anti-art. Now the whole game is put into question not by works of art but by collective action that, in Ragon's phrase, simply "dismisses" it.

Ragon's remarks are taken from a collection of essays, published in English under the title of *Art and Confrontation: The Arts in an Age of Change* (Jean Cassou, ed., New York Graphic Society, 1970), by nine French art critics, curators, and professors for whom the Paris student uprising of May, 1968, was both an exposure of the degraded condition of art in our time and an example of an alternative. The essays contain a checklist of complaints not only against the art market, the museums, the careerism of artists, the opportunism of critics, the speculations of collector-dealers, the aimlessness of art instruction, but against art itself. "Perhaps," writes Ragon, "it was first and foremost the 'work of art' that was aimed at in the confrontation." The complaints are for the most part the same as those heard in New York, but the French writers, some of whom show leanings toward Marxism (though all are opposed to Soviet aesthetic dogma and what one contributor calls "the frightful blunder of socialist realism"), are more outspoken than the Americans and reach tougher conclusions. Their common conviction is that the current ills of art cannot be cured piecemeal. Criticism today, says Jean Cassou, former Chief Curator of the Musée National d'Art Moderne, in his introduction to *Art and Confrontation*, ought to be total; it should apply itself to the culture as a whole, not be limited to "the way such and such a wheel turns inside the totalitarian machine." For these authors our "consumer society" is essentially inimical to creation; its merchandising culture treats works of art as objects, alienates them from the subjective experiences that brought them into being, and packages them for consumption as "cultural goods." With its promotion of a few sacred cows, the market system isolates the artist as a specialist striving for stardom in a narrow field of performance; in the last analysis successful artists "work exclusively for multimillionaires and museums." Nor is this situation improved by attempts to "democratize" art—for example, through multiples and increased museum attendance, since the multiple only increases the number of private collectors by making collecting petty, and

"there is no use luring people to museums if they haven't the means for arriving at a true understanding, at a personal experience of works of art."

Beyond the case against society there is the case against art itself—an individual activity in an age of teamwork, the puttering of a handicraftsman among technicians working with advanced mechanisms. In a word, the artist is an anachronism; his methods are pre-industrial and his equipment is out of date. He is trying to get to the moon in The Spirit of St. Louis. If, on the other hand, he attempts to integrate himself into the present, he can do so only by accommodating his work to technology and cultural education, which as now constituted are inhuman and repressive. According to Pierre Gaudibert, curator of the Musée d'Art Moderne de la Ville de Paris, the artist tries "to think of himself as a 'creator,' having at his disposal a limitless power in actions that are sovereignly free and demiurgic," but to maintain this illusion he must close his eyes to the actual conditions under which his work is produced and distributed. Some contributors to *Art and Confrontation* question whether a true facing of the issues is possible for the contemporary artist, who, to quote a text posted on a wall of the Maison des Beaux-Arts, "remains on the periphery of the realities of the street, the city, and everyday surroundings, creating images that are never integrated because they are destined for museums and the apartments of the rich, because they are articles of mercantile value or items for archives, cultural certificates, because their authority is probably conditioned by the cult of personality and signature, a trap laid by confidence tricksters." Other contributors, however, believe that advanced twentieth-century painters have found the means to convey the negative aspects of the modern cultural situation. In Ragon's opinion (and this comes close to contradicting some of his other views), Dubuffet and Fautrier, though still working within what the Beaux-Arts text called "the age-old definition of the artist handed down by dealers, schools, and institutes," have produced in France an art of confrontation, as have Bacon in England and de Kooning in the United States.

Gilbert Lascault, who teaches ancient languages at Nanterre, presents a long list of contemporaries, from Christo to Kienholz,

as confronters who have succeeded in undermining the stability of middle-class culture despite its defensive ruses, such as embracing hostile art in order to demonstrate its own liberalism. By comparison with most *Art and Confrontation* contributors, Lascault is extremely sanguine about what art can do. Though

Photograph by L'Agence Gamma.

he recognizes that novelties in art "shake only our sensibilities and not the world," he counts what others consider to be official avant-garde paintings and sculptures as revolutionary attacks. A slashed canvas by Fontana, who learned to manipulate perforations as a decorative device; a rumpled canvas on a broken stretcher by Pieter Engels (a pantomine argument in the formalist "what is art?" debate); a huge monochrome by Olitski, "an image of a world at once mediocre and off-center"—these are to

Lascault significant reflections of modern social and metaphysical reality and also symbolic assaults on that reality. Similarly, the "cool" art of American Pop painters—Warhol, Lichtenstein, Wesselmann, Rosenquist—appears to him a nihilistic challenging of social values, as well as a criticism of art that "asserts its [art's] inferiority to the mere possibility of revolution."

Lascault's reading of works is often farfetched—for one, his notion that a Warhol Campbell's soup can "reveals the nightmare on the inside of paradise and the happy moments in hell." Showing no awareness of the formalist and parody impulses in postwar painting and sculpture, Lascault is inclined to accept every novel visual effect as an instance of revolt and cultural subversion—exactly the response sought by the publicity apparatus of vanguardism. In seeing Rauschenberg, Johns, Indiana, Segal as forcing an unwilling society to acknowledge the existence of sex, decay, love, and death, Lascault is victimized by nostalgia for a radical avant-garde. To Ragon, by contrast, avant-garde art "has become official to the extent of being quoted on the Stock Exchange, collected by museums, Greek ship-owners, Nelson Rockefeller, Georges Pompidou, etc." Lascault's true hero is Dubuffet, who turns up in a majority of the commentaries in *Art and Confrontation*. If any artist is a professional confronter and anticulturist, it is Dubuffet. In 1951, he delivered at the Arts Club of Chicago a lecture on "Anticultural Positions," in which he took the side of the jungle against the Greeks, beauty, reason, written language, and individual identity—all traditional whipping boys of the avant-garde. (See Chapter 7, "Primitive á La Mode.") Since the Events of May, 1968, he has become the author of a manifesto, *L'Asphyxiante Culture*, (Paris: Pauvert, 1968) which proposes "institutes for deculturalization, nihilistic gymnasiums as it were, where particularly lucid instructors would give a course in deconditioning and demystification lasting several years, in such a way as to equip the nation with a thoroughly trained body of negationists who will keep confrontation alive, at least in small, exceptional isolated circles, amid the general entrenchment of cultural conformity." The entrenchment of cultural conformity is what Dubuffet counts on for the success of his shock tactics. In *Art and Confrontation* he is

quoted for his activism ("No more onlookers, nothing but actors"), his eroticism, his liking for mud, dirt, and camel dung, his contempt for pictures hanging on apartment walls, and Marx and Freud are evoked to explain the liberating significance of his taste for foul odors forbidden by a repressive civilization.

Yet Dubuffet's militant primitivism belongs not to the bush but to international avant-gardism, now turned into official culture, and Ragon finds himself obliged to point out that this artist's confrontations did not prevent him from accepting a retrospective at the Museum of Decorative Arts, in Paris, under the patronage of the Minister of State for Cultural Affairs and the Director General of Arts and Letters. That, after these blessings, Dubuffet could still write that "the State, as I see it, has only one face—that of the police" and that "I can't imagine the ministry of culture as other than the police of culture" arouses the suspicion of a put-on, and leads Ragon to wonder whether the part played by confrontationist artists is at all different from that of conformists. Even Duchamp, field marshal of anti-art, is not above censure as a collaborator of the museum-dealer-collector complex; he is accused by a young artist, quoted in *Art and Confrontation*, of having imprisoned the imagination in aesthetic illusions because he presented his bottle racks, urinals, and spades as art. The only true confrontation is for the artist to vanish and take art with him, in order—in the words of André Fermigier, school administrator, art critic, and author—"to restore to everyone full responsibility for his relationship with the world." An inscription on a wall of the Sorbonne summarized the position: "Art is dead; let's liberate our day-to-day life. Poetry is in the street." (See Chapter 4, "Surrealism in the Streets.") According to the consensus of confrontation, the death of art sets free the power of creation from individuals and passes it on to all.

The notion that art is the obstacle to expanded human creativity is an art-world notion; it would never occur to the man in the street that art stands in his way (for that matter, it probably never occurs to him that he wishes "to create"). In calling

for the death of art for the sake of liberating mankind, art confronts not society but the dilemma of its own existence in an epoch of new media that have assumed most of art's functions. It is significant that in America the first challenges to art by aesthetic vanguardists appeared in *Camera Work*, organ of the avant-garde photographer and gallery proprietor Alfred Stieglitz. In 1912, Benjamin De Cassères published in *Camera Work* this foreshadowing of anticulture and psychic insurrectionism: "I find my supremest joy in my estrangements I desire to become unfamiliar with myself I cling to nothing, stay with nothing, am used to nothing, hope for nothing. I am a perpetual minute." In affirming self-estrangement and anonymity as radical alternatives to inherited culture, De Cassères was invoking the "poetry" of the street crowd, and his self-identification with the "perpetual minute" was an elevation of the snapshot above the oil painting. "Democratization" of art, which is achieved only fractionally and on the spectator level by multiples and expanded museum attendance, is fully realized through the universal clicking of camera shutters, which provides every man with his own lasting minutes and seems to relegate art to the esoteric pastime of an élite.

Photography thus has an important part in the negation of art through confrontation with social reality. The camera, however, is still an instrument of individuals, and so it differs from painting only in being more accessible. The cameraman is tempted to consider himself an artist and to enter himself in the museum-gallery-collector sweepstakes. To surpass mere change in the number of people engaged in art, democratic creativity must begin by eliminating the egotism of art, and this, according to confrontation theory, is achieved in the mass event that sweeps the individual out of himself into the quasi-sacred rapture of a shared identity. It is this selfless "joy" that is celebrated in *Art and Confrontation* as the beyond of art into which art-making will be dissolved. In the Paris uprising, art was transcended by immersion into (to revert again to a phrase of Dubuffet) "a sort of continuous universal soup with the taste of life about it." Confrontation with society became for each individual a confrontation with the vestiges of his self-consciousness and self-seeking. Values were re-

versed through being reflected in the mirror of the enemy: "La Police S'Affiche aux Beaux Arts," says the poster reproduced on the jacket of *Art and Confrontation*. A similar magical reversal dispenses with art and ego values in American rock festivals. "A mud slide was built," reports a college newspaper, the University of Chicago *Maroon*, of a freak festival near Madison, Wisconsin, that would have delighted Dubuffet, "and a Mud King was crowned with a slab of mud topped with a mud plant. It was clean mud somehow."

The festival, whether of action, pranks, or picnicking, arouses feelings analogous to those of creation and thus appears as a replacement for art. Compared with art-making, however, collective enthusiasm is, like the ecstasy of drugs and dreams, an "artificial paradise," since its aesthetic effects are given by the event itself, without invention on the part of the spectator-participant. Aesthetically, the May Revolution was a "found" Happening, Woodstock was a proto-insurrection—in short, events of the same order. Both are episodes in the war of youth culture against the institutional culture inaugurated in the nineteenth century and again half a century ago by the so-called "college boys" of Futurism and Dada, a conflict that has always come to a head in the streets. In self-defense, official culture has learned to embrace the youth vanguard, just as galleries and museums eagerly supported student protests against the war in Cambodia and the massacres on the campus. But through being taken into the museum the avant-garde itself has been discredited in its role as an antagonistic force and no longer represents the disaffected young. Those who pledged themselves to despise art, derange accepted values, and change life are now being presented with their IOUs through the medium of events that "dismiss" art. Today's social confrontations declare that the slogan "Art is Dead" has become a hoax unless art in all its forms is given up and, as Ragon remarks, "the break with society is complete." No more anti-artists pestering their dealers about sales and arranging retrospectives. But since the life of art is now officially that of vanguard art, the end of vanguardism means also the end of all those ruses of scrutinizing itself and defiantly denying its own existence—ruses through which art has survived.

Political confrontation forces art seriously to examine its revolutionary pretensions. Perhaps art has only a secondary relation to the uprising of youth against oppressive institutions. Above all, art in our time is the major resource of individuals bent on freeing themselves from the culture of the crowd, whether it is represented by museum-gallery education or by mass events. For Ragon, "the aesthetic element that brings life to our streets" is advertising posters—a sufficient reason, it would seem, to preserve the autonomy of the studio. The phrases on the walls of Paris admired by the contributors to *Art and Confrontation* were a legacy of poets, painters, philosophers whose minds were developed by literature, not by "intensive participation." To write, on a Paris wall, "Under the paving stones the beach" is a kind of action quite unlike hurling a paving stone at the police. Art cannot confront society except in acts of originality, which official culture succeeds in absorbing but by which men are nevertheless changed in unpredictable ways.

19 / D.M.Z. Vanguardism

Values in art today presuppose the general values of originality and intellectual advance; that is to say, they assume the existence of a vanguard. The principle was formulated several decades ago by T. S. Eliot: "It is," he wrote, "exactly as wasteful for a poet to do what has been done already as for a biologist to rediscover Mendel's discoveries." Whatever one's opinion of Eliot's economics of novelty, there is no doubt that it dominates current thinking in painting and sculpture (or sculpture and painting, to put the arts in their present order of interest). A book presenting recent sculpture, Udo Kultermann's *The New Sculpture*, is subtitled *Environments and Assemblages* (Praeger, 1968), to differentiate it from the expressive structures of pre-nineteen-sixties sculpture, and the author attempts to explain how the creations of this decade constitute an "expansion of the artistic system"—a phrase fully in accord with the outlook of Eliot. Examples of the new sculpture are Robert Graham's realistic figurines of naked girls under Plexiglas domes, which, except for their sexiness, resemble mass-produced Victorian mantelpiece decorations; they are interpreted by Kultermann as representing, together with the sculptures of George Segal and Frank Gallo and the blue nude-prints of Yves Klein, "the thingness of the human body," and they are related by him both to the commercial mass media and to "the philosophy of Heidegger, Sartre, and Merleau-Ponty." (According to current American art-historical clichés, the asso-

Robert Graham, *Untitled*, 1969, mixed media.
Courtesy Kornblee Gallery, New York.

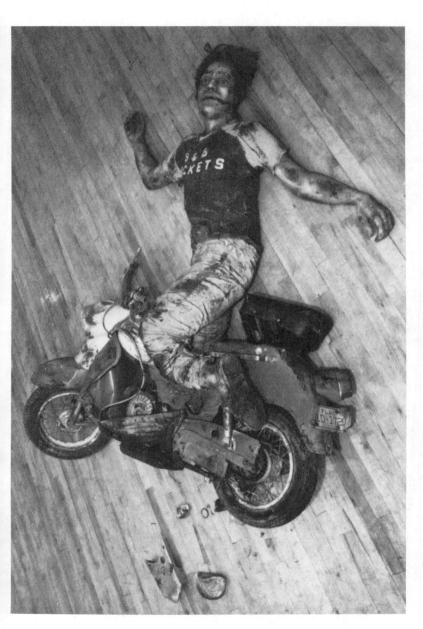

Duane Hanson, *Motorcycle Victim*, 1969, fiberglass, polyester and talc.
Collection Robert Mayer, Winetka, Ill., Courtesy O.K. Harris Gallery, New York.

ciation with Existentialism would push these sculptures back into the forties or fifties.) Another book gets the jump on *The New Sculpture* by calling its subject *Beyond Modern Sculpture* (Braziller, 1968)—its author, Jack Burnham, is also concerned with systems and the "thingification" of human beings, but he is even more profoundly involved with Eliot's formula than Kultermann, since he sees contemporary art as "a psychical manifestation of the scientific demiurge, which moves ceaselessly in a single irreversible direction." While Burnham includes in his book several of the artists dealt with in *The New Sculpture*, he ignores the neonaturalism and several other categories featured there, in order to concentrate on abstract constructions and Kinetic, programmed, and light art—in sum, on works associated with new technologies. "Increasingly, pure energy and information seem to be the essences of art," Burnham concludes his chapter on "Light as Sculpture Medium." "All else is being dropped methodically by the wayside."

Eliot would not have agreed with Burnham about the "essences" of art, but his analogy between poetry and science implies that in the arts, as in biology and physics, objective solutions are attained which ought not be repeated but from which it is necessary to go on to more advanced problems and solutions. If this is so, progress is inherent in art on the basis of its own past accomplishments. To embody this progress, a succession of avant-gardes must arise, each superseding the solvers of earlier questions. In the first years of the twentieth-century, a dynamic of this sort apparently prevailed in all the arts; and the presence of an avant-garde may still be taken for granted by those who link art with technological advances or with stylistic evolution. For some time, however, continued forward movement in the arts and the formation of vanguards have been a matter of dispute. Twenty-five years ago, the poet Randall Jarrell, in an article entitled "The End of the Line," flatly concluded that "Modernism as we knew it . . . is dead," and, twenty-five years before that, Paul Valéry's intellectual Hamlet, contemplating "The Crisis of the Mind," asked himself, "Have I not exhausted my desire for radical experiments, indulged too much in cunning compounds?" Comparable doubts about progress in the arts and the continued

emergence of avant-gardes have been reechoed in every decade since the First World War, often by vanguardists themselves. Any estimate of what is happening in painting and sculpture today will depend on one's view of this question. The belief that art continues to advance to new positions is behind the common tendency among curators, dealers, collectors, critics, and artists to embrace the latest mode and "drop all else methodically by the wayside." If, however, the end of the line has indeed been reached, each new vanguard only represents another way, in Jarrell's phrase, to "go back and repeat the ride."

Such seems to be the character of much of the art being produced today, in the opinion of Hans Richter in his *Dada, Art, and Anti-Art* (Abrams, 1970), originally published in 1965; as if in reply to Dr. Kulterman (as well as to the incredibly ill-conceived exhibition "The Art of the Real," at the Museum of Modern Art), he points out that "our time (as well as we ourselves?) has developed such a lust for physical presence that even the lavatory seat has become holy to us," adding, "we want not only to see it in a picture but also to *have* it physically." But, Richter recalls, citing specific object-works, such as Duchamp's bicycle wheel, the Dadaists perceived this forty years ago, and to repeat their transfer of everyday things into the museum "is not a rebellion but the opposite: an adjustment to so-called popular taste, a deliberate return to the garden dwarfs." In short, creations accepted as advanced may be simply fashionable—the work of an ersatz avant-garde that has revived the phrases and gestures of an earlier movement but is unable to go forward to a new concept. The effect produced by such decorations is not the shock of discovery but nostalgia—exactly the effect of the Grahams (as art, not as nudes) that I have mentioned above.

In literature, analysis of the phenomenon of vanguardism, or modernism, has been going on for years, but little of a similar nature has been undertaken in sculpture and painting. A study that seems to be the most comprehensive theoretical examination to date of the aesthetic vanguards in their common historical, social, psychological, and philosophical aspects is Renato Poggioli's *The Theory of the Avant-Garde*, which appeared posthumously in 1968 (Harvard University Press). The impulse to

take an inventory of the avant-garde or to paint a composite portrait of it may itself be an evidence that the record of the avant-garde is suspected of being now complete.

Noting that some artists and critics believe that the vanguards have vanished or are about to vanish, Professor Poggioli rejects this judgment on historical grounds. The root of the vanguard movements, he holds, is alienation; all the attributes of vanguardism—its activism, antagonism, nihilism, futurism, anti-traditionalism, obscurity, iconoclasm, cerebralism, abstraction, unpopularity—flow from the estrangement of the artist in modern society. Poggioli quotes Mallarmé's remark about the isolation of the artist in "this society that will not let him live" and Baudelaire's verdict that "the man of letters is the enemy of the world." It is the separation and hostility of the avant-garde that for Poggioli constitute the essence of avant-gardism and guarantee its survival as a "minority culture." To eliminate the vanguard, it would be necessary to eliminate alienation, and to eliminate alienation would require "a radical metamorphosis in our political and social system." As long as liberal-democratic capitalism remains intact, civilization will continue to be the scene of "a conflict between two parallel cultures." In the United States, the majority culture against which the hostility of the avant-garde is directed is the culture of the mass media—a "pseudo culture" that destroys qualitative values and oppresses the artist by forcing him to produce for the market or exist as a parasite. Given the basic causes for antagonism between the artist and society, the vanguard can vanish only if our civilization is transformed into a totalitarian order that bans all intellectual minorities and allows only the mass media to function.

For all the insights in *The Theory of the Avant-Garde*, Poggioli's analysis of the prospects of the vanguard seems to me to be based on conditions that are out-of-date. He sees the position of the artist in bourgeois society in the traditional perspective of the cultured European, supporting his outlook with quotations from Ortega y Gasset, Mann, Malraux, Lukács. Yet art today, especially in America, has ceased to be responsive to the dialectic of the alienation of the artist and the counterblows of a hostile mass culture. The notion of a vanguard embodying an

"adversary culture" (to use Lionel Trilling's epithet) or a "culture of negation" (to use the one adapted by Poggioli from von Sydow) is no doubt applicable to the period between the Armory Show (1913) and the pre-affluent stages of Abstract Expressionism (1952-1953); it reflects the kind of situation in which artists used to talk about "selling out" to Hollywood or Madison Avenue. In the forties and early fifties, artists like Gorky, Pollock, Rothko, Newman, Gottlieb, and de Kooning still carried on the tradition of cultural distance. Since the advent of Pop Art, however, no influential American art movement has been either overtly or tacitly hostile to the "majority culture." On the contrary, the leading idea in Pop, Op, color-field, Minimal, and Kinetic art and in Happenings has been to exorcise the negative impulses that tormented the earlier vanguards. Today, both the alienation of the artist and the antagonism of public opinion to art have been successfully liquidated. The art of the sixties is both in and of the "environment" and eager to collaborate in extending its characteristic features, whether in the form of images of suntanned nudes, street-corner monuments, or programmed mixtures of light and sound. This desire for non-hostile elaboration of aesthetic possibilities is the social meaning of the "thingness" of the new sculpture (being there without comment or offense) and of its technological orientation. The dour struggle for freedom has been superseded by the promise of a sensibility whose expansion is implicit in the laser beam.

Accepting Poggioli's identification of the avant-garde as alienated and hostile, one would have to conclude that, whether or not we have entered into a phase of totalitarianism, the avant-garde has ceased to exist. As I have indicated, this is often suspected, but such a conclusion is too simple. Though the social and psychological negations essential to the formation of vanguards are no longer operative, vanguardism as an idea exerts a greater force in the creation and dissemination of art than ever before. It regulates the sponsorship of artists and modes of art by museums, galleries, international exhibitions, critics, and collectors; it stimulates the feverish search by young artists for new

materials and extreme gestures; it determines the attention paid to works in the popular press. The socially reconciled avant-garde (an inconceivable self-contradiction in Poggioli's terms) enjoys the augmented prestige of a power distant from us in time; that is to say, of a myth, the myth of rebellion. The aura of defiance is effective in glorifying even prophets of participation, such as McLuhan and Kaprow, whose programs include leading strays back to the flock.

In sum, while art today is not avant-garde, neither has it been absorbed into the system of mass culture, as ordained by Professor Poggioli's analysis. The present art world is, rather, a demilitarized zone, flanked by avant-garde ghosts on one side and a changing mass culture on the other. This buffer area, immune to attack by both vanguard intransigence and philistine prejudice, contains an avant-garde public in which the alienation of the artist is muffled and which also provides a market for the expansion of mass culture into more sophisticated forms—an example is the popularity of Andy Warhol. In the aesthetic D.M.Z., all art is avant-garde, and all avant-gardisms, the ideas, attitudes, and tastes of a century of experiments and revolts, have been blended into a single tradition. All the advanced art modes of the last hundred years now constitute the modernism that is the normal mode of expression for a wing of popular taste—the Metropolitan Museum's "1940–1970" exhibition (see Chapter 17, "École de New York") is a typical product of the new Pop mentality. Like all traditions, this amalgamated modernism stimulates automatic responses, as illustrated by the wholesale acceptance by the avant-garde audience of the products of advanced movements, past and present, regardless of abysses between them—e.g., collectors equally enthusiastic about Vuillard and Duchamp.

Taken en masse, the innovations accumulated by the experimental movements from Impressionism to light shows are capable of generating an apparently inexhaustible variety of visual excitements, many of them on the level of the midway or amusement park. (That the younger generations of artists and spectators were born too late to enjoy the participation spectacles of Coney Island's Luna Park and Steeplechase accounts for a good deal

of their innocent belief in the originality of Kinetic art toys and engineered Happenings.) Like the New York skyline, sculpture and painting today form an impressive collective image composed of free-enterprise undertakings undistinguished in themselves. Seen up close, however, the works tend to sink back into their original formal categories, inviting such labels as Neo-Dada, Neo-Constructivism, Neo-Neo-Impressionism, or they arrange themselves in technological classifications—hard-edge, saturated-color, assemblage, electronics, robots. These clusters of modes identify trends competing for recognition as the newest. In sculpture, especially, the industrial proliferation of new materials and devices makes possible countless combinations in which originality of a sort is all but inevitable.

D.M.Z. avant-gardism has its own theory of art history: that the *angst* and anger of earlier vanguards were essentially superfluous, since, the argument goes, it is "as art" that the products of the vanguard have survived. (A stronger case could be made for the idea that it is as vanguard that art has survived.) The practice of demilitarized-zone critics of interpreting the visual expressions of alienation, anxiety, and rage by Fauvists, Futurists, Dadaists, and so on as incidents in a victorious march toward new heights of formal mastery (e.g., Stella, Olitski), accounts for much of the hallucinated rhetoric of current writing on art. (See Chapter 11, "Young Masters, New Critics.")

The D.M.Z. has its own aesthetic, too, which consists of "delectation," or "quality," keyed to the concept of historical advance. As a symbol of D.M.Z. originality, I should choose the colored plank of John McCracken, which turned up leaning against the wall of almost every exhibition of advanced art two years ago. (According to an unsubstantiated rumor, McCracken was offered an all-expenses-paid trip to Germany to install his board at Documenta.) One of its displays was at the Museum of Modern Art in the "Art of the Real" show, for which the board bore the title "There's No Reason Not To." The social acceptability of this creation emphasized by its label expresses most pungently the state of disarmament that has replaced the battlefront described by Poggioli.

Painting today is a profession one of whose aspects is the

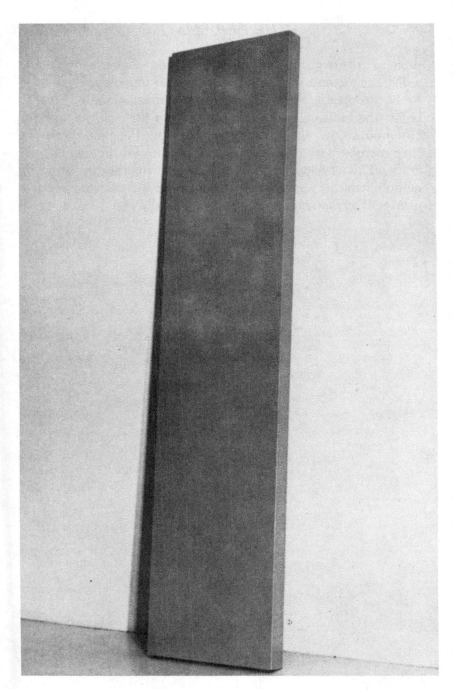

John McCracken, *Untitled*, 1970, wood, fiberglass, polyester resin.
Courtesy Sonnabend Gallery, New York.

pretense of overthrowing it. Once the vanguard myth has faded, the pretense that art is engaged in self-immolation will have to be dropped. (See Chapter 18, "Confrontation.") At that point, the bulk of production in museum art will, by a more circuitous route than that anticipated by Poggioli, probably have merged with the entertainment media and the commercial crafts. This development may leave room for the formation of new militant art vanguards—or at least for a freer (less socially managed) communication among individuals.

The artist today is offered a catalogue of styles and invited to choose. He knows, however, that the latest edition of the style book is already out of date. Everything that has been done in art opens another door, but the door faces a blank wall. To the artist, once someone else had made a move there is no use repeating it. In effect, therefore, each invention plugs up another avenue of advance. Thus, having cancelled or submerged traditional modes in art, the new has reached the point of cancelling itself. All advanced styles are simultaneously legitimized on the ground that they reflect present realities, and discredited on the ground that they belong to the past. Survey exhibitions of current American painting, such as the Whitney Annuals, are reports on what artists in that year have been able to do with the accepted visual vocabulary of the year before. Observers find the surveys depressing: the selections are inevitably too pat with familiar trends—though the exhibition catalogues, with ritual hopefulness, bravely claim, to quote a recent one, that the works in the show exemplify "new directions generating the most creative excitement." Excitement! The reigning spirit in American art of recent years has been cool-headed adaptation. A reviewer of the 1970 Annual protested that he was "dismayed" by "the degree of sheer cleverness and expertise displayed"—a response similar to Baudelaire's observation regarding the Salons of a hundred years ago that "everyone is painting better and better, which seems to us a lamentable thing."

That good or expert painting can be dismaying and lamentable is one of those floating problems of modern art that have never been adequately pinned down. What did the critic who was dismayed expect—that the machinery for solving problems conceived by art historians that kept painting and sculpture going throughout the sixties would suddenly give birth to unheard-of-flowers? The sixties was a decade of stylistic programming, not of outstanding creations. It brought to light no new radical idea nor widely persuasive image. Its obsession was the negative one of liquidating the preceding era of "expressionism" through works in which the artist effaced himself in his concept. One of its canons accepted by art dealers was the "non-painterly" surface which condemned traces of the artist's hand. Above all, the art of the decade lacked what Baudelaire called naiveté, that is, the shaping of works by temperament rather than by rule. It was a decade of experimenting with art materials, past styles, and art-critical concepts—in itself not unimportant. But art that is based on nothing more than a concept or a use of new materials is design—it was in new design that the sixties were richest.

Viewing the traditional gestures of revolt, the critic I have quoted reluctantly concluded that "the role of the avant-garde has become one of the casualties of the past decade." By the measure of earlier vanguards—for example, the Surrealists with their conception of attaining a new psyche, the Futurists with their discovery of the new physical and social rhythms of the twentieth century—his judgment was unquestionably correct. Conceiving design variations on existing styles—whether to fulfill commissions for world's fairs or for the textile industry, or to illustrate theories of space or color extrapolated from the history of modern art—is not an avant-garde activity.

Still, one should perhaps consider that the notion of a vanguard may itself no longer be a vanguard idea, and that to expect present-day painting and sculpture to equal or surpass the innovations of Cubism, Futurism, or Constructivism could be, except in the case of some rare individual, a mistake. Those who complacently applauded each novelty of the sixties, from Pop to shaped canvases, as if it were the latest in a series of revolu-

tionary "advances" are predisposed, when confronted by too-prompt overproduction in all of these modes, to be excessively pessimistic about the accomplishments of the decade. The "crisis" of painting has, once more, become a popular theme in the art journals. What is regrettable is not that the sixties should have ended on this note but that the continuing crisis of art, which is the fundamental condition of creation in our century, should have been for so long desperately denied.

Fortunately or unfortunately, yesterday's avant-garde art becomes today's new design. The following jingle should help in memorizing the principle:

> Art movements in decline
> Produce nouveau design.

Though painting and sculpture in the sixties may have lacked avant-garde élan (for which no basis existed in either its politics, philosophy, or social theory), they were moved by an intense desire to keep up with the realities of the present day as these were manifested chiefly in technology and the mass media. The seemingly unrelated modes of art prominent in the sixties, representational and abstract, all pointed toward phenomena made part of everyday life by advertising and entertainment art, electronics, animated mechanical gadgets, supply-house equipment and parts, news photography, wholesale reproductions of paintings and sculptures. Pop and Op art, Kinetic constructions, light art, modules and machine-shop sculpture, silk-screen photo and typographical assemblages, color-area painting, computer-patterned figures, abstractions and cutouts, mixed-media spectacles matched the visual and somatic effects of the industrial environment. In pursuit of technological freshness, painting and sculpture put aside their traditional mediums—wood, stone, paint, cast metal—in favor of new manufactured materials and industrial-age waste: the decade opened with junk assemblages and reliefs, moved on to aluminum, Plexiglas and other plastics, and tense cables and wires, and wound up in a conscious rejection of both new and old art materials in preference for the earth, rocks, animal

matter, and raw substances (strips of felt, rubber and copper sheets, lead pellets) of the "anti-form" movement.

The "sheer cleverness and expertise" that the critic of the Whitney objected to are precisely the qualities that have enabled art in the sixties to expand design possibilities through apparently limitless stylistic derivations and combinations of materials. The quantity of visually competent matter currently presented in the art galleries and art magazines is literally over-whelming. By the same measure of visual competency there is not much to object to in the products of the typical figures of the decade—e.g., Noland, Stella, Kelly, Warhol—except the pre-tentiousness of the claims made for them. In essence, the sixties carried forward the work of the Bauhaus in the Weimar period (1919-1925), when the school mixed principles of art with objectives of product design; it is symbolic that in the closing year of the sixties the mammoth documentary history of the Bauhaus, by Hans M. Wingler, was published by the M.I.T. Press, and that the Los Angeles County Museum organized an exhibition for the United States Pavilion at the Japan World Expo, in Osaka, under the title "Art and Tech-nology." In 1923, "Art and Technology—A New Unity" was the theme of Gropius, founder of the Bauhaus: "If a creatively talented person had a factory at his disposal with all its machin-ery," wrote Gropius, anticipating to the letter the Los Angeles artist-industry collaboration, "he would be able to create new forms that would differ from those produced by hand crafts."

The orientation toward super-technique has been met with skepticism by a few artists and critics, but this was so in the case of the Bauhaus, too. The question is to what degree the industrial-design outlook is forced upon art by the character of the century. "With absolute conviction," declared Lyonel Feininger, one of the painter-masters at the Bauhaus, "I reject the slogan 'Art and Technology—A New Unity'; this misinterpretation of art is, however, a symptom of our times" (one of whose other features he found to be "the aimlessness of the typical art school"). Another Bauhaus master, Georg Muche, went farther: in his view "the close contact between modern art—especially painting —and the technological development of the twentieth century

must lead inevitably and with surprising consequence to mutual rejection." Muche went on to say, as if he were describing the 1960's attack on subjective individualism in art, that in his enthusiasm for technology "the artist . . . disproved his own existence. The square became the ultimate picture element for the superfluous—for the dying—field of painting." After mentioning that the "enthusiasm for modern design" is "extraordinarily intolerant toward art," Muche concluded that "art has no ties to technology; it comes about in the Utopia of its own reality." Despite opposition, however, Gropius's affiliation of art with technology prevailed at the Bauhaus, perhaps because, as Feininger had noted, the temper of the time favored it. The antagonism brought to the fore by Muche was settled by reducing the role of art. "Independent creative work," observes Wingler in the margin of Muche's statement, "never again acquired the significance it had held during the first years of the Bauhaus; art was relegated more and more to a peripheral role in the work of the Bauhaus."

The virtue of the Bauhaus lies in its intellectual forthrightness and its willingness to draw candid conclusions, in contrast to the coyness of the contemporary American art world in defending "High Art" while repudiating it in practice. The Bauhaus based its program on its realization that once the idea of the individual artist and of his metaphysics of creation were discarded, art had to find its meaning in social utility. Unwilling to educate "little Raphaels," as he contemptuously put it, Gropius conceived the purpose of the Bauhaus to be "the training of artistically talented people to become creative designers in the fields of the crafts, industry and architecture . . . The Bauhaus wants to serve in the development of present-day housing, from the simplest household appliances to the finished dwelling." The ultimate goal was the unity of the creative arts under architecture as "the total work of art." Lazlo Moholy-Nagy, who used his oil paintings as studies for works with practical application, denied the significance of the modern art movements with the contention that "despite all formal differences" they were attempting to achieve "the same clarification of visual design principles. The common denominator of all the

'isms,' from naturalism to constructivism . . . is the continuous, unconscious struggle to conquer the pure, primary, and autonomous means of expression and design." This view, which subsumes the sensibilities and the drama of individual artists and the philosophies of the modern schools under a single formal purpose, has an uncanny resemblance to the formalist criticism of the sixties, which analyzes works in all modes, from Futurism and Dada to Abstract Expressionism, as applications of Cubist conceptions of space. But Moholy's statement is theoretically more complete in that it holds that avant-gardism has culminated in the will to improve the aesthetic quality of mass produced goods.

In the union of art and technology (including art itself as a technology), which I have taken to be the symbol of the sixties, the idea of a vanguard as the bearer of a singular vision or message of the times is replaced by the vigorous expansion of all modes of art conceived to be advanced in so far as the public taste is concerned. Gropius was justified in denying that the Bauhaus sought "to propagate any style, system, or dogma"; the artist as designer cuts across the styles of all creative élites in order to bestow modernism directly upon the aesthetic Silent Majority through the objects they use and images that are familiar to them. Lichtenstein re-designs the comic-strip box and the popular art reproduction, Chryssa the electric sign, Snelson the cables of power stations, Judd the row of factory supply bins. Vanguard art demands to be understood and even to change the spectator; the understanding and the change are the point of it. Art as design offers gifts of the new to the Majority without demanding comprehension in return. It brings the aesthetically uneducated person up-to-date in regard to taste, while leaving his beliefs, attitudes, and prejudices intact. Like applied science, which supplies the advantages of the self-defrosting refrigerator and the electric tooth brush, regardless of the consumer's knowledge of electronics, applied design induces the individual's participation in progress as naturally as a sudden improvement of the weather. Spiro Agnew is undoubtedly a modernist in his crockery and sport shirts, as he is in his use of jets and his reliance on the ABM. The Silent Majority and its leaders accept the bonanzas showered on them

by science, technology, and design as proof that good Americans are favorites of the Divinity. They anticipate no problems accompanying new technics, new things, new forms—and if problems arise their reaction is one of irritation.

The Majority has its own art forms: sentimental genre scenes, big-eyed waifs, likenesses of ancestors and great men, de-luxe-hotel "abstracts" of fishing boats, airport handicrafts. As for modern art, it is still, as I suggested twenty years ago, regarded as belonging to the Age of Queer Things. Yet the Majority can be lured into the contemporary world by means of new-style goods that serve the needs of daily life—an inflatable hassock decorated with traffic signs a la D'Arcangelo, Sears' self-sticking wallpaper "with colorful daisies [borrowed from Warhol] or without daisies." Besides seeking cooperation with technologists and engineers, present-day American artists have tried to project themselves directly into the surroundings of the Majority through products midway between art and supermarket ornaments and spectacles, such as light displays and Happenings, posters, color prints, banners, and multiples.

In the perspective of the sixties, it is evident that the Bauhaus had to contend with an irony: that when art is created for its own sake industry will appropriate it (if possible without royalties), while when it is offered as "creative design," industry will tend to ignore it. (The principle seems to be that art is more practical than practical art programs.) Nevertheless, there was a continuous tension at the Bauhaus between the painters who "wanted to be nothing but painters"—Klee, Kandinsky—and the succession of architect-designers—Gropius, Moholy-Nagy, Mies van der Rohe—who headed the school toward the product market. "At the Bauhaus," said one level-headed contemporary, "there are a few masters who are also masters even without the Bauhaus; the others are just Bauhaus masters." In a mixture of this sort, it is the artist who ultimately gets squeezed out by the institutional programmers. The Bauhaus course in basic art principles, called the Preliminary Course, which was taught by Klee, Kandinsky, and Albers, among others, came under increasing fire, first from the school administration, later from left-wing students, who attacked the usefulness of the

Josef Albers, *Study for Homage to the Square: Closing*, 1964, oil on board.
The Solomon R. Guggenheim Museum.

Herbert Bayer, *Intersected Circles (on grey)*, 1970, oil on canvas.
Marlborough Gallery, New York.

course. In the end, after years of patient protest and withdraw-
ing into themselves, Klee and Kandinsky found themselves
obliged to quit the school, as Schlemmer and other artists had
done before them. The artist as trainer of designers proved to
be in a basically conflicting situation.

The popularity of art in America today derives from its
design appeal, but American art will not settle for a role in
product design. American artists are aware that art for industry
is, as Muche pointed out, limited by the needs of distribution,
managerial control, and profits. Beyond the social utility of what
he produces, the American artist seeks a deeper meaning; he
has not ceased to be a Romantic. In the sixties, meaning lay in

the idea of winning a place in art history. Lichtenstein re-designed comics not to make them newer, better, or funnier, but to make them art-historical. (See Chapter 10, "Marilyn Mondrian.") The uneasiness of the American artist as designer, which echoes the uneasiness of Klee and Kandinsky at the Bauhaus, is especially manifested in the fantastically over-elaborated rhetoric of art-historical critical apology which has become part of the verbal inception of the works.

Art in America now exploits design but keeps itself aloof from the norm of social usefulness. In his giant Art and Tech-nology "Icebag," Oldenburg did not attempt an improved version; he redid the old drugstore fabric icebag, with its screw cap, in salmon-pink vinyl, enlarged it to eighteen feet in diameter, and animated it with gears, hydraulics, and blowers that would swell it in waves to a height of sixteen feet. An object of this sort, both old-fashioned and unusable, stands the Bauhaus tradition on its head or puts its tail in its mouth. For all the solemnity of sixties formalism, the expressionist revolt in Ameri-can art lingers on in slapstick and deadpan—including obtaining ex-orbitant expenditures for what Gropious called "useless" machines and sketches of unrealizable projects. Experience seems to indicate that art cannot keep step with technology—it is either ahead of it or behind. In retracing the old problems of European mod-ernism, American art is today neither avant-garde nor back-ward. It is managing to balance itself between past and future. In short, it is keeping up. Once its anti-subjectivist dogma is put out of the way, it may pass from conceiving the present as technology to dealing with the ultimate reality of the new—the condition of the individual and of man.

21 / The Museum Today

A museum under pressure to take a stand on Vietnam, women, or blacks finds it expedient to distinguish between history and art history. History includes repression and war; art history is concerned with these only insofar as they are reflected in works of art. Exhibiting "Guernica" does not imply that the Museum of Modern Art has taken a position against Franco, any more than exhibiting Ingres's "Odalisque with Slave" implies an attitude toward Women's Liberation or equal rights for blackamoor harem personnel. Theoretically, art belongs to a realm removed from temporal events; in it, a different measure of seriousness prevails. Even Trotsky, who judged human undertakings by their usefulness to the Revolution, conceded—in opposition to Lenin's dictum that "art belongs to the people"—that painting or poetry has interests that belong exclusively to itself. As the physical embodiment of the separateness of the arts, the museum is privileged to claim immunity from the issues of the moment. It represents the eternal in human performances, or at least the longer lasting. In Malraux's view, the museum stands above the torments and defeat that the iron determinism of history inflicts on the man of action. Its sacred obligation is to compile and keep intact the record of human freedom and creativeness, and this demands that it resist adulteration by matters not yet resolved into the enduring forms of art.

In actuality, however, modern art has destroyed the barrier between art and events. Its history includes the history of non-art and anti-art—that is to say, of art amalgamated with cultural artifacts (flags, Coca Cola bottles) and of works directed against aesthetic transcendence (Duchamp's Mona Lisa with mustache, Picabia's stuffed-monkey "portrait" of Cézanne, Renoir, and Rembrandt). Modern art has exalted creations that proclaim their own transience (disintegrating collages, Tinguely's self-destroying "Homage to New York" see Chapter 14, "Past Machines, Future Art"). Modernism identifies art that is lifted above nature and events with the Academy, and the continuity of avant-gardism lies in its attacks on the Academy's official delusion of permanence. Very early in our century, Futurism declared open war against monuments surviving from the past by raising the battle cry of Marinetti: "Burn the museums!" From ready-mades to earthworks, the aspiration of modernist painting and sculpture has been to mingle its products with the facts of life.

Thus two contrasting tempos have prevailed in the art of the past hundred years: the slowed pace of the academic "realm of art" and the event-stimulated dynamics of the vanguard. The interlocking of art and history, of the lasting and the ephemeral, has been a central philosophical problem of the modern epoch—a problem oversimplified both by the academic detachment from current developments and the avant-garde immersion in them. Most of the outstanding thinkers and artists of the modern period either have established a position somewhere between these extremes or have contradicted themselves by asserting both. Marx, despite his general conception that the "cultural super-structure," to which art belongs, develops in conformity with the evolution of the means of production, held that Greek art jutted out of its time as "in certain respects . . . the standard and model beyond attainment." Baudelaire, father of modernist consciousness and impresario of "the hero of modern life," reviled the philistine belief in automatic progress through science and technology and spoke of the realization of the eternal within the contemporary. Masters of modern art from Cézanne to Picasso and de Kooning have found in the art and attitudes of

the past points of resistance to the drift of avant-gardist art movements in the wake of new inventions, theories, and social changes. In the prevailing era of "the revolutionary simpleton" (to recall the epithet of Wyndham Lewis), it has become clear that art is in constant danger of being liquidated into a defoliated presentness, as represented by the data of the mass media and by technological innovation.

Since the war, art museums in America have become increasingly avant-garde; in many respects, they have outstripped art itself in pursuit of the new. The plunge into the stream of change has radically altered the museum's earlier relation to the past and to art as well. Aware of itself as a medium of mass education in novelty, it presents works of all times and places as *news*, laying stress on their "relevance" to the contemporary. The museum is of now and of time to come to a greater extent than it is of the past. Principle arbiter of what shall be considered art, it has recognized that the historian's tracing of stylistic relations among creations of the past and the present (including works lacking in style) confers upon him the power to magnify the effect of these works upon the future—or to nullify it. Like the political historian, the art historian has been recast into a conscious maker of history, not merely the orderly recorder of accomplishments of former times. In his freedom to participate in determining the direction of art he has become an agitator. Since art in our time arises to a greater extent out of ideas about art than out of admired art objects (Cubism out of Cézanne's methods, rather than out of imitation of his landscapes and still lifes), the evaluation of works cannot avoid being interpretive in a partisan way. Every major period-survey exhibition presented in the past two decades—"The 1930's" exhibition at the Whitney Museum, "The 1960's" at the Museum of Modern Art, the "New York School" at the Los Angeles County Museum, the "New York Painting and Sculpture: 1940-1970" at the Metropolitan Museum, to name but a handful—has been a more or less aggressive use of aesthetics *cum* art history in an effort to direct the creation of art in the United States. In that its contemporary subject matter lacks definition and is contingent on the outcome of ideological conflicts, the museum is obliged

to justify its choices of exhibitions by its strategic manipulation of art in a state of change.

Since the museum, instead of being the embodiment of art history, has become an institutional power engaged in creating art history, its awareness of its aims has grown increasingly incoherent. To compensate for its cloudy relation to the art of the past, it endeavors to synthesize an aesthetic essence out of constantly changing ingredients. In the face of rising attacks on its social role it is prepared to go as far as necessary toward self-transformation, stopping just short of not existing. Since the museum has voluntarily abandoned the closed garden of art in favor of playing a part in current history, its reason for excluding politics is no longer metaphysical but practical—more exactly, it is bureaucratic: "The museum is not an agency set up for political purposes." Yet in all except politics it collaborates with social change. Its stress is on informality and popular demand, and it is incessantly on guard against enveloping its exhibits in an aura of high culture, or setting art apart from anything. Sharing the sentiment that in a democracy nothing ought to exist, at least in public, that is not for everyone, it firmly repudiates "élitism," though this has not prevented it from continuing to sanctify an assortment of heroes. Adjusted to the cultural egalitarianism of the museum, art appears to have become a kind of protean, catchall mass medium into which are filtered minor currents of invention excluded by the more firmly channeled media, such as broadcasting, films, circuses, and parlor games. Any object or spectacle that falls into no other category will be accepted as belonging to a new art form.

An interview conducted on television by Aline Saarinen with Mr. John Hightower, director of the Museum of Modern Art, and negotiator with artists' protest groups, summed up attitudes underlying the activities of museums, from their overall programs and interests to their "community-service" orientation (e.g., the "Harlem on my Mind" exhibition at the Metropolitan) and their hospitality to new industrial substances and processes (e.g., "The Machine" exhibition and E.A.T.). What emerged from the interview was a popularist outlook (Hightower called it "human") and the determination to dissolve painting and

sculpture into broader aesthetic streams. (An heir of the Bauhaus spirit recently suggested that the word "artist," limited by its association with the studio, be dropped in favor of "art man"— a creator in any genre, from furniture to leather sandals.)

In reply to a question as to what "people should experience in museums," the spokesman for the Museum of Modern Art declared that "first of all it ought to be fun," and said that he hoped this fun might be "connected with some sort of visual experience which they [the spectators] may not get anywhere else" (presumably, an undersea expedition would qualify). Having thus characterized the museum as an agency of mass entertainment and education, Hightower proposed an unlimited expansion of its critical-aesthetic function: the museum, he speculated, might operate as "a kind of editor to pick on elements that affect all the things that go on in contemporary society." Nothing, apparently, would escape its attention and the benefit of its expertness. It would, Hightower went on, "recognize [he did not explain how] what is, essentially, a very valid artistic expression, whether it's gardening or pulling the magnificent bird out of the oven on Christmas Day." In effect, the museum would amount to a species of aesthetic commissariat, passing on "the look and character of everything." Yet it would, according to Hightower, remain resolutely nonpolitical, since to take a stand on matters that agitate artists and the public, such as the war in Vietnam, would weaken its authority "as a kind of detached, unsullied, unbought and unbuyable critic."

Leaving aside the self-declared moral and intellectual immaculateness of the museum (Hightower, however, later readily admitted that the museum was a "club" of a small group of trustees, dealers, and artists), its present nature, according to Hightower, is such that it can take in anything as "very valid artistic expression" but, like the museum of the past, it will take in politics only in the form of the aesthetic. The "Information" exhibition that occupied the Museum of Modern Art throughout the summer of 1970 displayed a glass mechanism for polling visitors on a statement by Governor Rockefeller about Vietnam; this animated ballot box remained on the acceptable side by

being a visually stimulating artifact. But a Black Panther distributing literature—also an information-disseminating mechanism —would be ruled out as beyond the frontier of the aesthetic. Perhaps if the Panther were set in a frame or enclosed in a plastic case. . . . Obviously, the rule of "artistic expression" is inadequate to exclude politics in the way that the older rule of art could, and if pressure mounts the museum's ban will have to be enforced on completely arbitrary grounds. This is another way of saying that in regard to social issues the museum today is intellectually demoralized.

In Hightower's perspective, which evidence indicates is typical of museum avant-gardism, art institutions are on their way to being totally integrated into social activity, except for its political aspects. The museum wishes to "serve the community"; in this it is already political. But its services must be confined to the aesthetic, or to the aesthetic side of things—for example, paintings on the exposed walls of slum buildings. Having helped to dissolve art into life, the museum wishes to segregate life as art. But when painting and sculpture are made equal to other forms of "visual experience," including that of Christmas turkeys, what grounds remain for denying the demands of militants that excellence in art be subordinated to the notions of "relevance" put forward by women, blacks, peace fighters, "younger artists"? When everything has found its way into the museum, the place of art will have to be outside it.

Listening to Hightower, his television interviewer appeared to gain the impression that paintings and sculptures had become superfluous at the Museum of Modern Art. "If you had your way," she asked, "would you move up to the older museums in the country what are now the Old Masters of modern art?" The Director thought this "a really ticklish question," but decided that for practical reasons it was not expedient for the Museum of Modern Art to get rid of its art collection at the present time.

Like the director of the Museum, its "Information" exhibition took the offensive against painting, and in the name of the aesthetic. It invoked political crisis to discredit putting paint on canvas, but the exhibition itself had no political point. Con-

sisting of varieties of electronic communication devices and their screens and punch cards, huge blow-ups of magazine art reviews, recorded verses about Bobby Seale, spectator-questioning booths, slogans, photos, number games, "Information" was an aesthetic cuddling with politics as a substitute for thinking about it. In a book issued by the Museum in conjunction with the exhibition, Mr. Kynaston McShine, who directed the show, called attention to "the general social, political and economic crises that are almost universal phenomena of nineteen-seventy," and he indicated that, in the light of torture in Brazil, imprisonment in Argentina, and shootings in the United States, "it may seem too inappropriate, if not absurd, to get up in the morning, walk into a room, and apply dabs of paint from a little tube to a square of canvas." Recognition of the existence of historical crisis by artists and critics is a welcome change from the sealed-off formalism of the nineteen-sixties; there are indications that the latest fashion of the art world, even for the most stubborn hierarchs of pure abstraction and "quality," is to be "politically concerned" (though not political). McShine's description of painting, down to his reference to the shape of the hypothetical canvas, echoed the impoverished formalist conception, but it repudiated not a particularly empty kind of painting but painting itself.

At the same time, however, "Information" was in no sense a call to join up and go fight against tyranny and war, as left-wing works in the thirties urged people to do. The exhibition used the political argument to reinforce an aesthetic that, like Hightower's diffused "artistic expressions," could provide a negation of art. Such exhibits as rows of computer digits, a telephone on which one could dial a poem, or Walter de Maria's wall-sized self-advertisement in a clipping from *Time*, could hardly be more effective against police brutality in Rio de Janeiro or Los Angeles than a painting, no matter how non-political, or de Maria's own sculpture of a bed of sharpened spikes. What was at work in "Information" was the eagerness of the museum to welcome some kind of up-to-dateness in which the role of painting and sculpture would be reduced. That this was a paramount motive of the exhibition was indicated by McShine's portentous, yet not unfamiliar, observations that

the whole nature of collecting is perhaps becoming obsolete. And what is the traditional museum going to do about work at the bottom of the Sargasso Sea [Mr. Hightower's "visual experience that the spectator may not get anywhere else"], or in the Kalahari desert, or in the Antarctic, or at the bottom of a volcano [this should be one place the museum might want to stay out of]? How is the museum going to deal with the introduction of the new technology as an everyday part of its curatorial concerns?

With its presumption of an aesthetic competence capable of reaching in to "all the things that go on in contemporary society," the museum of today is sensitive to the poverty of painting as compared with the infinite forms of nature and the man-made. The "Software" show at the Jewish Museum that same year ("software" is the input and the output of information-processing systems; e.g., a telegram, ticker tape) quotes the challenge of its director, Professor Jack Burnham, author of *Beyond Modern Sculpture* (see Chapter 19, "D.M.Z. Vanguardism"), to the effect that his display "makes none of the usual qualitative distinctions between art and technology. Rather, it defines technology as a pervasive environment altering our consciousness vastly more than art." (In the Arctic the same could be said of snow, so it seems rather parochial not to exhibit an igloo.) "At a time when," Burnham continues, "aesthetic insight must become a part of technological decision-making, such art/technology divisions seem nonsensical." Here again, the aesthetic has taken precedence over art, and in opposition to it. The museum has come to share the values of the design department of an electronics company or of American Motors, which sponsored "Software." The attitude toward painting is not merely indifference but a hostile wish to extinguish it as obsolete. History, in the form of technology, has condemned painting and those to whom it still has meaning; a publicized item of "Software" consists of the ashes of the "entire lifetime of artworks" by a former painter and sculptor who saw the light last summer and took his creations to the crematory. This destiny for things ideologically declared to be historically outlived ought to have given the Jewish Museum a shudder.

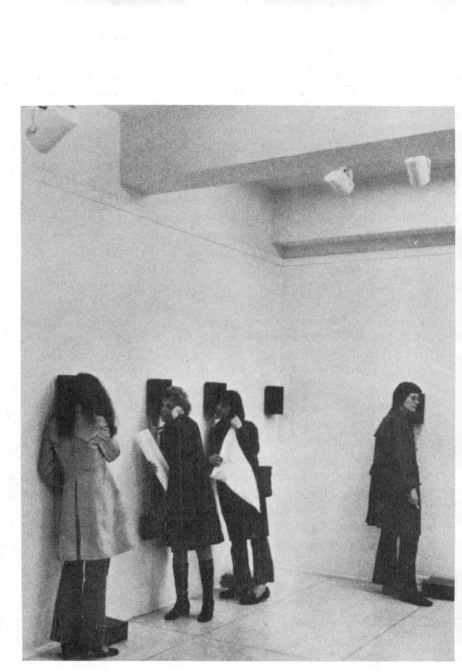

Les Levine, *Wire Tap*. 1969-1970.
"Software" at the Jewish Museum sponsored by American Motors.

Professor Burnham quotes McLuhan in support of his time-putsch: "The artist senses at once the creative possibilities in new media, even when they are alien to his own medium, whereas the bureaucrat of art and letters moans and bristles whenever his museum of exhibits is threatened by invasion or desertion." Significantly, in view of the activist and "creative" role assumed by organizers of museum exhibitions, Burnham had apparently forgotten that he is a professor and has identified himself as an artist, while deriding painters as "bureaucrats." (Incidentally, again to illustrate the contraditions of an avant-gardism that excludes politics, shortly after the opening of "Software," a fracas developed between exhibitors and the Museum concerning the incorporation of quotations from Eldridge Cleaver and Mao Tse-tung.)

The dilemma of the museum is that it takes its aesthetic stand on the basis of art history, which it is helping to liquidate. The blending of painting and sculpture into the decorative media, the adulteration of styles, the mixing of genres in order to create an "environment" for the spectator have completed the erosion of values derived exclusively from the art of the past which was begun by the avant-garde art movements. What is needed to replace those values is a critical outlook toward history and the part played by creation in contemporary culture, politics, and technology. Aesthetics does not exist in a vacuum. The museum seems unaware how precarious it is to go as far out from art as it has on no other foundation than its simple-minded avant-gardism. In the direction it has taken nothing awaits it but transformation into a low-rating mass medium.

22 / Set Out for Clayton!

"Everyone is welcome! If you want to be an artist, come forward! Our Theatre can use everyone and find the right place for everyone. If you decide to join us, we congratulate you here and now!" This announcement that recruiting is taking place at the Clayton Racetrack for the Nature Theatre of Oklahoma is read on a street corner by Karl Rossmann, hero of Kafka's *Amerika*. The Theatre in which everyone is welcome to be an artist is nature as art, a happiness-generating "man-made environment" (to use the phrase popular in current writings on ecological art). "One of the most significant functions of this Theatre," wrote Walter Benjamin, "is to dissolve happenings into their gestic components." In the Theatre, everyone not only can be an artist but is a work of art. As such, everyone is automatically in "the right place"; that is to say, in the world museum. A New York artist, Vito Acconci, periodically notifies the art world, by mail, that on certain dates he will mount a stool in his studio *x* number of times and that this "work" may be viewed at the designated hours. The mounting and dismounting could well be the act assigned to Rossmann in Oklahoma. What does one do in the Nature Theatre? One acts oneself. How can one act oneself when one knows that one is acting? How can one not act oneself? Enough of discussion. "A curse on those who do not believe in us!" Kafka's announcement concludes. "Set out for Clayton!"

The Marxist philosopher Herbert Marcuse interprets the breakdown of the barriers between art and life, as in the case of Acconci, as a radical assault on bourgeois culture. The Nature Theatre, however, is the vision of a situation beyond all cultures—a situation that offers a role to everyone, regardless of talent or training. It is a democratic Utopia in which the metaphysical problem of identity, whose solution Marx deferred until the advent of the classless society, is dealt with directly by individuals, each acting in accordance with his inner form. Because the disintegration of class culture (evidenced by the immersion of all strata of society in the same mass media) has outstripped the disintegration of social classes, the cultural revolution has preceded the political-economic one. Relieved of inherited forms, the individual has gained the privilege of molding his own identity out of data pertaining to his body and any mode of busyness ("gestic"). Besides mounting stools, Acconci counts his pulse beats and moves the contents of his apartment to the art gallery and back again. This activity is sanctioned as art by the logic that changed art history into the history of cultural artifacts, and it is presided over by the sublimated mask of Marcel Duchamp. Marcuse quotes a French thinker: "I dance, therefore I am." To enroll in the current equivalent of the Nature Theatre it is necessary only to purge oneself of reverence for masterpieces and to respond to paintings and sculptures as though they were phenomena belonging to the order of rows of windows in a high-riser or snow flakes melting on the hood of a parked car.

I report on Acconci without having seen him do his act. Why should anyone see him? That his art is exactly like anything else is the point of it. Once you've got his idea, it is as superfluous to witness his performance as it would have been to follow Duchamp into a store to see him select his bottle rack. "Already," writes Gene Youngblood, in an essay on "World Game: The Artist as Ecologist," in *artscanada*, "the image of the artist has changed radically. Increasingly, it is the artist's *idea*, not his technical prowess, that is important" (his italics). In the Nature Theatre, there are actors but not necessarily spectators. As the art-world phrase goes, the relation between artist and audience

has been revolutionized. It is enough merely to hear about works of art or to receive information about them through other media. Youngblood describes a mobile television "gallery" in Düsseldorf (the West Germans seem suddenly to have sprung into a forward position in aesthetic avant-gardism) that commissions artists to execute earthworks and other environmental novelties expressly for broadcast, and he quotes the proprietor of the gallery to the effect that his "TV gallery exists only as a series of television transmissions. There is no gallery room. We communicate art, we do not sell objects. . . . Collaboration with TV stations . . . is the only hope for the fine arts if they are to endure." In this context, the desire to have "the fine arts endure" is rather surprising. According to Marcuse, "the thesis of the end of Art has become a familiar slogan." Can spectators without objects cause art to last longer than objects without spectators? Perhaps hearsay art will take on the longevity of folklore.

Parallel to the Nature Theatre is World Game, which Youngblood expects "may become the most important art event in history." The Game is based on the contention of Buckminster Fuller that, in Youngblood's words, "it's now possible to make all humanity physically successful"—an intrinsically Nature Theatre idea ("If you decide to join us, we congratulate you here and now!"). Using data from Fuller's World Resources Inventory, "World Game approaches Spaceship Earth as a work of art." The objective of the Game is not, however, to contemplate the world, in the manner of nineteenth-century nature poets, but to change it. If the world is a work of art, it is also an inexhaustible pile of art materials. Every living creature is a detail in the ecological assemblage; even the mite of carbon dioxide produced by Acconci's exertions contributes to air pollution. The formal activity of World Game consists of composing "geosocial scenarios" by which to transform the art/reality environment. In establishing a global hookup capable of "programming a total environment for total man," the Game brings to fulfillment the theories represented by earth art, information-systems art, process art, electronic-phenomena art, chance art, data-registration art, and conceptual art. Youngblood lists a score of artists who are forerunners of World Game playing.

They are art-world Names, such as Andy Warhol, Les Levine, Allan Kaprow, John Cage, Dennis Oppenheim, Robert Morris, and Otto Piene. But when the world network of Game "extension groups" goes into operation (Youngblood is participation planner and, presumably, recruiter at the California Institute of the Arts), "Names won't be necessary, and there will be roles for everybody in the great art works of tomorrow."

An earthworks artist has defined art as moving materials from one location to another; a Matisse is paint transferred from tubes to a canvas. In this view, the artist is a species of porter; perhaps this accounts for the fact that porters are a much-favored motif in pre-Columbian sculpture and Egyptian wall painting. Ecologically, we are all porters, in that we pick up air and food from the environment, store them for processing, and convey them back to their source. An artist is a porter who has declared himself an artist while he continues his work as a porter. As in the Nature Theatre announcement, it is necessary only to "come forward."

Robert Morris has come forward more frequently and in more roles in the last five years than anyone else in the art world. He has discovered the secret of postwar vanguard art: that existing works are translatable into ideas which can then be demonstrated by models accompanied by a text. His playing of reality against art, and as art, seems entirely uninhibited by any simple affection for paintings or sculptures. His "reality" art has traversed Jasper Johns's "thing" paintings, Minimalist cubes, boxes, I-beams and L-beams, anti-form (*arte povera*) accretions, process art (tree seedlings in a green house at a Museum of Modern Art exhibition), earthworks, events reported on film, and (momentarily) the renunciation of art in favor of political action. Morris is the leading theoretician-practitioner of an art that could be made by anyone and appreciated through hearsay. "Morris," writes Marcia Tucker, in her monograph on the artist (*Robert Morris*, Praeger, 1970), "eliminates distinctions between 'aesthetic' experience and 'real' experience. . . . The experience of this art is distinguished *quantitatively*, not *qualitatively*, from that of natural events or objects." (her italics) Making quality superfluous removes the major obstacle to immediate art performance

(anyone with a recipe book can do it), as well as to immediate acceptance (since the audience has been liberated from uncertainties of judgment based on sensibility). Avant-garde art is at last put on a solid footing by the elimination of the conflict between what is justified by art ideas and what one likes. If there is no difference between art and life, there is no difference between the artist and his public. Instead of representing creative mysteries, the artist becomes a group leader. Collective projects, not the cultivation of individuals, are the aim, and it is sufficient that participants are kept cheerfully occupied.

World Game is the antithesis of what might be called the "I" Game, which artists have traditionally played in solitude in order to bring to consciousness and transform the inner "Resources Inventory" of individuals. Like World Game and the Nature Theatre, "I" Game is open to everybody, and it has the extra advantage of requiring neither organization nor any apparatus more complicated than pencil and paper. In this aspect, "I" Game is more democratic than World Game but less sociable. Indications are that since art in our time tends to swing from extremes of introspection (Expressionism) to extremes of objectivity (Bauhaus, Minimalism), "I" Game may be expected to return to the foreground of art should World Game and its earthworks and conceptual subsidiaries become excessively popular. What is important, however, is that swings both outward and inward have been occurring in the orbit of related ideas about art. Like Action Painting, which is an "I" Game, all forms of ecological art regard art as an activity and seek a result that is not an object but a force acting on the spectator—even when it acts on him through rumor. For Morris, says Miss Tucker, "the question 'What does it mean?' [is] irrelevant. The central issue becomes, instead, 'What does it do?'" Should someone during these shifts take the trouble to become a great painter, there would not, I suppose, be any strong objection.

Like the Abstract Expressionists of the nineteen-forties, World Game recognizes that art today is being produced in the midst of a world crisis—a situation the art movements and art

criticism of the nineteen-sixties took great pains to deny. The crisis is very much alive in the mind of Herbert Marcuse, and he associates it, no doubt correctly, with the present tendency to dissolve forms and mingle art and life. In an article entitled "Art as a Form of Reality," contained in a collection of statements *On the Future of Art* (Viking, 1970) delivered as lectures at the Guggenheim Museum, Marcuse considers the art/life mix to be an expression of revolt against the profit system and its commodity culture. He identifies "real" art with anti-art, and anti-art with the New Left. But, oddly, the radical connections of art-as-life do not endear it to Marcuse. For him, art is higher than revolution; it is scarcely an exaggeration to say that it is higher than life itself. He believes that drowning art in reality is a violation of art values and also unrealizable. Art, no matter what it pretends to be, remains art, and if it tries to be something else it manages only to be bad art. This view puts Marcuse into conflict with the negative and utilitarian art of this century since Futurism and Constructivism.

Marcuse's axiom is the not unfamiliar one that art is "essentially" different from everyday reality as well as from the realities of science, technology, and politics. What makes a work art is its participation in form, which participation removes it from nature and events into a separate realm. Marcuse is committed to the art object; modernist notions of art as action, event, process, communication seem to him distortions of the inherent nature of art. Without needing to name them, Marcuse is condemning World Game, earth artists, conceptual artists, Robert Morris, and electronic-systems artists, such as James Seawright and Jack Burnham—the last two fellow-contributors to *On the Future of Art.* Indeed, to juxtapose Marcuse's idealistic conception of the art object as a "self-contained whole" —"something 'higher,' 'deeper,' perhaps 'truer' and 'better,'" whose creation was "guided by the idea of the beautiful"—with the ecological artist's pragmatic definition of art as moving rocks, dirt, household furnishings, or bodies from one place to another provides a ripe fragment of "found" comedy.

Marcuse's most telling argument against today's "living art" relates to its social effects: that in imagining that it can transform the environment it denies the experience of estrangement and

powerlessness characteristic of present-day life. Audience-participation Happenings and displays present what seem to be pieces of reality on which spectators can act, but this reality is aesthetically contrived, and thus unlike the reality over which most people have no control at all. In this way, "living art" changes antagonism to things as they are into approval, and Marcuse concludes that "illusion is strengthened rather than destroyed." So he accuses anti-art of being falsely revolutionary —a conclusion hard to refute. But he is also against art that is genuinely revolutionary, i.e., that attacks inherited forms. He wants to revolutionize society but to keep art intact above society, in the form it presumably has always had. Art cannot be blended with life, and life can become aesthetic only when "a new type of men and women" begin building an altogether new society. But even the perfect reconstruction of man and his environment will not affect the transcendent status of painting and sculpture, including works of the past; they will continue to embody "a beauty and truth antagonistic to those of reality."

Marcuse's position is an instance of the intrinsic conservation of the contemporary Marxist outlook on art. In the name of a future new society, it rejects the changing imaginative substance of the present. Blaming everything on the capitalist system amounts to blaming *only* the capitalist system. Craft work executed in precapitalist slave workshops carries no stigma for the Marxist aestheticians, and it even forms part of changeless standards by which to denounce the creations of free minds. In splitting form from content, Marcuse locates himself firmly in the academic tradition. Philosophically, it may be convenient to isolate art from non-art phenomena; to conceive art to be synonymous with form helps, for example, to explain how works produced in one epoch can carry over into another. But this "solution" overlooks the progressive deformalization of the modern imagination under the flood of random events and mass-communication patterns. It overlooks, too, the great works of modernism that are improvised in one-of-a-kind forms (*Thus Spake Zarathustra*, "Guernica," even the *Communist Manifesto*) or built out of raw fact (*Moby Dick*, Impressionist painting, collage).

No doubt World Game and artists on Youngblood's list of

"living-art" pioneers function on the edge of farce and often fall into self-delusion and hoax. Earth artists are unlikely to push the farmers and the oil and mining companies out of the way so that they can change the face of the globe. But in art it is folly to demand that works should conform literally to claims made for them. The sincerity of "living art" lies not in its ability actually to become part of nature but in the logic with which it carries on the struggle of earlier twentieth-century art movements against fixed ideas of the aesthetic. The resort to direct experience and to materials outside of art is an aspect of the cultural crisis; it is the response of artists continually compelled to begin anew. Reality-versus-art may be a slogan of the New Left, but it was also a slogan of nineteenth-century American painters, from Catlin through Eakins (See Chapter 1, "Redmen to Earthworks") though they, too, were unable, as Marcuse says of today's anti-artists, to escape "from the fetters of the Art-Form." Situations of novelty and crisis induce programs of making do with what lies at hand. The Oklahoma Nature Theatre is a vision of America as a place where anyone can begin again with himself as he is. There, art imposes no forms on life. In the Nature Theatre each must create his own part and his style of performing it. The Nature Theatre is the democratic alternative to the New Order—Marcuse's and anyone else's. The future of art in America has become perfectly clear. "Everyone is welcome! Set out for Clayton!"

Index

ACKNOWLEDGMENTS

My thanks to *The New Yorker* in which the chapters of this book originally appeared, except for "On the De-definition of Art" which was delivered in substantially its present form as a commencement address at the Maryland Institute, College of Art, in Spring 1971.